THE ART OF
Letter Carving
IN STONE

TOM PERKINS

THE CROWOOD PRESS

First published in 2007 by
The Crowood Press Ltd
Ramsbury, Marlborough
Wiltshire SN8 2HR

www.crowood.com

This impression 2011

British Library Cataloguing-in-Publication Data
A catalogue record for this book is available from the British Library.

ISBN 978 1 86126 879 2

Acknowledgements
I would like to thank my wife, Gaynor, for her help in seeing this project through, John Neilson for all his help with scanning and arranging many of the diagrams, Christopher Elsey for supplying much of the text on gilding, Sara Millington-Hore for her valuable editorial input and all the letter carvers who have contributed images and written about their work, whose contributions have been invaluable to the book.

Unless otherwise stated, photographs of processes are by G. and T. Perkins and diagrams by T. Perkins.

Frontispiece: Tom Perkins, V-incised Welsh slate menhir, 2m high, one of five stones, EU-funded commission for the Peddars Way National Trail, Norfolk, 2000. (Photo: Daphne Hoskin)

Typeset by Focus Publishing, Sevenoaks, Kent

Printed and bound in India by Replika Press Pvt. Ltd.

Contents

'Let the beauty we love be what we do.
There are hundreds of ways to kneel and kiss the ground.'

Jelaluddin Rumi

'Our aim should be, I think, to make letters live…
that men themselves may have more life.'

Edward Johnston

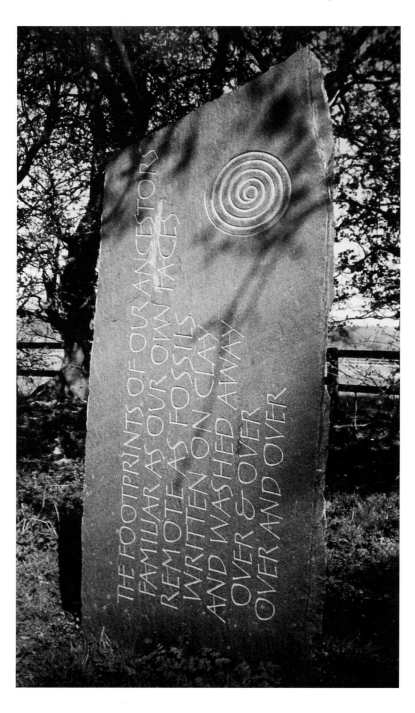

Foreword

People are often surprised that anyone still carves stone inscriptions by hand. 'Can't you get a machine to do that?', they ask. You can, of course – at least up to a point. However, just as a handmade pot is not the same as a mass-produced one, so every part of a hand-carved inscription is the result of a direct, human process. And more than that, the letter carver (in the way the term is used in this book) has designed the letters, and not used someone else's typeface conceived for a different purpose. That, above all else, is what it is about.

There is in fact something of a revival going on in the making of stone inscriptions. A century ago, Eric Gill laid the groundwork for a new breed of 'studio' letter carvers, much as he would have disliked the concept. Though few of his successors proved able to match the standards of design he had set, letter carving nonetheless survived through the second half of the twentieth century. A few determined practitioners (see Chapter 1) held out against a climate increasingly inimical to hard-won craft and design skills.

Tom Perkins arrived on the scene in the late 1970s and quickly established a reputation as a designer and carver with an original voice. When you look at a piece of lettering carved in stone by Perkins, the word 'integrity' comes to mind, in both its senses of 'wholeness' and 'honesty'. Up close the chisel marks bear the same sense of purpose as the letters themselves. The part is a microcosm of the whole. These are not letters designed to create a superficial 'look', as a display typeface might. They have a life of their own, springing from their maker's rigorous sense of design, itself a product of long reflection, well-absorbed influences and, perhaps, an inherited predisposition to craftsmanship from his shipwright father and several generations of skilled artisans before him. As Gill said in a different context, these letters are 'things, not pictures of things'.

At the age of thirteen, Perkins was introduced to Roman letters by an art teacher, sparking off an all-absorbing interest and giving him a firm sense of what he wanted to do with his life. In 1974 he went to Reigate School of Art to study calligraphy, where he met his future wife, Gaynor Goffe. She tells how Tom would spend every spare moment drawing and painting letters. So by the time he started letter carving at Richard Kindersley's workshop in London, though not yet twenty years of age, he already had a profound knowledge of letterforms. This would deepen further as he became familiar with the chisel. The relatively limited range of forms he now uses is the result of years of experimenting and refining; 'extracting essence', in the phrase of the potter Hans Coper. Designers of typefaces tend to be more celebrated than letter carvers, not least because their designs are multiplied in millions and often carry their names, but the 'essence' Perkins has extracted from those twenty-six letters bears comparison with the work of the best contemporary type designers.

It will be no surprise to Perkins' students that this book does not contain gimmicks or performances designed to impress, but rather seeks to teach by example, homing in on the essentials. It is characteristic that he has chosen to include photographs of the work of other people (several of whom he has himself taught) as well as his own, and to give space to their views.

I had the good fortune to spend nearly a year as Tom's assistant. Much as I admire his work, the most valuable gift I take from that time is the sense that the practice of letter carving is more than just playing around with shapes, meeting a client's brief, earning a living or simply perpetuating a tradition. Letter carving is a craft rooted in several basic human preoccupations: language, design and making. This book will help students and practitioners with the technicalities of their work, but will also, I hope, impart something of what has driven its author along a remarkably single-minded path for some thirty years.

John Neilson

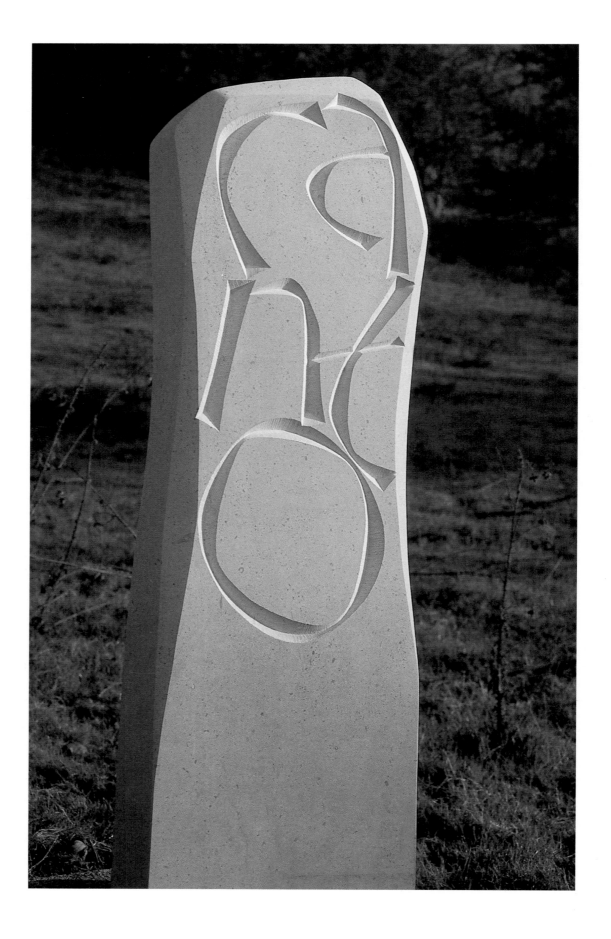

Introduction

Letter carving in Britain as practised by artist-craftsmen at the beginning of the twenty-first century is gaining new popularity against a background of decades of sparse educational opportunities in this field. Whilst the classical approach to letterform advocated by Eric Gill is still very much in evidence and continues to provide a sound foundation for those wishing to learn the craft, other approaches are feeding into contemporary practice. This includes the influence of German work, notably that of Sepp Jakob (see pages 23,24) and his colleagues and students. Also, in 1988 the formation of Memorials by Artists (MBA) and Letter Exchange (a society for letterers of all disciplines), further broadened people's outlook of what was possible in letter carving.

Letter carving in stone is a craft requiring very little in the way of equipment. I remember many years ago sitting in a café in South Kensington next to David Kindersley after he had spoken at a conference on lettering at the Victoria and Albert Museum. Someone from the Crafts Council was speaking at some length about all the equipment young craftsmen needed in order to set up. Kindersley leant across to me and whispered 'all you need is a hammer and chisel'. Add to that a sturdy wooden easel and a diamond sharpening plate and one has all that is necessary to make a start in letter carving.

After acquiring the equipment the next most important thing is to use it! For some peculiar reason many people imagine that good letter carving technique will happen right from the start. If you experience some difficulty to begin with, this is perfectly normal. Whilst the rudiments of the letter carving techniques can be picked up relatively quickly with regular practice, the ability to make good letterforms and arrange them into effective designs is a much longer process. Many of the letter carvers in this book have been working with letterforms and carving for many years, and while the novice letter carver can make attractive items soon after beginning, refining technique and improving letterform and design is an ongoing process.

Few people consider that the making of inscriptions is an art. A lack of understanding about the different possible approaches to the design and use of lettering together with

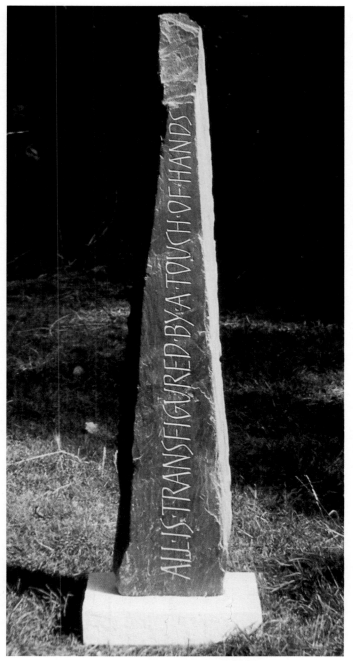

Tom Perkins, 'All is transfigured…', V-incised Welsh slate menhir. 110cm high. Private collection. Words by Vernon Watkins. Kind permission of the Golgonooza Press.

John Neilson, 'Canto', Hopton Wood limestone. Text in Spanish by artist, also on back (En el canto de la piedra suena el mar: 'In the song of the stone sounds the sea'). Private garden, Somerset, 2004. 122 × 35 × 10cm.

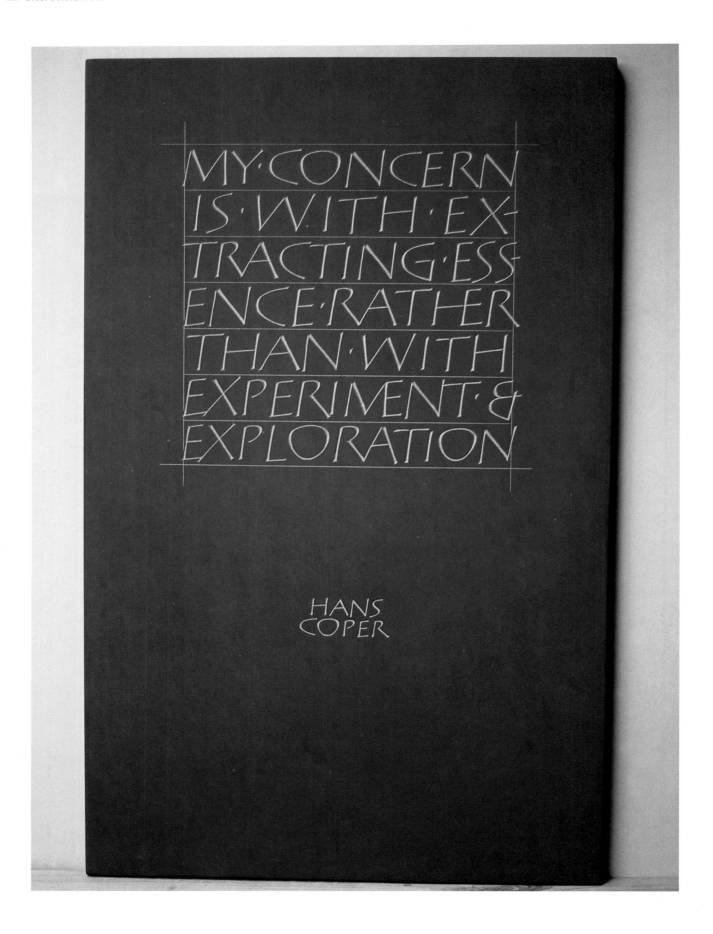

MY·CONCERN
IS·WITH·EX-
TRACTING·ESS
ENCE·RATHER
THAN·WITH
EXPERIMENT·&
EXPLORATION

HANS
COPER

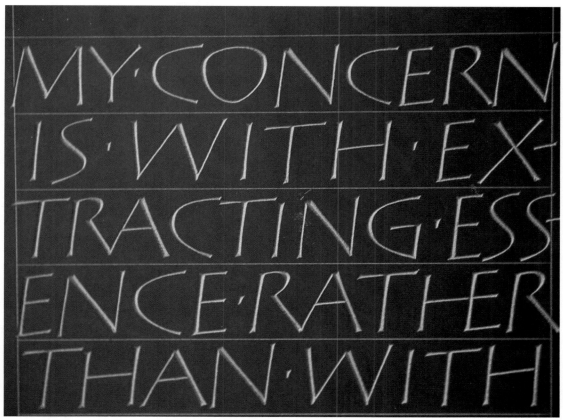

Tom Perkins, detail of Hans Coper quotation.

Opposite: Tom Perkins, V-incised and painted Welsh slate, 1994. 30.5 × 49.5 × 1.5cm. Quotation by Hans Coper.

the lack of adequate educational opportunities in the making of letters by hand has contributed to this situation. It is unfortunate that although most art schools in the country have a course on the making of pots, virtually nowhere is there a course on the making and designing of letterforms, especially from a traditional perspective.

From the beginning of the process of learning letter carving, time should also be given to the drawing and writing of letterforms. There is a burgeoning network of courses provided by organizations such as the Calligraphy and Lettering Arts Society, the Memorial Arts Charity, the Orton Trust and West Dean College. Instruction in the drawing of letters is harder to find but much can be attained through regular practice with the aid of the drawn lettering in this book, and if possible, a little feedback from an experienced letter carver. As well as working with the classical forms, keeping a sketchbook or scrapbook of other letterforms you find interesting will help both in developing an increased perception of letterform and in the development of a repertoire of forms.

Lettering is largely an interpretative art; taking existing letterforms and making variations on them. Obviously, letter carving in most instances needs to retain legibility, so the letterforms cannot be too extreme in these situations; though

for personal work such criteria may not necessarily apply.

There are at least three different levels in the practice of letter carving today. First, there is the work of the craftsman whose approach is one of copying or tracing existing letterforms such as typefaces or fonts. This can be done skilfully, but remains imitative nonetheless. Everybody starts this way. As W.R. Lethaby, architect and first principal of the Central School of Arts and Crafts, said, 'how creative would you be if you had spent all your life in a darkened room?' It is hoped that from this common starting point, the practitioner will move forward to the next level, which is the work of the designer-craftsman, whose approach is concerned with the intelligent adaptation and modification of existing letterforms so that the letters become in a very real sense a reflection of the individual maker. It is very difficult for the uninitiated to tell the difference between levels one and two. The third level is the work of the artist-craftsman where the interpretation of the letterforms can be highly individual and marked, they seem to resonate with and enhance the meaning of the text. The work in this book comes from people working with the approaches described in the second and third levels.

Moving into a new century with an increased amount of interest and the subsequent growth in numbers involved in letter carving, there is every hope that it can build upon its twentieth-century heritage and thrive as new opportunities for its use are found.

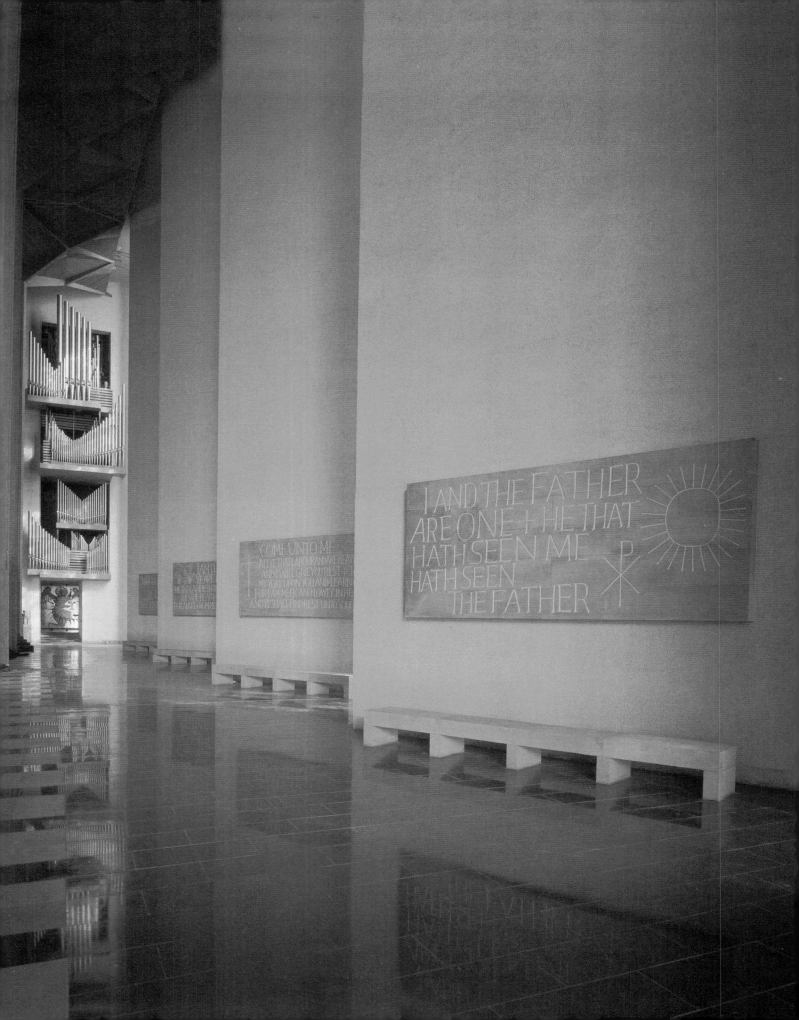

1

Background to Letter Carving

Influential Twentieth-Century Letter Carvers in the UK

Eric Gill (1882–1940)

One thing is certain: as a carver of inscriptions he stands supreme. There the workman scaled the heights of pure form, and some of his inscribed stones possess the anonymous and inevitable quality we associate with the works of the great civilizations, where an almost frightening technical skill, for a rare moment, is the free instrument of the highest sensitivity – and the word is made stone.[1]

These moving words were written by the painter and poet David Jones about his friend Eric Gill. Without Gill's remarkable contribution to the art of the incised letter in stone in the first half of the twentieth century, it is doubtful whether hand-carved letterforms, practised at a high qualitative level, would have survived into the modern era in Britain.

Gill was very fortunate to come into contact, in 1899, with the 'father of modern calligraphy', Edward Johnston (1872–1944). Johnston started teaching classes in calligraphy at the Central School of Arts and Crafts in London in 1899, and Gill had begun attending these classes while articled to the ecclesiastical architect W.H. Caroe. Gill describes his first sight of Johnston writing with a broad-edged pen thus:

Ralph Beyer, 'I and the Father are One', one of eight 'Tablets of the Word', each approximately 15 × 7ft (4.6 × 2m) in Coventry Cathedral. V-incised in Hollington sandstone, 1960–61

It was no mere dexterity that transported me; it was as though a secret of heaven were being revealed.[2]

Gill was equally impressed with Johnston the man:

…he profoundly altered the whole course of my life and all my ways of thinking. Just as 'art nonsense' could not stand against him so also 'thought nonsense' was toppled over. He was a man miraculously deliberate of speech and equally deliberate in thought.[3]

Although some of Gill's early inscriptions show the influence of having been laid out with a chisel-edged calligraphy pen, he fairly soon abandoned this practice and his later letterforms were drawn in outline with a pencil rather than directly written with a pen, though he always valued what he had learned from Johnston.

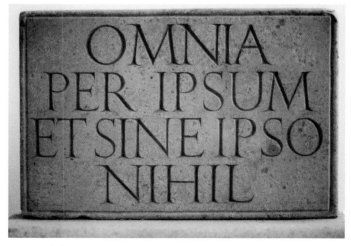

Eric Gill, 'Omnia per ipsum…', inscriptional tablet in Hopton Wood limestone. Carved in 1913 and given to his father for his birthday. 14.5 × 22.5cm. (Reproduced by kind permission of Myrtle Skelton)

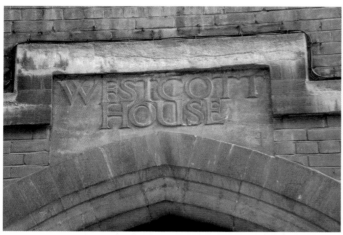

Eric Gill, 'Westcott House', raised lettering, Theological College, Jesus Lane, Cambridge, 1904. This seems to be the first job on which Gill cut, at the lower right corner, a Latin cross with four dots, which was a kind of signature.

Gill converted to Catholicism in 1913 and throughout his life was deeply concerned with the problems of the craftsman in modern industrial society. Gill saw himself in a very real sense as collaborating with God in redeeming the material world by infusing it with the spiritual:

> I simply say that holiness is the name for that quality in things by which we judge them good. Its full meaning escapes definition in words. It is a spiritual thing; it must be apprehended by the spirit.[4]

Gill saw the act of making things as far more than a Darwinian struggle for survival:

> …the most important motive for man's activity in doing or making are neither animal instincts nor caprice. We hold that love is more important and not merely prettier than instinct. Upon such a ground and from such a place of vantage we survey the works of men. We see all things as evidence of love. We make what we love – in accordance with our love so we make. A pair of scissors, no less than a cathedral or a symphony is evidence of what we hold good and therefore lovely, and owes its being to love.[5]

At the beginning of his career as a letter carver in the early years of the twentieth century, Gill was keen to get back to first principles in lettering:

> And what was fine lettering? It was in the first place rational lettering; it was exactly the opposite of 'fancy' lettering. That was the new idea, the explosive notion, and, you might say, the secret.[6]

Gill, under the guidance of Johnston, went back to the source of our modern alphabet – the classical Roman capi-

David Kindersley, 1952.

tal. Although he made thorough studies of the Trajan letter, he famously once said: 'My inscriptions are no more like the Trajan than Caslon's type is',[7] and 'while we may remember Trajan lovingly in the museum, we must forget all about him in the workshop'.[8] Gill's capital letters subtly evolved all through his career and he was constantly making slight adjustments to his letterforms. It would be wrong to view his forms as static and unchanging.

David Kindersley (1915–95)

Probably the best-known assistant to Eric Gill was David Kindersley. Kindersley worked with Gill from 1934 to 1936, eventually settling in Cambridge in 1945 and working there until his death. Kindersley very ably continued the tradition of fine Roman capitals pioneered by Gill, and in particular was very knowledgeable in the art of spacing letters (he worked on a computerized system for spacing letters in typography for the latter decades of his career). Whereas Gill was predominantly concerned to get back to first principles, advocating a more rational approach to letterforms

and their arrangement, Kindersley, as well as using classical Roman capitals, re-introduced a more decorative approach using flourishes. This harked back to the 'command of hand' exercises of the English writing masters of the eighteenth century, such as George Bickham in his famous book The Universal Penman.

Slate was a material used very little by Gill – there are apparently no recorded inscriptions carved by Gill in Welsh slate, though he did carve a small number of inscriptions in Delabole slate. Slate was taken up by Kindersley, as its fine grain lent itself very well in particular to his flourished work, where the marked contrast between thick and thin strokes is vital. Kindersley, after a visit as a senior research fellow to the University of California, Los Angeles in 1968, started to produce in graphic form a series of experimental alphabets and sayings by the Sufi Idris Shah. These experiments went on to influence a freer approach that appeared in some of his carved work. In a personal note at the beginning of his biography, he says:

There are two sides to a letter cutter's nature – or there ought to be. Just like any other craftsman or artist he will be spending a lot of time making things that he feels should be explored and making other things that other people want, and these two aspects of his work are quite different.[9]

The David Kindersley workshop, now the Cardozo Kindersley workshop, has been very successfully continued since his death by his wife Lida. The workshop has, since the 1950s, trained apprentices – some of the best-known being Lida Lopez Cardozo herself, Kevin Cribb, Keith Bailey, David Parsley, David Holgate and David Kindersley's son Richard, who have all had long and successful careers, and this tradition of training apprentices continues.

Ralph Beyer (1921-2008)

A further important figure in the field of letter carving in the second half of the twentieth century was another ex-Gill assistant, Ralph Beyer, who was with Gill from 1937 to 1938. Beyer was born and brought up in Germany, which his family fled in 1933. His father, Oskar, was a leading art historian and an expert in early Christian symbols, as found in the catacombs in Rome. According to Beyer, 'Without doubt the two main influences on my work and development as a letterer are Rudolph Koch and Eric Gill.'[10] Another key influence

The Cardozo Kindersley Workshop, V-incised Welsh blue-black ledger stone, St Albans Abbey, Hertfordshire, 1979. 376 × 92cm

Ralph Beyer, carving a Zen poem.

Ralph Beyer, one of eight 'Tablets of the Word', each approximately 4.6m × 2m, in Coventry Cathedral. Pink Hollington sandstone, 1960–61.

was the painter and poet David Jones, who created freely composed painted inscriptions from the 1940s through to the 1960s, and whose work was also affected by the more primitive quality of early Christian inscriptions.

Beyer worked with a slightly condensed, squared capital letterform throughout his career, giving his work a remarkable homogeneity. His most significant and best-known public work is the series of inscriptions in Coventry Cathedral. These are known as 'The Tablets of the Word', each measuring approximately 15 × 7ft (4.6 × 2m), on which are incised words from the New Testament. Beyer has said:

> I was attempting to create letters, words and sentences which would be read, and also work which reflected the art of our time and its search for new forms of expression.[11]

Beyer taught at various art colleges from the late 1950s and then for eleven years at the City and Guilds of London Art School. He also taught one day a week on the typography degree course at Reading University, which he found most rewarding and continued to do until his retirement in 1986.

Beyer was one of the first, if not the first, to use a freer approach to the design of carved inscriptions with letters not strictly between lines, with little interlinear space and use of asymmetry in the layout. In an article in 1991 he stated:

For freely-created and freely-composed lettering there are no rules: the meaning and nature of the words will make their own demands. The future holds untold possibilities: we need the word, the graphic word, the word transcribed creatively, and in a public context.[12]

Beyer throws light on his work in his own words, as follows:

> Memorials, headstones and recumbent stones, foundation stones, commemorative stones, cornerstones for churches, lettering on fonts, on the exterior of shops, houses, blocks of flats. These are some of the commissions and many applications of letter-design, which I have carried out since the late 1950s. The basis of this work was laid in the late 1930s when I was taught letter carving and stone masonry by Eric Gill himself and by his assistants in his workshops. This training opened up a range of work for private clients and above all for architects, by which I have earned my living from the time when I left HM Forces in 1946 and for the nearly sixty years since. Craftsmanship in stone and letter design increased my experience and finally led to teaching lettering and graphic design to students in schools of art and in the typography department of Reading University. This also gave me decided views of style and the role of lettering for buildings of every type.

> When I was being taught by Eric Gill at Pigotts, I was doing a little work on his giant relief panels in stone that had been commissioned by the British government for the new building for the League of Nations in Geneva – a carved relief in stone with text in bold letters set against the figures of people and animals. The words 'Thou Mastering Me God giver of life...'(from Gerard Manley Hopkins' 'Wreck of the Deutschland') taught me something about the use of carved sculpture with lettering, used to communicate the work's message on an equal level – so to speak. Many years later I saw, and found profoundly impressive, mosaics on walls and ceiling in St Mark's, Venice, which used the same juxtaposition. In the 1950s I saw reproduced examples of David Jones' poems and other texts selected by him, worked on a small scale using water-colours and Chinese white throughout. These compositions and the direct impact of their words were an inspiration to me as were the inventive, wide-ranging graphic works of the eminent German calligrapher and type designer Rudolph Koch.

> My first public commission was for lettering and symbols on a large slate altar designed by Keith Murray for the Royal Foundation of St Katharine's at Shadwell, for which I

designed my own letters and incorporated symbols. Another early chance I had for lettering in large scale on architecture was for the modern Church of St Paul's, Bow Common, for the same architectural partnership. This time the letters were cast in concrete in situ, forming a band around the top of the porch walls, picked out in Venetian red. But my most spectacular commission after this was to design all the lettering for Sir Basil Spence's new Coventry Cathedral (1961–62). The most challenging aspect of this was to carry out the texts and symbols, based on the early Christian inscriptions in the catacombs of Rome, on the eight Tablets of the Word (four tablets on each side of the nave up to 15 × 7ft [4.6 × 2.1m] with letters of varying heights). Neither the lettering nor the symbols are taken direct from these often primitive carvings, but I endeavoured to express the words forcefully in the spirit of the art of our time. The carving of these panels was hand-done by me and my assistant onto pink Hollington sandstone. These letters and symbols, then, were composed over forty years ago for this particular context and the idiom belongs to the building, so their apparent influence on graphic and advertising design was far from my mind.

The work in the cathedral led to other commissions in which words of philosophy and poetry were important and for these commissions the informality that was the approach in Coventry was more or less maintained. For instance, the inscribed boulders in the Paul Tillich Park, New Harmony, Indiana. But after the big Coventry commissions, the functional work, described at the beginning of this statement, continued and required a more formal style: I never regretted this and have always aimed at simplicity and legibility, especially when the information had to be transmitted. I was able to engage with architects over considerations of scale and position and the designs were always related to the design of the building. I look back to these jobs, where I was an architect's subcontractor, with pleasure.

In recent years I have felt able to choose and express words to which I personally related. These pieces, some of which have been sold and installed, are uncommissioned and have been exhibited in various locations. Most of them are smaller and therefore easier to handle and are short quotes from poetry or prose that I have found beautiful or important. Apart from the choice of size, layout, and stone it is necessary to express the words through the letter style. My aim is to give the words meaning and impact for someone seeing them for the first time.[13]

John Skelton, V-incised slate opening plaque. (Photo: Sussex Express)

John Skelton (1923–99)

Like Ralph Beyer and David Kindersley, Eric Gill's nephew John Skelton, another successful and influential letter carver in the post-war era, also had a direct link to Gill.

Skelton was apprenticed to Gill in 1940, but due to Gill's death in November that year Skelton was only with him for a few months. Following this, Skelton worked for about a year

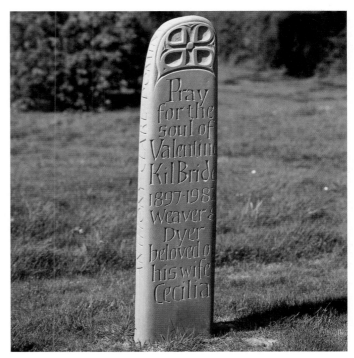

John Skelton, memorial to Valentine Kilbride, V-incised lettering, red sandstone 122 × 30.5cm. Ditchling burial ground, 1984.

Michael Biggs, inscription on rear wall of Garden of Remembrance, Dublin. Letters carved as a shallow cushion section, 1980.

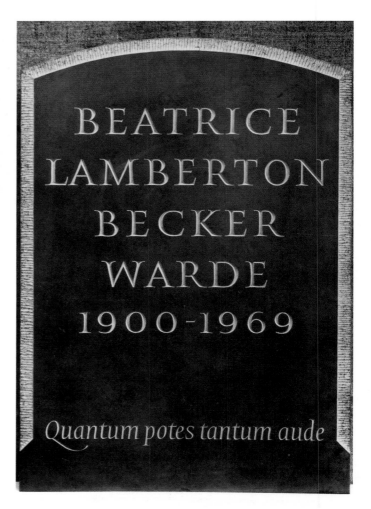

Will Carter, headstone to Beatrice Warde, V-incised Welsh slate, Epsom, Surrey, 1971. (Photo: Edward Leigh)

with Joseph Cribb (Gill's first apprentice) at Ditchling Common, Sussex. After war service, Skelton had a period as an assistant to a monumental mason in Lewes, eventually setting up his own workshop in Burgess Hill in 1950 but later settling in Streat, Sussex, where he continued to work until the end of his life.

He developed a recognizable style of his own, freely mixing squared and angular forms, imparting a lively dynamic to an inscription. He introduced sculpture and letter carving courses at West Dean College, near Chichester, and trained several apprentices including Jack Trowbridge, his first apprentice, who was taken on in 1953, Paul Wehrle, who started with him in 1958, and his own daughter, Helen Mary. Jack Trowbridge in particular developed into a very sensitive and inventive letter carver, but now works primarily as a silversmith in Cornwall.

Michael Biggs (1928–93)

A contemporary and friend of John Skelton's was the stone carver Michael Biggs, who lived most of his life in Dublin. Although better known in Ireland as a liturgical artist and sculptor, Biggs managed to evolve a distinct identity of his own as a letter carver through his exploration of Irish vernacular forms that he adapted very successfully for carving in stone. There are many of his distinctive and deeply carved inscriptions to be seen in Dublin.

Will Carter (1912–2000)

Notable for his very distinguished printing and typography, Will Carter started letter carving at evening classes with David Kindersley in the late 1940s. He developed

very distinctive capital letters that he dubbed 'Carter's caps', which are bold versions of classical Roman letters with marked, strong serifs. Many examples of his letter carving can be seen in and around Cambridge where he worked throughout his career.

Michael Harvey (1921–)

Another letter carver with strong typographic connections is Michael Harvey. He originally started letter carving with Joseph Cribb at his Ditchling Common workshop in the early 1950s. He then went on to work in Dorset with Reynolds Stone – a well-known wood engraver and letter carver. In addition to his letter carving, graphics and type design, Harvey has made a notable contribution through his publications on lettering design and letter carving (see Bibliography).

Roman lettering from the Forum, Rome: similar letterforms to the Trajan inscription studied by Father E.M. Catich.

Father E.M. Catich (1906–1979)

Another American figure of particular note in the development of twentieth-century letter carving, and notably, of the classical Roman letter, is Father E.M. Catich. He became an expert on the Trajan inscription in Rome where he was studying for the priesthood at the Pontifical Gregorian University from 1935 to 39. He made extensive studies of the Trajan inscription, taking detailed rubbings and photographs. This formed the basis for a portfolio published in 1961 called 'Letters Redrawn from the Trajan Inscription in Rome', which contained, as well as reproductions of the rubbings he made, detailed outline drawings of letters traced directly from the rubbings. This accurate record of the actual letters in the inscription has provided an invaluable resource. Perhaps Catich is best known for his book The Origin of the Serif (see Bibliography), which contains his thesis that the Trajan Column letters had, prior to carving, first been brushed onto the marble using a chisel-edged brush. Using his remarkable skill with a brush, which he gained as a showcard writer working in Chicago in the 1920s, he was able to recreate the Trajan letters very accurately and this method is accepted by many as the way in which the Trajan Column letters were made.

Letter Carving in Continental Europe

A limited number of European individuals have made a marked impact in letter carving in the past few decades, notably in Germany, France and Belgium.

Sepp Jakob (1925–93)

Both a sculptor and letter carver, Sepp Jakob taught at the Meisterschule in Freiburg for many years, and the carving work of both himself, his son Wolfgang, and many of his students and contemporaries can be seen in and around the area. His sculptural approach to stone emphasized the use of bold, close textures of lettering, particularly raised letters – where the background stone has been removed – as well as incised forms. Jakob's

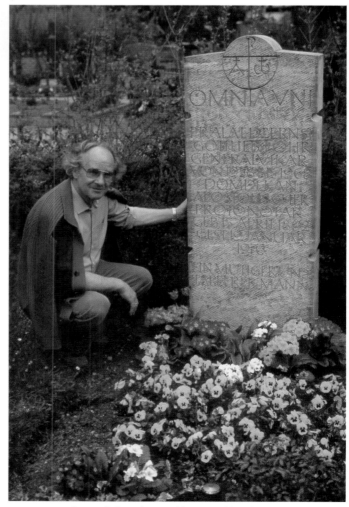

Sepp Jakob with one of his carved headstones.

Sepp Jakob, raised lettering.

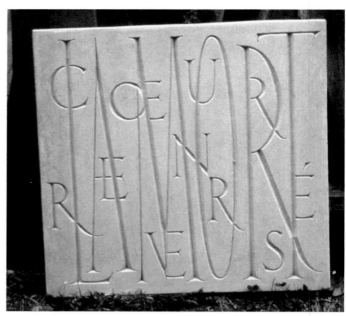

Jean-Claude Lamborot, 'La mort coeur renversé', V-incised French limestone. (Reproduced by kind permission of Mme Lamborot)

book *Schrift und Symbol* written with Donatus Leicher (see Bibliography) shows an array of the remarkable work being carried out at the time in Germany, and a radically different approach to letterform, design and particularly to the texturing of surfaces, to that happening in Britain.

Jean-Claude Lamborot (1921–2004)

In France, contemporary letter carving was supported by virtually a lone voice – that of Jean-Claude Lamborot. As the Belgian letter carver Kristoffel Boudens has remarked in a recent edition of Forum, the Letter Exchange magazine, Lamborot was

> …finding his own unique voice as a letter carver in a country where contemporary fine lettering in stone was non-existent.[16]

Whilst admiring classical Roman inscriptions, particularly those he had seen in the Gallo-Roman Museum in Lyons, much of his own work has a more robust and vernacular feel to it. He enjoyed juxtaposing letters, usually V-incised, in striking, inventive compositions often carved on pebbles. Lamborot was a considerable influence on Kristoffel Boudens, who, working in Bruges, is part of a well-known lettering family – his father Jef having been a very influential calligrapher in Belgium for

many decades. In the 1970s Kristoffel Boudens' brother Pieter was the first to establish a workshop specializing in fine contemporary letter carving. Pieter, uniquely, was able to work for spells with both Sepp Jakob and David Kindersley and was consequently able to draw from both these contrasting traditions.

Contemporary Letter Carving in Britain

The last few decades, and in particular the past fifteen years, have witnessed an increasing awareness of the craft of letter carving, with more and more people taking it up, both professionally and as a creative interest. The work of the pioneer letter carvers of the early twentieth-century revival initiated by Eric Gill, and the continued development of high-quality letter carving throughout the twentieth century, has maintained a profile for letter carving. The work of many of these craftsmen is shown throughout this book.

The publication of a number of books on the techniques of letter carving by David Kindersley and his wife Lida, Michael Harvey, and Richard Grasby, published during the 1980s, all helped to stimulate more interest in the craft (see Bibliography). Added to this, the impact of Jakob and Leicher's Schrift und Symbol was beginning to gather momentum in Britain, and this alerted British letter carvers to the potential for different design approaches. Both the

Cardozo Kindersley workshop and the Richard Kindersley studio have made a significant contribution, for several decades, in training numerous apprentices.

Additional to these factors came the formation, by Harriet Frazer in 1988, of Memorials by Artists (MBA) – an organization for encouraging high-quality memorial work by disseminating commissions amongst an increasing number of letter carvers – and this creation of work opportunities has further fuelled the growth of the craft. The related Memorial Arts Charity organises short letter carving courses and has funded several apprenticeships.

Additionally in 1988 a new lettering society, Letter Exchange, was formed. It organizes monthly lectures from practising lettering designers and lettering craftsmen. This forum for the interchange of ideas has also acted as a stimulus to the further development of letter carving.

A further impetus in creating and contribution to maintaining the steady flow of interest in letter carving has been West Dean College in Sussex, which since the 1970s has offered weekend and other short letter carving courses, in addition to many other arts and crafts.

The number of high-quality lettering exhibitions has also increased over the last decade, in particular through Letter Exchange, MBA, the Calligraphy and Lettering Arts Society, and the Society of Scribes and Illuminators. As a result of the combined influence of the above factors the current situation is one where there is a thriving network of letter carvers throughout Britain, producing a wide range of interesting and exciting work. Some have been working for decades, others have appeared more recently on the scene, and the craft is attracting new practitioners at an increasing rate. The work of many of this new wave of letter carvers is shown throughout this book.

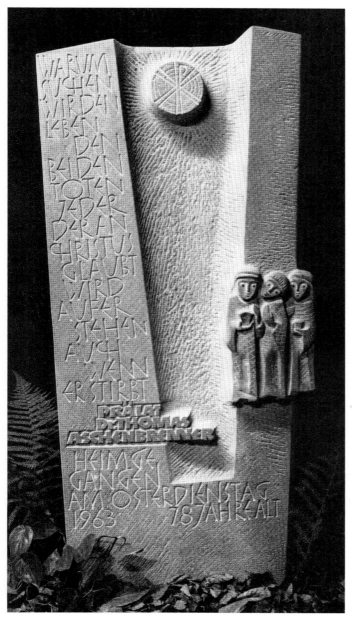

Sepp Jakob, red sandstone, caved in mid 1960s. 168 × 65 × 30cm.

Notes

1 Jones, D., 'Eric Gill: An Appreciation', in H. Grisewood (ed.) Epoch and Artist (Faber & Faber Ltd, 1973), p.300–301.
2 Gill, E., Autobiography (Jonathan Cape Ltd, 1940), p.119.
3 Ibid.
4 Gill, E., Art and a Changing Civilisation (John Lane the Bodley Head Ltd, 1934), p.138.
5 Gill, E., 'Art and Reality' in Anand, Mulk Raj, The Hindu View of Art, (George Allen & Unwin Ltd, 1933).
6 Gill, 1940, p.136
7 Shewring, Walter (ed), Letters of Eric Gill (Jonathan Cape, 1947), p.305.
8 Gill, E., An Essay on Typography (J.M. Dent & Sons, 1941), p.66.
9 Shaw, M., David Kindersley His Work and Workshop (Cardozo Kindersley Editions, 1989), p.6.
10 Beyer, R., 'Ralph Beyer', Letter Exchange (No 5, 1992)
11 Beyer, R., 'Dot the 'i': Twentieth century German Lettering', Letter Exchange (Spring 1991, p.52)
12 Beyer, R., 'Dot the 'i': Twentieth century German Lettering', Letter Exchange (Spring 1991, p.53)
13 Ralph Beyer, statement provided to the author for this book.
14 Richard Kindersley, statement provided to the author for this book.
15 Booklet published with the 2002 exhibition in Gloucester Cathedral: A Celebration of Forty Years of Bryant Fedden Workshops.
16 Boudens, K., 'Forum' newsletter, Letter Exchange (No 8, 2004, p.10).

2

Tools and Equipment

When you are starting out, letter carving does not require many tools or much equipment. The basic tools are the letter carving dummy and chisels.

The Letter Carving Dummy

The preferred tool for the artist letter carver in Britain is the rounded letter carving dummy or mallet. As David Kindersley said in his book Letters Slate Cut (see Bibliography) about the letter carver's dummy:

> Shoddy blows are more easily avoided on a round surface, and you will soon appreciate the direct drive that results from hitting correctly. (1981, p.28)

The dummy usually has an ash wood handle and the head is made of malleable iron. Dummies are available in weights from 1–2½lb (0.45–0.9kg). For a beginner, a 1lb (0.45kg) dummy is sufficient and is less tiring to use than a heavier one. A 1½lb (0.68kg) dummy is the more usual weight used by most experienced letter carvers, except when carving harder stones like granite, or very large letters, when a heavier weight is required. I find a 0.68kg (1½lb) dummy suitable for all my letter carving purposes, though letter carving hammers are also available for very hard stones and large-scale work if preferred. In the trade tempered steel hammers, which give a harder, sharper blow for cutting into hard materials like granite, are used more predominantly. However, the dummy is suitable for most of the work of artist-craftsmen letter carvers, who mainly use less hard materials such as sandstone, limestone and slate.

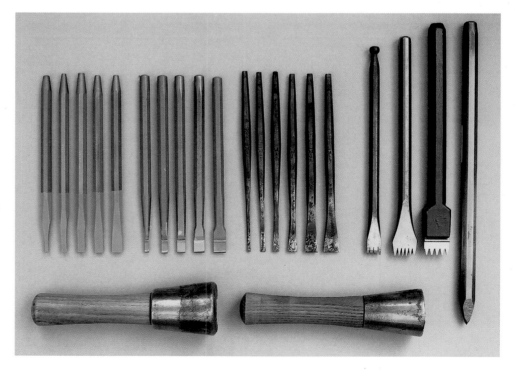

A range of letter carving tools. From left to right: group of five Al-Orr tungsten-carbide tipped letter carving chisels ranging from 3 to 10mm; group of five Europ/Univers tungsten-carbide tipped three-star letter carving chisels ranging from 4 to 12mm; group of six hand-forged steel letter carving chisels ranging from 3 to 16mm, made by Tim Morgan. Larger size chisels (2.5cm and larger) are available from these manufacturers but are not required for the novice letter carver. Near right: group of four stone carving tools, including three claw chisels and a point. Below: two letter carving dummies (1½lb and 1lb).

Working position using dummy and chisel, working on a rectangular easel.

Letter Carving Chisels

There are two basic types of letter carving chisel – steel or tungsten-carbide tipped – and they are usually hammer-headed. The great advantage of tungsten-tipped chisels over steel is that they retain a sharper cutting edge for longer. Tungsten-tipped chisels come in different grades of tungsten and it is important to specify when ordering whether they are for use on marble, stone and slate, or for use on granite. Tungsten-tipped chisels for use on marble are suitable for carving all kinds of slate and stone except granite. They are available in a range of sizes from 3mm (⅛in) to 2.5cm (1in) and beyond. To begin with, the more useful sizes are 3mm (⅛in), 5mm (³⁄₁₆in) and 6mm (¼in). Steel chisels are available in similar sizes and are more suitable for softer sandstone, limestone and Welsh slate, because the chisel tip is drawn out particularly finely. The chisels illustrated opposite are for use on stone and marble. If you need to work in granite, there are letter carving chisels available specifically for such harder materials.

In addition to letter carving chisels, other types of basic stone carving tools include claws and points. Widely used in sculpture and masonry for shaping stone, the letter carver may find them useful for giving texture when required to the surface of the stone.

Tungsten-tipped and steel letter carving chisels illustrated are amongst those most commonly used by letter carvers, but there are other makes available and it is really a matter of personal preference. When ordering chisels you will need to specify the following: whether they are tungsten-tipped, or steel; whether for use on stone, marble, or granite; the size of chisel tip; and whether it should be hammer or mallet-headed.

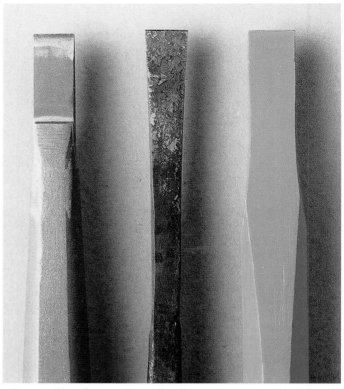

Close-up of chisel tips. Left to right: 1) Europ/Univers, 2) hand-forged, 3) Al-Orr.

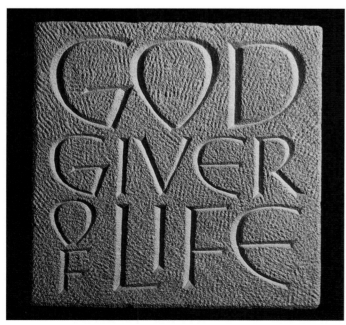

Tom Perkins, 'God giver of life', V-incised Bath limestone with claw-tooled surface, 30 × 30cm.

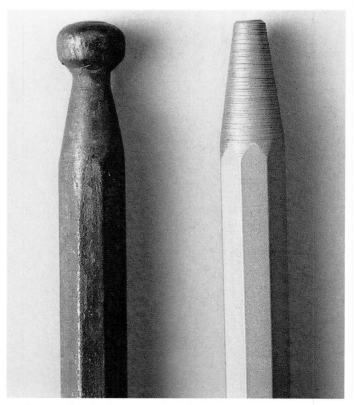

Close-up of mallet-headed chisel (left), and hammer-headed chisel.

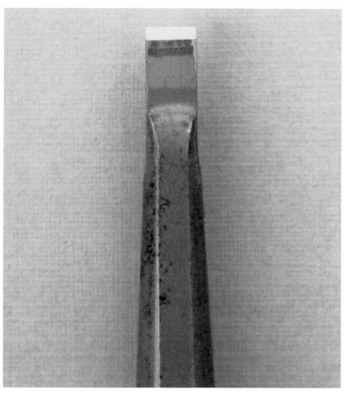

Close-up of chisel tip after sharpening, showing straightness and extent of bevel from chisel tip (approximately ¹⁄₁₆in).

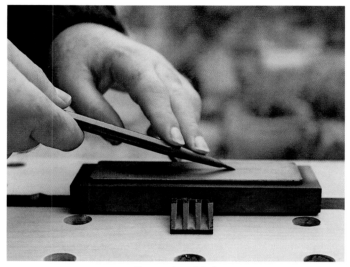

Sharpening chisel.

Sharpening Chisels

Both tungsten-tipped and steel chisels need to be sharpened before use. Very good results can be obtained using a diamond sharpening stone, which is a metal plate impregnated with diamond, available in fine, medium and coarse grades. These can be used dry or with a little water for lubrication. If water is used, ensure the plate is dried after use.

To sharpen, the chisel shank should be at an angle of approximately 20 degrees from the surface of the plate. Move the chisel backwards and forwards about half a dozen times to sharpen it on one side. Then the chisel needs to be turned over and the sharpening repeated on the other side, to create a bevel on both sides. The frequency of the sharpening process whilst carving depends on the hardness or abrasiveness of the stone or slate. It is important to check the chisel edge for sharpness several times during a day's letter carving; the harder the stone, the more frequently it should be checked.

When a chisel gets very worn down, nearing the end of the tungsten-tip, it becomes quite thick and it is simplest to replace it with a new chisel. However, if preferred, the steel shank of the chisel can be ground back on an electricity-powered wheel, and the chisel allowed to cool down naturally (not put in water). Care should be taken not to overheat the chisel end, as this can cause the tungsten and the steel to separate.

Close-up of chisel tip: side view showing sharp bevel on both sides of the chisel.

The Letter Carving Easel

In Britain, the most common way of supporting the stone or slate while letter carving is on a wooden easel, which is usually rested at a slight angle against a firm wall or designed to be free-standing on a wooden base.

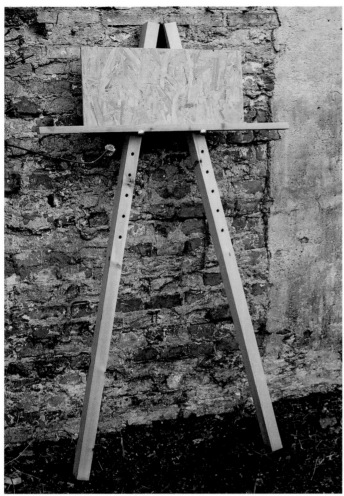

'A' frame easel, supported against a wall.

Close-up of hinge for the inside top of the 'A' frame easel.

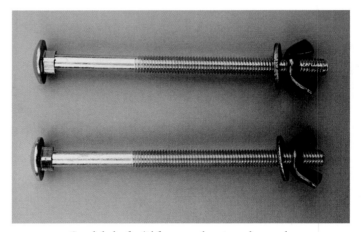

Coach bolts for 'A' frame and rectangular easels.

Working with the stone or slate in an upright position is not universal. In continental Europe and in the USA, letter carvers tend to work with the stone in a flat position.

The 'A' Frame Easel

This is the simplest form of letter carving easel to make and is adequate for small- to medium-size work. This easel consists of two lengths of 7.6 × 5cm (3 × 2in) wood, approximately 1.8m (6ft) long, standing upright and fixed with a sturdy hinge at the inside top. A number of holes, 11mm (⁷⁄₁₆in) in diameter, are drilled at roughly 7.5cm (3in) intervals down each post to accommodate the pair of 10mm (⅜in) steel coach bolts needed to hold the horizontal bar on which the stone rests in place. A 76cm (2ft 6in) length of wood is adequate for this bar. It is useful to have at least two or three such bars of different thicknesses, such as one of 2.5cm (1in) square, one of 5cm (2in)

square and one of 7.6 × 5cm (3 × 2in), to accommodate stone of different thicknesses.

The level at which the bar is placed depends on whether you intend to carve standing or sitting, which will be affected by the height of the stone and level of the inscription or part of the inscription being carved, as well as individual preference. It is advisable to set the bar at a height where the lettering is slightly below eye-level, to prevent your arms tiring during carving. With this easel, which is not designed for use with large, heavy stones, the bar can sit on the coach bolts, which can be secured at the back with wing nuts.

Before carving small pieces of stone, a 10mm (⅜in) plywood backing board, approximately 57 × 31.5cm (22 × 12in), should be placed upright at the back of the bar to prevent the stone from falling through the gap at the top of the 'A' frame. The stone should be clamped to the easel, with a small piece of card placed between the clamp and the stone to protect the surface of the stone. As a precautionary measure against the 'A' frame opening out too far, or unexpectedly, a length of small-link chain or nylon rope can be placed through the lowest

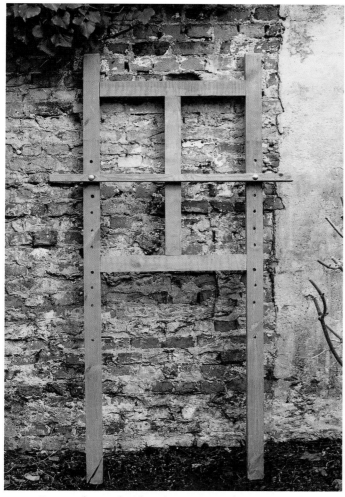

Rectangular easel without base, supported against a wall.

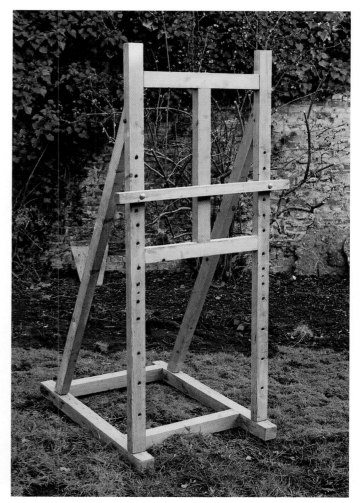

Rectangular easel with base.

holes on both posts and joined together, so that the chain or rope is slightly slack when the 'A' frame is open. The 'A' frame should lean firmly, at a slight angle, against a solid wall.

The Rectangular Easel

This is a more substantial easel, also relatively simple to make, which can support larger pieces of stone than the 'A' frame. The only form of wood needed to construct this easel is 7.6 × 5cm (3 × 2in) (except for the horizontal support bar, for which details are given after the main structure). For the main vertical supports two 1.8m (6ft) lengths are needed – these can be slightly longer if preferred. For the horizontal parts of the structure two 60cm (2ft) lengths are needed, and one 70cm (2ft 4in) length for the shorter vertical central support. As for the 'A' frame, it is useful to have two or three horizontal bars 91cm (3ft) long of different thicknesses – 2.5cm (1in) square, 5cm (2in) square, and 7.6 × 5cm (3 × 2in) – to support stone of different thicknesses.

The pieces of wood for the main structure are joined at six places with mortise and tenon joints, and glued with wood adhesive at these joints (which is optional but safer). Holes of 11mm (⁷⁄₁₆in) diameter are drilled as for the 'A' frame, at 7.5cm (3in) intervals down the two main vertical supports, to accommodate the 10mm (³⁄₈in) coach bolts used in conjunction with the horizontal bar that is used to support the stone. The bar for this easel, unlike the 'A' frame, has two 11mm (⁷⁄₁₆in) diameter holes drilled at a distance corresponding to the horizontal distance between each pair of holes on the main supports. Each bolt is placed through both the bar and an upright support, and as an extra precaution can be fixed with washers and wing nuts at the back of the easel. If the stone being used is narrower than the gap either side of the central strut, you will need to place a piece of 10mm (³⁄₈in) plywood, approximately 50 × 30cm (20 × 12in), on the back of the bar.

As for the 'A 'frame, the rectangular easel can be firmly leant at a slight angle against a solid wall. With both an 'A' frame and a rectangular easel consideration should be given to the stability aspect, especially if it is standing on a smooth

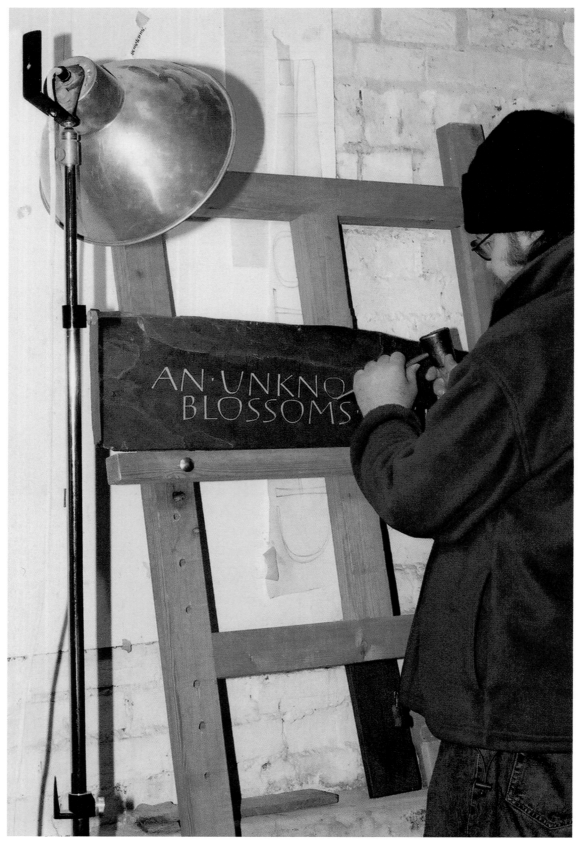

Lamp for use whilst carving.

or polished floor; you may wish to take extra measures to secure the easel from slipping forward. It is also possible to construct a free-standing rectangular easel, resting on a base frame. The heavier the timber used for these easels, the more stable they are. An easel with a base is particularly useful when demonstrating the craft in public where it may not be possible to lean an easel against a wall.

Lighting

Good overhead lighting is essential when letter carving, and this should be supplemented by one or two moveable lamps, giving a side light to enable the carver to see the light/shadow of the V-cut better. It may be helpful for the beginner to have a side light coming from both sides. Carving in natural light out of doors is very helpful, especially for the beginner – weather permitting!

Health and Safety

It is sensible for the letter carver to take precautions to protect their eyes from chips of stone and stone dust, and also to take measures to prevent inhalation of stone dust. If you already wear glasses, this should be adequate eye protection for most hand carving purposes, though protective spectacles can be worn over some glasses. Many types of protective spectacles are available, and it is advisable to buy them with side-guards for extra protection. If you are carving large-scale letters or using angle-grinders to shape stone, protective goggles are essential (as are ear defenders when using angle-grinders).

To prevent inhalation of stone dust various types of mask are available. The more heavy-duty respirator mask should be worn when much stone dust is being created. However, the disposable types of mask are suitable for most letter carving activities done by hand. Check with the supplier or manufacturer that the type of mask you are purchasing provides adequate protection for the type of activity in which you are involved. People who are allergic to stone dust or have respiratory problems should seek medical advice before using a respirator-type mask.

It is advisable to wear sturdy footwear when carving; ideally, steel toecap footwear is a sensible precaution. Such footwear is a prerequisite if you are working on or visiting a building site, where you will also have to wear a British Standards (BS) protective helmet.

To ensure stone is safely set on the easel, and to minimize the risk of stone falling from it, it is necessary to fix the stone firmly to the easel with a G-clamp and to take any necessary measures to ensure the easel is stable against the wall and not liable to slip.

There are certain situations where it is not advisable to put a very large, thick or bulky stone on an easel at all. In these instances it may be necessary to work the stone flat on sturdy trestles or to build up a low platform with breeze blocks against a firm wall and to stand the stone on this, with the stone inclined at an angle against the wall.

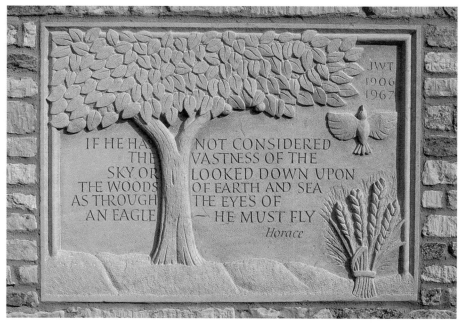

Alec Peever, relief carving, Ketton stone. Composed to incorporate symbols depicting the life of an aviator and farmer. Peterborough, 1985. 120 × 75cm.

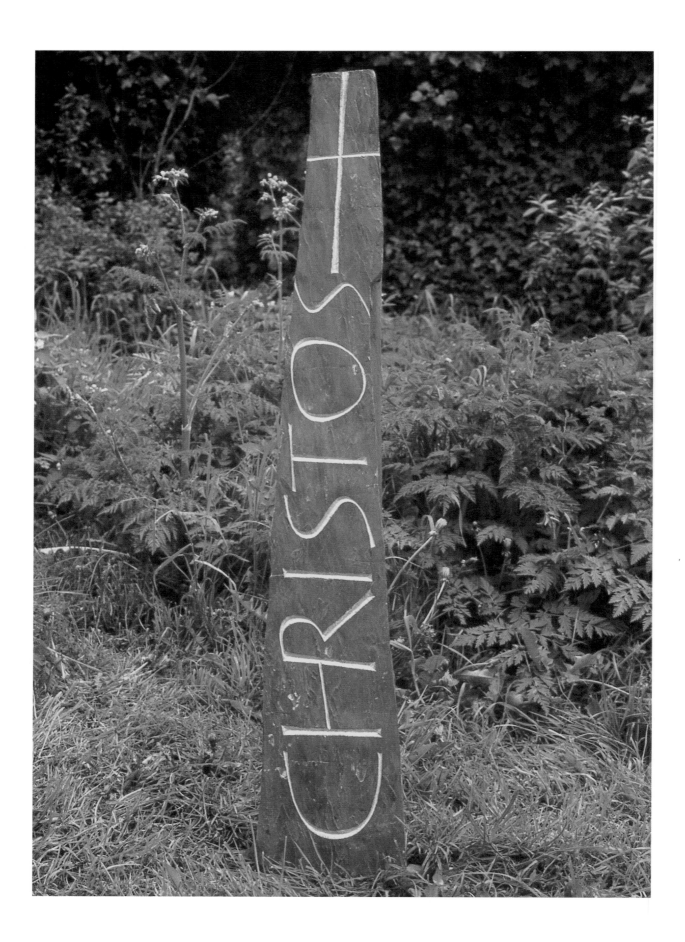

3

Stone

The British Isles are rich in suitable stone for letter carving, as described in Stone Building by Ashurst and Dimes (see Bibliography):

> Great Britain probably has a greater variety of rock in a smaller area than has any comparable part of the world. (1977, p.1)

For letter carving, the hardness of the rock is a prime consideration (the softer rocks being naturally easier and quicker to carve), together with an even and fine-grained consistency. Durability, in terms of how the stone reacts to different weather conditions, is another prime factor, especially for outdoor inscriptions. It is not my intention to go into the geology of rocks, but to suggest some stones and slates that are suitable for letter carving. The Natural Stone Directory (see Bibliography) gives full explanations of rock types from a geological perspective, as does Stone Building, previously mentioned.

Tom Perkins, V-incised memorial in blue Hornton stone, commissioned through Memorials by Artists, 1992. 92cm high.

Tom Perkins, V-incised alphabet in Portland limestone.

Opposite: *Tom Perkins, 'Christos', V-incised riven Welsh slate inscription, 2005. 92 × 17 × 3cm.*

Tom Perkins (assisted by Macolm Sier), V-incised and painted inscriptions in Ancaster limestone, 100cm high. Commissioned by The Boots Company plc through Art for Work Ltd, for the Millennium Sculpture Park, Beeston, Nottinghamshire. (Text by kind permission of John Fairfax, poet)

Sedimentary Rocks

Of the three categories of rocks, the sedimentary rocks offer many varieties for letter carving. Sedimentary rocks are formed from the accumulation of water-borne sediments and calcareous deposits on the sea bed. Varieties of limestone such as Portland, and limestone from the Hopton Wood area of Derbyshire, and blue Hornton from Oxfordshire, are all suitable. Types of sandstone such as York stone, and Scottish and Cumbrian red sandstone are also suitable. Other limestones and sandstones may also be recommended by individual quarries as suitable for letter carving but it is advisable to obtain a small sample to try carving before ordering unfamiliar stones, and to specify that it is required for letter carving, as the quality of sedimentary rocks can vary considerably.

Tom Perkins, 'Absurdum est…', V-incised York stone.

John Neilson, V-incised lettering and relief carving in St Bees sandstone, shown unfinished. Commissioned through Cumbria Public Art.

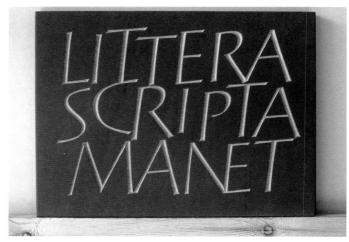

Tom Perkins, 'Littera scripta manet', V-incised fine-rubbed Welsh slate.

Tom Perkins, V-incised Cumbrian green slate inscription for Prior's Court School, Thatcham, Berkshire. Commissioned by Dame Stephanie Shirley.

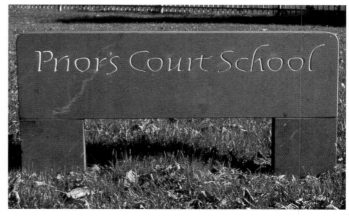

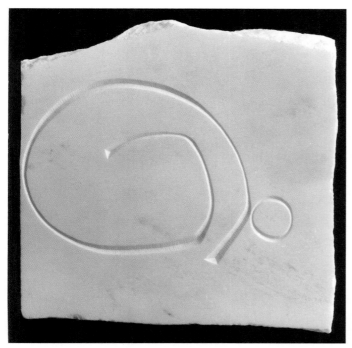

Kristoffel Boudens, 'Go', V-incised in white marble. The 'O' is taken from the first line and the 'G' from the second line of a larger composition, and re-made. 20 × 20 × 1.5cm.

Metamorphic Rocks

Of the metamorphic rocks, slate – not categorized as a stone – is particularly favoured by letter carvers. Metamorphic rocks are sedimentary rocks that have been subjected to heat or pressure under the earth's surface. The blue-black Welsh slate is relatively soft, very durable and takes a very finely-cut letter. The Cumbrian blue-black and attractive green slates, often with natural mottling, are also suitable for letter carving. Green slate is somewhat harder than Welsh blue-black and perhaps not so advisable in the first instance for the beginner. Delabole slate is available from Cornwall, especially in smaller sizes: check availability for larger-sized pieces of letter carving quality, apart from natural boulders. Imported slates are also available, although some of these can bleach out to a light grey colour in an outside situation so it is as well to be aware of this.

Other metamorphic rocks suitable for letter carving are imported marbles, especially from Italy – these are available from most local monumental masons. White marble, or coloured marbles with fairly even surface markings, are easier to carve than the speckled ones, which tend to have a more variable consistency. With any unusual imported stones it is advisable to obtain a small sample or offcut and carve a letter in it before ordering. Be aware that stones having very attractive surface markings may prove to be technically challenging to work.

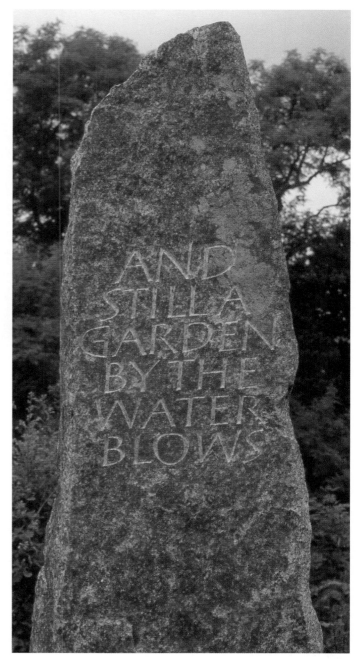

Tom Perkins, V-incised granite menhir, located in the grounds of Antony House, Torpoint, Cornwall, 2001. Commissioned by Richard Carew Pole.

Igneous Rocks

Igneous rocks are formed of molten material that has solidified under or on the earth's surface. Of these, granite is the main one used for letter carving, and is mainly sourced from places such as Cornwall, Wales and Scotland, but many types of granite are imported. Granite is a very hard and durable rock. It requires chisels specifically for very hard rocks, and is not recommended for beginners.

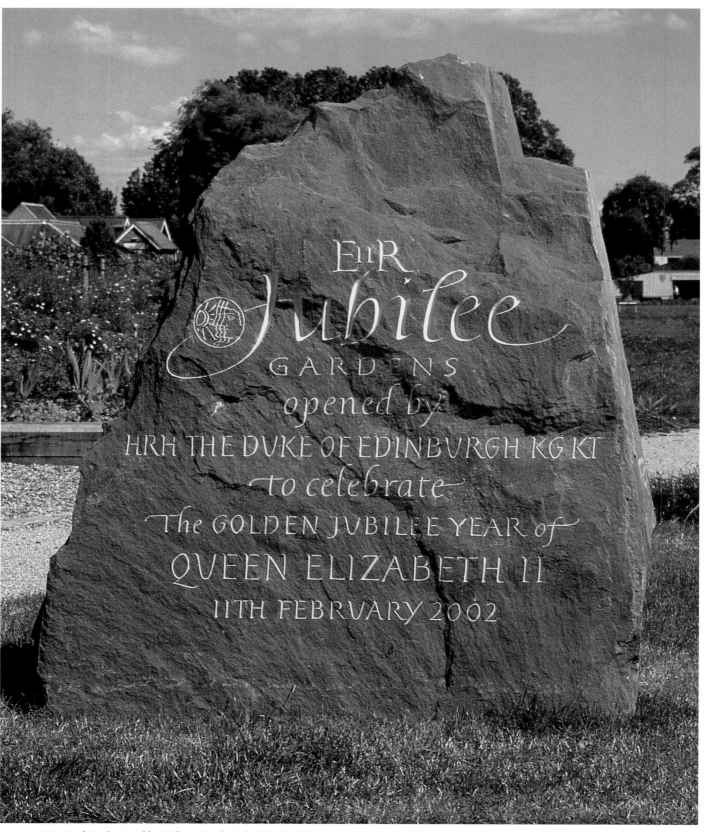

Tom Perkins (assisted by Helmut Hochrien), V-incised riven Cumbrian green slate boulder. Commissioned by East Cambridgeshire District Council for the Jubilee Gardens, Ely.

Ordering Stone

Most stone or slate is obtained either directly from a quarry, stone supplier or a local monumental mason, which you can find listed in your local Yellow Pages. The Natural Stone Directory, which is regularly updated, also lists every working quarry in Britain and Ireland, and gives coloured pictures of many of the available stones along with information about recommended uses for the material.

It is best to seek advice from the quarry or monumental mason to ascertain the suitability of the stone or slate, as it will not all be suitable for letter carving. If you are ordering a large piece, which can cost several hundred pounds, it is useful (if you are not accustomed to carving this particular type of stone) to obtain and try carving a sample piece before making a final decision. It is also important to be aware that when ordering from a quarry it can take one to two months, sometimes longer, to get a piece of suitable quality, particularly if it is a large piece – 'large' being over 1.5m (5ft).

When ordering, check if the quarry will deliver and if it is a particularly large, heavy piece, consider how the stone will be unloaded on arrival. Some quarries, if they do not deliver themselves, will arrange delivery by a national carrier, and large stones usually arrive on a wooden pallet. Check whether or not the carrier will have a tailgate that lowers automatically; the stone can then be moved by two or more people onto a flat-bed trolley. Exceptionally heavy pieces delivered on a pallet may require use of a forklift truck. In such instances, contact with local farmers or builders has proved useful in my own experience.

When ordering a piece of stone or slate, as well as specifying that it should be of suitable quality for letter carving and giving dimensions – height, width and thickness – you will also need to specify the finish required. The surface of the stone or slate can be left as sawn, or can be fine-rubbed to give a smooth finish. Slate is normally ordered with a fine-rub to the face and all four edges for plaques, and with a fine-rub to all visible surfaces for a memorial. With slate, if a natural-looking, riven surface is required, this should be stated when ordering. Certain other stones can be split successfully and obtained with a riven surface. When considering natural boulders, consultation with the supplier as to their suitability for letter carving can be helpful in finding a sound piece. It might be worth considering having your own supply of natural boulders, and obtaining a load from a quarry. Some quarries have these available at very reasonable prices.

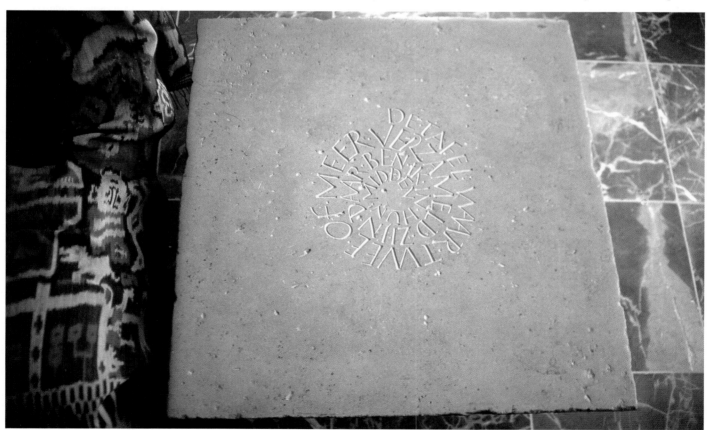

Kristoffel Boudens, 'Where two or more are gathered together, I am among them', spiral shaped text on table top.
Old Burgundy limestone floor tile. 65 × 65 × 7cm.

The piety of every man and every woman's whispered prayer clasped in the grain of wood and stone & in the grace of ancient air

Tom Perkins (assisted by Malcolm Sier), V-incised menhir, Cumbrian greenslate and St Bees Cumbrian red sandstone. 2m high. One of five stones, an EU-funded commission for the Peddars Way National Trail, Norfolk. Text by Hugh Lupton. The texts on these stones are quotes from a cycle of stories and songs that were commissioned to celebrate the Peddars Way. They were written by storyteller and poet Hugh Lupton and set to music by Helen Chadwick in a project called 'A Norfolk Songline'. The Peddars Way is a Roman road that crosses Norfolk from south to north (from Knettishall Heath to Holme). The Romans built it over the northernmost section of the ancient trackway that has come to be called the Icknield Way. It has probably been, in places, in constant use as a thoroughfare for ten thousand years. The stories and songs were written as an evocation and invocation of the memories that are held by the road and the landscape that surrounds it. The book 'A Norfolk Songline' is available from Hugh Lupton (hughlupton@aol.com).

4

Letter Carving Techniques

The basic technique of V-incising letters in stone can be readily acquired with regular practice, whereas the successful design of letterforms and an understanding of their design applications benefit from sustained study and development. Before the techniques of letter carving are described, it is necessary to indicate the method of holding the dummy and chisel.

How to Hold the Dummy and Chisel

For right-handed people the dummy is held firmly, but not too tightly, in the right hand and used to tap the end of the chisel, which is held in the left hand as shown. This is reversed for left-handed people. Most of the tapping action is from the wrist, with some movement of the arm.

Working Position

Inscriptions can be carved with the stone either in an upright position, usually on a letter carving easel, or leaning against a wall – depending on the size and shape of the stone. You can carve standing or sitting. Standing affords more freedom of movement but with large, heavy pieces of stone, where you want to avoid moving the stone once it is positioned for carving, it is usually necessary to carve the upper parts of the inscription standing and the lower parts while sitting.

On the Continent and in the USA, letter carving is mainly carried out with the stone in a horizontal position. My preference is to carve with the stone upright or nearly upright for the following reasons. First, one sees the inscription

Working position for carving with chisel and dummy.

square-on, which in many cases is how it will be seen when in situ. Second, the dust clears away naturally, due to gravity, as carving proceeds, and third, an upright stance is much easier on the back and neck.

Carving Techniques for V-Incised Letters

In order to carve a V-cut letter, there are three possible techniques: chasing, chopping and stabbing. Different letter carvers will blend these techniques in a variety of ways; most experienced letter carvers use a mixture of chasing and chopping techniques to incise a letter. However, when starting letter carving the best method to use at first is chasing alone. There are no rules as to how these techniques are combined.

For all V-incising techniques, the V-section is kept at a constant angle – 90 degrees is suggested to begin with. There is no ideal depth of V-section, the depth of carving depends on the particular material, the scale of lettering, the lighting conditions where the inscription will be located, and whether the inscription will be painted or gilded, in which case it need not be cut as deeply as when it is to be left just carved.

In general terms, letters carved into a relatively soft stone and left unpainted, to be situated out of doors (such as on a headstone) will need to be carved more deeply. This will result in a steeper angle of V-section, around 60 degrees, whereas carved and painted letters on a slate inscription to be situated indoors will not need to be carved so deeply.

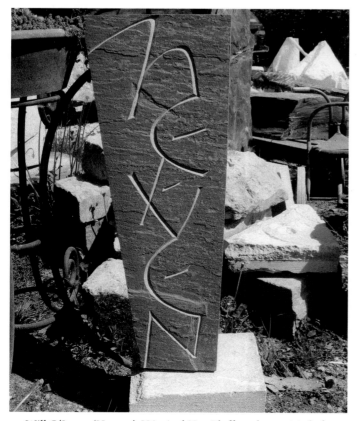

Will O'Leary, 'Heaven', V-incised Hay Bluff sandstone. Made for exhibition at Mill Dene garden, 2004. 27.5 × 69 × 3cm.

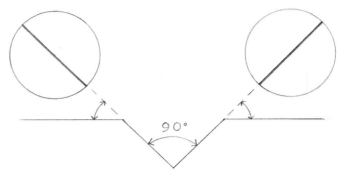

Diagram to show the angle of the V-cut, and circled, the chisel edge, which needs to be angled to match the side of the V-cut.

Showing that the sides of the V-cut stay at the same angle, whatever the depth of the V-cut.

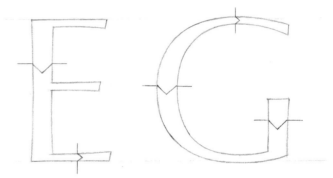

Showing wide parts of letters having a wider and deeper V-cut than narrow parts of letters.

Chasing

This is a carving technique in which the chisel moves comfortably forward through the stone by the rhythmic tapping of the chisel head with the dummy, without getting stuck. This unimpeded movement is achieved by finding the correct angle; first, of the whole length of the chisel shank to the surface of the stone; and second, the angle of the cutting edge of the chisel to the surface of the stone.

The chisel shank should be held at a shallow angle to the surface of the stone. If the angle is too steep, the chisel edge may get stuck in the stone, and if the angle is too shallow, the chisel may skid over the stone. The angle of the chisel edge to the surface of the stone should be approximately 45 degrees, which matches the angle required to make a V-cut with a 90-degree section.

The carving from one end of a stroke to the other is termed a 'pass', and to carve a completed V-section a number of passes up alternate sides of the stroke are necessary. The regular movement of lightly tapping the chisel head with the dummy leaves behind a track of small steps of stone, the regularity of which will reflect

the regularity of the tapping. Maximum control of the chisel is achieved through small, regular bursts of tapping, advancing at a distance of roughly 10mm (⅜in) for each burst of tapping.

Chopping

Once you can incise a form fairly successfully through chasing, the chopping technique can be attempted. This enables you to remove larger amounts of stone from the V-cut more quickly and efficiently. The whole length of the chisel shank is at a steeper angle to the surface of the stone than with chasing. The angle of the chisel edge to the surface of the stone is still approximately 45 degrees in order to produce a V-section of 90 degrees, and it travels diagonally down into the bottom of the V-cut. This movement is then repeated for the length of the stroke being carved, alternating up the sides of the V-cut, as with chasing.

When the full stroke width of the letter and required depth of V-cut are achieved, the row of triangular teeth left in the bottom of the V-cut are removed by holding the chisel shank and edge vertically and lightly tapping. This has the added advantage of straightening out any wobbles in the bottom of the V-cut.

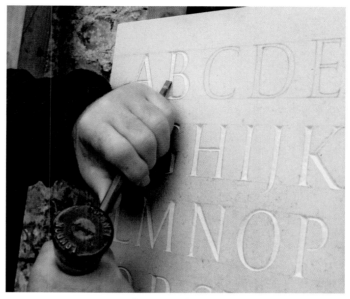

Chasing up the stem.

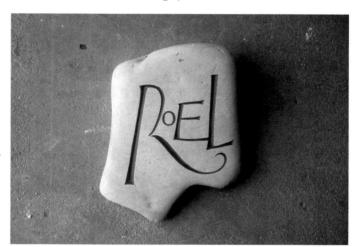

Kristoffel Boudens, 'Roel', V-incised French limestone pebble, 25cm wide.

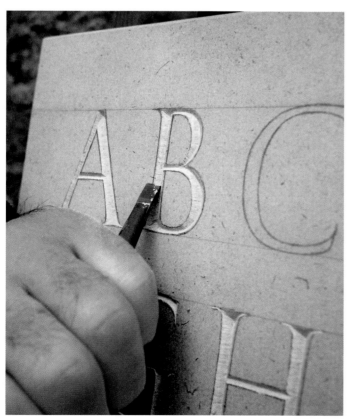

Close-up of chasing up the stem.

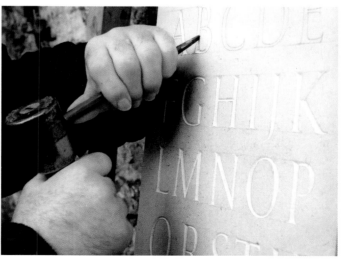

Chopping technique.

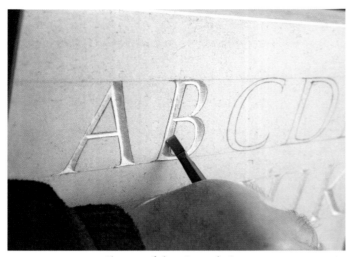

Close-up of chopping technique.

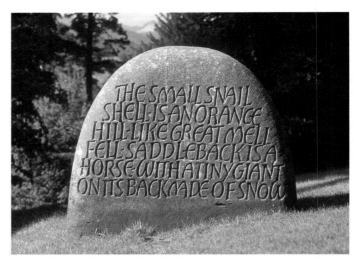

John Neilson, 'Snail'. V-incised St Bees sandstone. Text by pupils of Stainton Primary School, Cumbria; one of seven pieces as part of the 'Skylines' project initiated and managed by Cumbria Public Art. Commissioned by Cumbria Arts in Education.

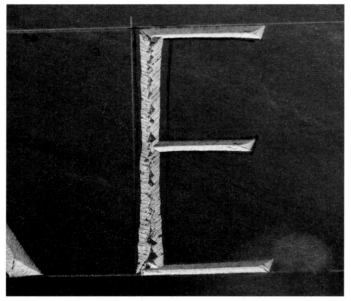

'E', partially carved, showing 'teeth' remaining in the bottom of the V-cut after use of the chopping technique.

Stabbing

For carving letters up to approximately 5cm (2in) high this technique is not necessary, as it is not a very refined technique and it is not possible to carve smooth curves in this way. It has more use for the initial stages of the carving of large-scale letters, to remove greater amounts of stone.

The stabbing technique involves holding the shank of the chisel at an angle of about 45 degrees to the surface of the stone, and the edge of the chisel parallel to the surface of the stone. The chisel is driven into the stone with the dummy, then moved along the stroke a little, and the movement is repeated, moving up the stroke for one pass. The technique is carried out alternately on each side of the stroke for several passes until the required stroke

width and depth of V-section are reached. You can complete a stroke with stabbing, but a more refined stroke would be achieved by finishing off with chasing or chopping (and these would especially be needed at some stage for curved strokes).

Carving Roman Capitals

Roman capitals are the root forms of our Western alphabet and are superbly adapted for working in stone. The fact that the letters are upright and the curves follow a circular pattern give clear criteria for achieving good letterforms. Learning to carve the component strokes of Roman capitals, in the context of selected letters, provides a good basis from which to carve other letterforms. The Roman capitals diagram with numbered arrows shows the suggested stroke order for carving for right-handers. Most carving directions are the same for left-handers apart from horizontals, where the direction is reversed. It can be confusing for beginners to find letter carvers suggesting a different order of carving strokes, and to some extent it is a matter of what you are used to. Stroke order need not be taken too literally; it is just a suggested cutting sequence for those who are starting, though such things as change of direction on curves will need to be considered.

Begin by placing a piece of slate or stone with a smooth, rubbed surface on the easel, making sure it is secured with a G-clamp. Note that the chisel corner is placed slightly inside the corners of the strokes to avoid carving outside of the drawn outline by mistake.

Carving Stems

It is easier to carve letters approximately 5cm (2in) or larger to start with, as carving small letters requires more skill and refinement of technique. Either draw or trace a stem in pencil onto the stone (use a white crayon on slate or dark-coloured stone) or transfer it to the stone or slate using handwriting carbon paper (as described in the section (see Chapter 10). Note that the stem width should be approximately one-eighth of the letter height and the stem should be slightly concave, which makes it thinner in the middle: this produces a more subtle shape than if the sides are parallel.

Select a chisel with an edge the same width or a little larger than the letter stem width. Hold the dummy and chisel as shown. To start, place the right corner of the chisel at the bottom-left point of the stem. Lightly tap the chisel with the dummy, chasing in a slight curve from A to B. To begin carv-

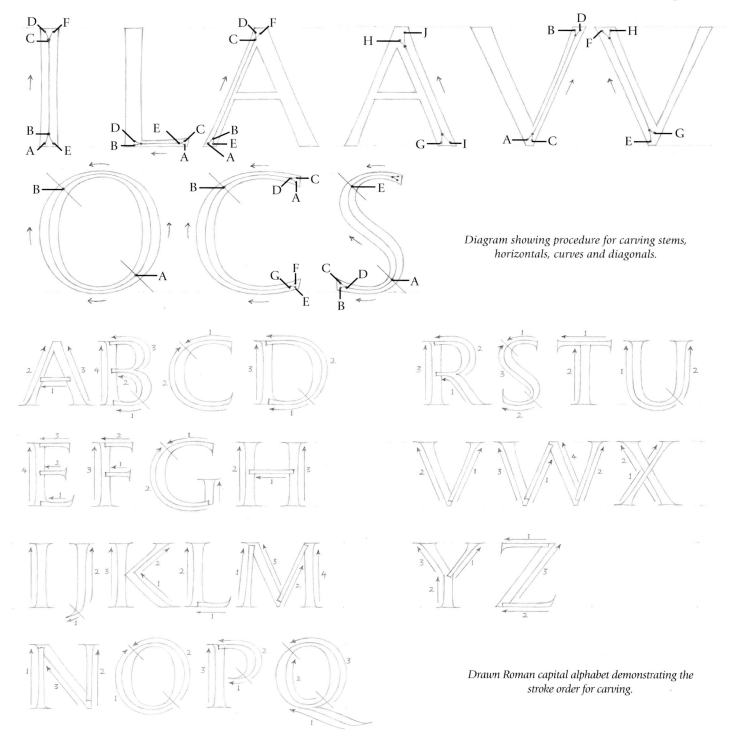

Diagram showing procedure for carving stems, horizontals, curves and diagonals.

Drawn Roman capital alphabet demonstrating the stroke order for carving.

Stages in carving stems.

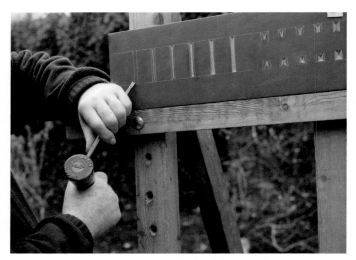

Beginning carving on the left side of the V-cut for a stem.

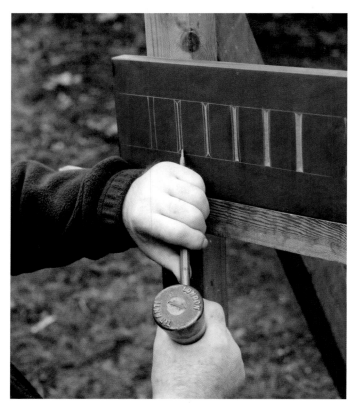

Beginning carving on the right side of the V-cut for a stem.

ing the left side of the V-cut stem, it may be helpful for beginners to score a straight line with a ruler and, using the corner of the chisel, up the middle of the stem, to give the chisel some grip on the stone or slate when starting to carve the stem. With the right corner of the chisel on the centre of the stem at B, chase up the middle in short, 1cm (⅜in) bursts until you get to C, thereby beginning the left side of the V-cut, then aim out towards the top left D in a slight curve, gradu-

ally lightening the touch to decrease the depth, swivelling the chisel edge gradually to finish with the right corner of the chisel at D. This initial cut up the left side of the stem will only be to a depth of approximately 2mm (¹⁄₁₆in).

Repeat this sequence, this time with the left corner of the chisel at the bottom-right of the stem E. Begin carving the right side of the V-cut stem, finishing with the left corner of the chisel at F. Keep alternating these sequences of carving from A to D and from E to F until the V-cut is about half the width of the stem. Next, it is advisable to start making the triangular stop cuts at each end of the stem.

Carving Stop Cuts

Carve the stop cut at the bottom of the stem first by starting at E, and carving up towards B until the right corner of the chisel reaches B. Relocate the chisel at E and carve upwards again, at the same time slightly swivelling the chisel so the left corner moves towards A. Repeat the sequence until all the surplus stone is cut away.

Note that from the base to the point of the stop cut is an inclined plane. For the stop cut at the top of the stem it is a similar procedure, but with the chisel approaching a downwards direction. Start with the right corner of the chisel at F and carve down until the right corner reaches C. Next, place the chisel slightly to the left of F and carve down again, at the same time slightly swivelling the chisel edge so the left corner moves towards D. Return to the top of the triangle and repeat the sequence until the surplus stone is cut away. Left-handers will cut bottom and top stop cuts from the opposite corners.

After completing the bottom and top stop cuts, return to A and complete the carving of the main stem, cutting each side of the stem alternately, thereby deepening the V-cut

Stages of carving stop cuts.

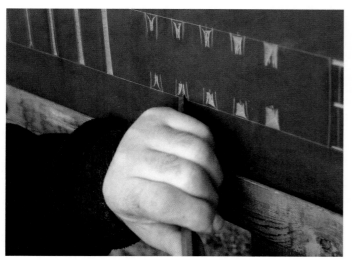

Carving a stop cut at the bottom of a stem.

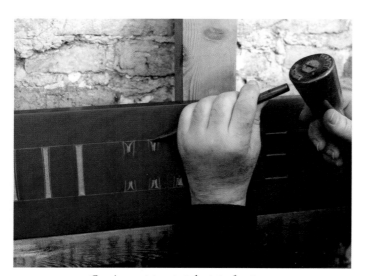

Carving a stop cut at the top of a stem.

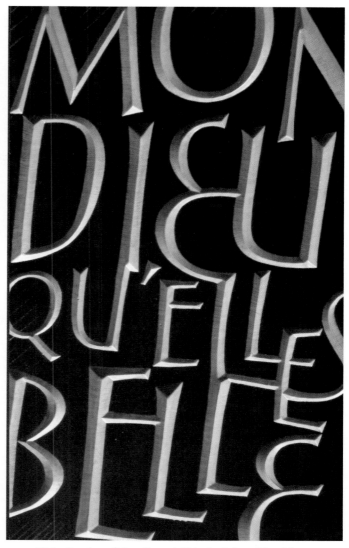

Pieter Boudens, 'Mon dieu…', V-incised slate. 20 × 18cm.

until the two sides form a right angle. As you widen and deepen the stem you will need to deepen the stop cuts at the top and bottom of it from time to time.

Carving Straight Horizontals

As straight horizontals in capital letterforms will join on to a stem, it is suggested that an 'L' or 'E' is carved to practise both a horizontal stroke and the junction with the stem. Draw an accurate 'L' or 'E' onto the stone or slate, or trace an enlarged letter from the diagram and transfer it to the stone. The letter should be 5cm (2in) or larger.

It is preferable to carve horizontals before stems, as advocated by David Kindersley in his book Letters Slate Cut (see Bibliography): 'corners are much more easily broken when

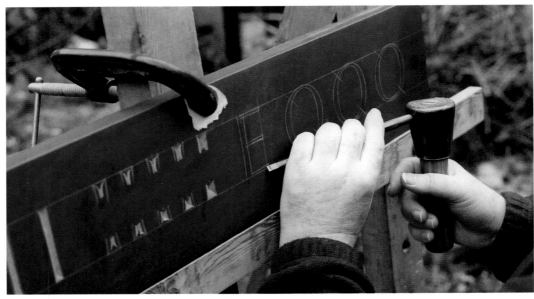

Beginning to carve the lower side
of the bottom horizontal of 'E'.

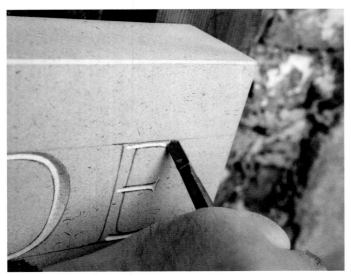

Carving a stop cut on the horizontal stroke of 'E'.

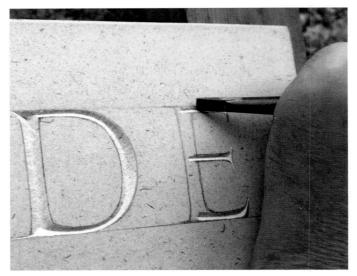

Carving the upper side of the top horizontal of 'E'.

the chisel is entering an already deeply cut V-section' (1981, p.30). Horizontals, in a classical Roman letter, being narrow relative to stems – about half the width – are therefore carved to a shallower depth but still with the same 90-degree V-section as a thick stem.

To carve the lower side of the V-section place the right corner of the chisel at A, and chase up the middle of the horizontal stroke towards B, which is approximately halfway across the main stem. Next, to carve the upper side of the V-section, place the left corner of the chisel at C and chase towards D. Return alternately to A and C, chasing up first one side and then the other side of the horizontal stroke for several passes.

Carve the triangular stop cut at A, C and E. To do this, position the chisel with the left corner at A and carve up until the left corner of the chisel reaches E. Next, place the left corner of the chisel slightly up from A and repeat the sequence, slightly swivelling the chisel so the right side moves towards C. Repeat this sequence until the surplus stone is cut away.

Resume carving the horizontal stroke, chasing alternately from A to B and from C to D until the sides of the V-section form a right angle. Deepen the triangular stop cut as necessary. Carve the middle and upper horizontals of 'E' in a similar way to the base horizontal. To carve the main stem, repeat the procedure for carving a stem discussed previously. The bottom of the V-cut of the horizontal merges into the triangular stop cut at the base of the main stem. Left-handers will find it easier to carve horizontals from left to right.

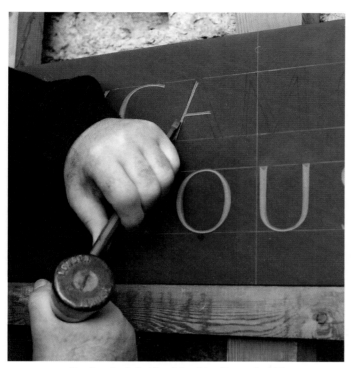

Carving the left side of the thin diagonal of 'A'.

Carving Thick and Thin Diagonals

On capital letters, thick diagonals should be the same width as upright stems, and thin diagonals the same width as straight horizontals. To carve an 'A' carefully, draw it 5cm (2in) or larger onto the stone or slate, or enlarge and trace the 'A', transferring it to the stone or slate.

First, carve the horizontal of the 'A' (see method under 'Carving Straight Horizontals', left). Next, carve the thin diagonal. Start the left side of the V-cut by placing the right corner of the chisel at A, and chasing past B and C to D. After this, to start the right side of the V-cut, place the left corner of the chisel at E and chase past B and C to F. Continue carving alternate sides in this way for a few passes.

The triangular stop cut ABE at the base of the thin diagonal stroke should be carved next, using the same sequence as for stop cuts at the base of thick stems. There is no stop cut at the top end of the thin diagonal, as this stroke feeds into the main thick diagonal. Continue carving alternate sides of the thin diagonal until a right-angled V- section is achieved.

Next, carve the thick diagonal by placing the right corner of the chisel at G and chase to H in a similar way as carving an upright stem, then place the left corner of the chisel at I and chase to J. Continue carving alternate sides in this way for a few passes, then carve the stop cuts at the base and top of the thick diagonal in the same way as for carving them on an upright stem. Continue carving alternate sides of the thick diagonal until a right-angled V-section results, deepening the base and top stop cuts as necessary.

It is worth also carving a 'V', as the bottom junction will be a good guide for tackling similar junctions on 'M', 'N' and 'W'. Draw or trace a 'V' from the diagram, enlarged as necessary, to the same letter height as the 'A', onto the slate or stone.

First, begin to carve the left side of the thin diagonal, starting with the right corner of the chisel at A and chasing up the centre of the thin diagonal to B. Then, to begin carving the right side, place the left corner of the chisel at C and chase up the centre of the thin diagonal to D. Repeat, chasing up alternate sides for a few passes. Then cut the triangular stop cut at the top, in a similar way to carving the stop cut at the top of an 'I'. Continue carving up alternate sides of the thin diagonal until a right-angled V-section is achieved. Note that a thin stroke needs to be much shallower than a thick stroke, and therefore this thin diagonal will not need many passes to obtain the required depth. If you are carving a 'V' with a sheared point at the base, then you need to carve a small triangular stop cut before starting to carve the thick diagonal. This base junction, to begin with, requires careful thought and observation of the carved 'V' shown in the letter group images.

For the left side of the thick diagonal, place the right corner of the chisel at E and chase to F, then for the right side of the thick diagonal, place the left corner of the chisel at G and chase to H. Carve up alternate sides, as for a thick stem, for a few passes. Next, cut the stop cut at the top in a similar way as for a thick stem – for example, an 'I'. Continue chasing up alternate sides of the thick diagonal until a 90-degree V-section is achieved.

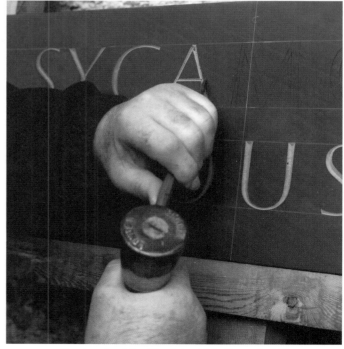

Carving the right side of the thick diagonal of 'A'.

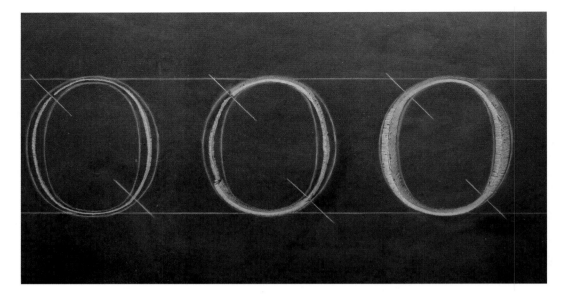

Three preliminary stages of carving 'O'.

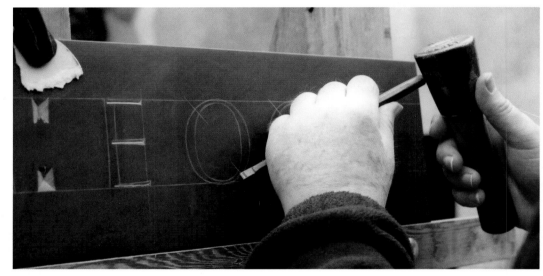

The starting position for carving 'O'.

Carving Curves

When carving curves, note that the direction of carving changes depending on whether you are working on the left-hand curve such as with a 'C', where it is clockwise, or right-hand curve such as with a 'D', where it is anti-clockwise. Additionally, there are subtle changes in the direction of the chisel edge itself as you follow the curves.

An 'O 'demonstrates all the necessary manoeuvres for carving curves, and other curved parts of letters follow this pattern. When making the letter 5cm (2in) or larger, draw an 'O' onto the stone or slate, or trace and transfer the 'O' illustrated, enlarging as necessary, onto the stone or slate.

For the left side of the 'O', place the right corner of the chisel at A and chase in a clockwise direction along the middle of the stroke to B – this begins the left side of the V-section. Then place the left corner of the chisel at A

and chase, clockwise, along the middle of the stroke to B, thereby beginning to carve the right side of the V-section. Chase alternately up the left and right sides of the stroke in this way, deepening the V-section until you reach the edges of the letter and a right-angled V-section is produced. Obviously, the depth of the cut will vary with the thickness of the curved stroke, being deepest where the curved stroke is widest, and only a depth of a few millimetres (on a letter of this scale) where the stroke is most thin.

For the right side of the 'O', place the right corner of the chisel at A and chase in an anti-clockwise direction along the middle of the stroke to B. This begins the left side of the V-section. Then place the left corner of the chisel at A and chase, anti-clockwise, towards B, beginning to carve the right side of the V-section. Continue carving alternate sides until the stroke is the required width and depth, as for the left side of the 'O'.

OPEN-ENDED CURVED STROKES

Open-ended curved strokes, such as the tops of 'C', 'G' or 'S' and the base of a 'C', are carved in a similar way to straight horizontals; that is, carving from the open end towards the body of the letter (with the exception of the 'S' base, which is carved towards the open end). Left-handers will find it easier to carve towards the open ends, except for the 'S' base.

Draw a 'C' 5cm (2in) high or larger onto the stone or slate, or enlarge as necessary and trace one from the diagram and transfer it to the stone or slate. To start, carve the lower side of the top curve with the right corner of the chisel at A and chasing towards B. To start the upper side of the V-section, place the left corner of the chisel at C and chase towards B. Continue in this way, carving alternate sides of the stroke until the full stroke width is carved, and carve the stop cut ACD, with the left point of the chisel at A, cutting in an upwards direction towards D.

Next carve the main curve of the letter, as for 'O', starting by carving the left side of the V-section, with the right point of the chisel at E and carving to B. For the right side of the V-section, place the left point of the chisel at F and carve to B, continuing to carve up alternate sides in this way until the V-section is deepened sufficiently and forms a right angle. Finally, carve the stop cut EFG, as for the top stop cut and in the same way as for straight horizontals.

It is useful to practise carving an 'S', because, as mentioned previously, unlike other open-ended curved strokes the bottom curve is carved towards the stroke end rather than away from it. Draw an 'S' 5cm (2in) or larger onto the stone or slate, or enlarge as necessary and trace from the diagram and transfer it to the stone or slate.

Carve the top first, as for a 'C'. Next, carve the base. To do this, place the right corner of the chisel at A and chase towards B, thereby starting the lower side of the V-cut. Then place the left corner of the chisel at A and chase towards C, thereby starting the upper side of the V-cut. Continue carving alternate sides in this way for a few passes until the full stroke width is achieved and the sides of the V-section form a right angle.

Next, carve the stop cut BCD by placing the right corner of the chisel at B and cutting upwards and inwards from B to D, turning the shaft of the chisel in a more vertical direction as the left point of the chisel nears C. Repeat until the surplus stone has been removed.

Finally, carve the diagonal by placing the right corner of the chisel at A and carving towards E, starting the left side of the V-section. To start the right side of the V-section, place the left corner of the chisel at A and carve to E. Continue carving alternate sides in this way until the required depth has been achieved, the same as for a thick stem.

Carving bottom of 'C'.

Partially carved main curve of 'C'.

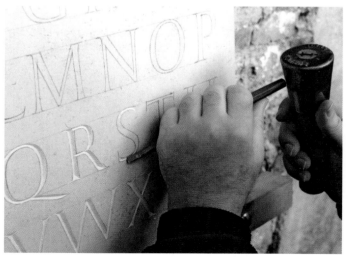

Carving the lower side of the 'S' base.

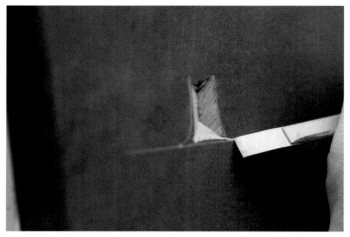

Carving a right-hand serif on a stem base.

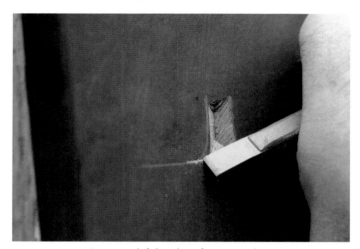

Carving a left-hand serif on a stem base.

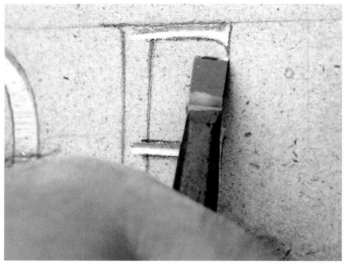

Carving the top serif on Roman capital 'E'.

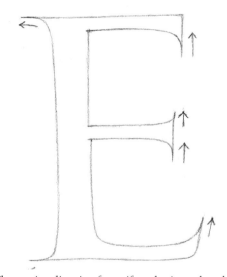

The carving direction for serifs on horizontal strokes.

Carving Serifs

The Roman capital letters illustrating the carving of component strokes are sans serif and these are recommended to start with because serifs require a delicate touch and skill, as only the corner of the chisel is in contact with the slate or stone and it is very easy to make a slip. When serifs are required, for those at the base or top of stems, carve from the end of the serif in towards the stem for the right-hand serif, and carve outwards away from the stem for the left-hand serif – in both cases using the right corner of the chisel with a very light touch (reverse direction for left-handers).

The length of serifs is approximately a stem width each side. For serifs on thin stems, as for example the Roman capital 'N' and on thin diagonals such as with 'A' and V', the serifs are proportionately narrower. For serifs on horizontal straight and curved strokes, the carving direction depends on which horizontal serifs are being carved – see the diagram of 'E'. The serif on the base arm of 'E' can be carved upwards or downwards.

Kristoffel Boudens, 'L'amour sans merci…', V-incised limestone.

Carved Roman Capitals in Portland Stone

The images of the alphabet carved in Portland stone shown here by way of example are grouped in a similar way as for the drawn Roman capitals shown in Chapter 5, since common letterform features require similar carving treatment.

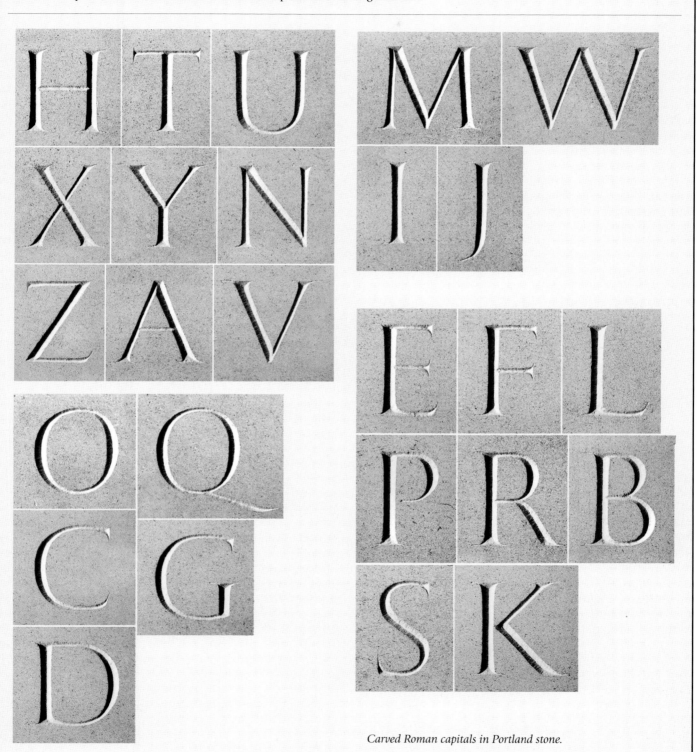

Carved Roman capitals in Portland stone.

Carving Problems and Solutions

The following information may be of help, particularly to the beginner.

KEEPING A STRAIGHT LINE

If there is a problem maintaining a straight line when carving the V-cut up the centre of the stem, try scoring a straight line with the corner of the chisel, use a ruler, to give the chisel grip when starting to carve. Also, try shorter bursts of carving, of around six taps at a time, which should help prevent the carving going much off the mid-line. You can then frequently assess the situation and correct the carving direction before it has gone off centre by too much.

ASYMMETRY OF THE V-SECTION

If the V-section develops asymmetry, try carving up the shallower side of the V-section with the chisel edge at a slightly steeper angle than normal, to shift the bottom of the V-section across to a more central position. It may also help to stand in a position more opposite to the side of the V-section you are carving – this helps you to work into each side better and develop a more symmetrical V-cut.

UNDERCUTTING

When chasing, a slight undercutting of the opposite side of the V-cut may be produced. If the undercutting is so marked that it causes a problem then it may be prevented by ensuring the corner of the chisel does not move beyond the bottom of the V-cut into the opposite side of the V-section. If the problem persists, it may help to locate the corner of the chisel in the bottom of the V-cut, then move it very slightly out of the bottom and retain this location. If the chisel gets stuck whilst chasing, the angle of the chisel shank may be too steep.

REMOVING TOO MUCH OR TOO LITTLE MATERIAL

If the chisel slides or fails to remove material whilst chasing, the angle of the chisel shank may be too shallow. If lumps of stone or slate break off beyond the edges of the drawn letterform, the chisel shank may be too steep (thus eating into the material too much) or the chisel is perhaps being hit too hard.

STROKE WIDTH

If the stem, horizontal stroke or curve is carved too wide this may be because the angle of the chisel edge to the stone or slate is too low, thus removing too much material, or it may be due to hitting the chisel too hard, with the same effect.

If a stroke is carved too wide, avoid widening other similar strokes to match. It may be useful in the earlier stages of letter carving to use a narrower chisel for carving thin strokes and stop cuts; this may help to achieve the more delicate carving required in these situations.

WOBBLES AND CHIPS

If a wobble or a chip occurs beyond the stroke edge, leave it – do not widen the whole stroke to absorb it – as a stroke that is carved too wide is far more noticeable than a slight wobble or chip. There are two ways of dealing with errors at the edge of a stroke:

■ If the wobble or chip is fairly small you can take down the surface of the stone at the problem spot by sanding with wet and dry paper, used dry in this situation (around 240–320 grade, depending on the size of the chip).

■ If the chip is larger you can fill the gap by mixing stone, dust and clear epoxy resin, such as Araldite, applying it with a small spatula. If necessary, this repair can be carved through quite satisfactorily.

CORNERS

To avoid the corners of the stone or slate breaking off when carving at the junction of horizontal and vertical strokes, for example as with the 'H' cross bar and stem, steepen the chisel shank, and ensure you carve the horizontal stroke first.

DEPTH ON CURVES

To avoid carving too deeply at the transition from wide to narrow parts of a stroke's round curves, gradually lighten the touch to make the V-section shallower in the thinner parts of the curves.

Example Carvings

The Millennium Celebration Stone

The following commentary explains an individual letter carver's approach to a particular letter carving work he has carried out. Jon Gibbs marked the Millennium in the form of his Millennium Celebration Stone, illustrated below.

> In 1999 I became quite disillusioned by the way that the 2000th anniversary of Christ's birth was being turned into a media circus and overwhelming retail opportunity. As a reaction to this materialism I set myself a project to create a collection of lettering in a variety of media that was based on well-known Christian texts and symbols. The size of the Millennium Celebration Stone is based on the Golden Section (5:3), and the juxtaposition of incised and relief letters may be seen as a reflection of the bipartite nature of Christ as both spiritual and corporeal. The Chi-Rho is a well-known image based on the Greek name for Christ and the AMDG (Ad Maiorum Dei Gloriam) is a well-known Latin acrostic. This mingling of the languages is perhaps resonant of the transfer of the scriptures down through the ages. (Jon Gibbs, statement provided to the author).

The Animals in War Monument

The inscription designed and carved by Andrew Whittle for this monument illustrates a very large-scale work, using a combination of V-incised and raised lettering. Here, Andrew describes the commission:

> I was delighted to have the opportunity to design and cut all the lettering associated with the Animals in War monument in Park Lane. There are two elements to the lettering; a massive raised title and acres of incised lettering. The lettering had to be laid out on a Portland stone wall which curves on plan whilst leaning forward (not a problem on the back where I simply followed the joint lines but the front was more complicated), and a horizontal grid had to be set up, avoiding where possible the joint lines which rose and fell.

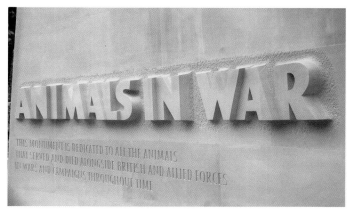

Andrew Whittle, the 'Animals in War' monument, Park Lane, London. Portland stone wall 4m high by 20m, worked in situ, 2004. Front of monument.

Andrew Whittle, the 'Animals in War' monument, lettering on the reverse.

LEFT: *Jon Gibbs, 'Millennium' inscription, V-incised and raised lettering in Diptford slate from Devon. 50 × 30cm.*

I spent a long time refining a letterform, an old favourite, which at some point was a sans serif rustic. I wanted the letters to be as ideal as possible for chopping into Portland without compromising the essential nature of the form. The alphabet was drawn at three different sizes and weights plus an italicised version. The raised letters originally followed the same format but had lost the feel I was looking for in their extreme boldness and were simplified towards a more normal ultra bold sans. The interleaving of the letters allowed for larger letters within the same space with the practical bonus of less background to be worked. (Andrew Whittle, statement provided to the author).

The Language Pillar

This collaboration between Sally Bower and Mark Frith demonstrates another form of large-scale public letter carving work. It is located in the Tibetan Peace Garden or Samten Kyil (the place of contemplation, to give it its Tibetan name) in Geraldine Mary Harmsworth Park, next to the Imperial War Museum in London. It carries a message of wisdom, hope and peace from the Dalai Lama in English, Tibetan, Hindi and Chinese. The garden was originally conceived by the sculptor Hamish Horsley and funded by the Tibet Foundation.

The four carved faces of the pillar are 2.8m (9ft 2in) high, built of three blocks of Portland stone. Sally Bower drew the lettering in all four languages, and Mark Frith carved the texts with additional help from John Das Gupta, who carved the Hindi. Collaboration makes it possible to produce very different work from that done alone: each person brings individual skills that complement those of the other(s).

The texts of the four languages varied in length (English 524, Tibetan 424, Hindi 365 and Chinese 222 characters) but were drawn and carved so that each language covers its own side of the pillar and ends at the same point, leaving the Dalai Lama's signature as the only element in the same place on each face. The work was carried out in situ between February and May 1999.

The Language Pillar carries not only the profound and compassionate spirit of the Dalai Lama's message, but the spirit of the artists themselves. Committed to an extraordinarily complex project, they brought the best of themselves to this work, and it shows. As Robert Ford, who as a young man was with the Dalai Lama in Tibet, has written:

To me the reproduction of the pen strokes of the Tibetan script and the vastly different brush work of the Chinese characters on the obelisk are an accurate portrayal and are outstandingly beautiful. (Quoted at opening ceremony).

A much fuller description of the project can be found in the interview between Peter Bower and the creators Sally Bower and Mark Frith in the Calligraphy and Lettering Arts Society publication The Edge (see Bibliography), from which the following descriptive extract has been adapted by Sally Bower:

Hundreds of people came to the festive opening. Monks playing wind instruments accompanied His Holiness who had a yellow canopy held over him. At the unveiling Sally, Mark and John were presented to His Holiness, who presented them with white silk scarves. Sally recalls, 'we exchanged a few words. It was wonderful to have his acknowledgement and also to watch his eyes as he read the Tibetan on the Pillar. It was a moment we will never forget.'

Detail of the English face of 'The Language Pillar', drawn by Sally Bower and carved by Mark Frith. In the free design of the English inscription the letters vary in size to accommodate the differing line lengths. (Photo: Mark Frith)

LEFT: Sally Bower and Mark Frith, 'The Language Pillar', 2.8m high. Tibetan Peace Garden, next to the Imperial War Museum, London, 1999. The Dalai Lama reading the Tibetan face of The Language Pillar. (Photo: Connor O'Dwyer)

Carving Raised Letters

Although in Britain the V-cut letter has predominance in carved lettering, letters can also be carved in relief, especially where a bold, more sculptured impact is required. The most successful forms for raised lettering are bold or heavier-weight letters, without marked thick or thin stroke contrast, as raised thin strokes would be more vulnerable and liable to break – and for this reason more difficult to carve.

To carve a raised letter, securely fix a smooth or reasonably smooth-surfaced piece of stone or slate to the easel or place flat and draw a letter at a height of around 7.5cm (3in). The size of the chisel to be used would depend on how much stone is to be removed around and within the letters (the letter counter-spaces contained within the forms). In this instance take a 6mm (¼in) chisel, and initially carve a V-incised line just outside the drawn form.

Holding the chisel edge flat on the stone or slate, with the shank of the chisel at an angle as shown opposite, begin to remove the background stone to the required depth by chiselling, initially (for the first skimming), to a depth of around 3mm (⅛in), depending on the hardness of the stone. With very hard stones, you may have to remove less material at the first skimming; with some softer stones you may be able to remove more.

Complete the removal of the background stone surrounding the letter and from the letter counter-spaces to this level, then repeat the process until the required depth has been reached, leaving the sides of the forms slightly inclined inwards towards the top. This is technically easier to achieve than making the sides absolutely vertical, which can be done if preferred.

The background can then be chiselled flat and left with a rough surface, or finished off to give a smooth surface. If a textured background surface is required, it can be finished off with a claw chisel or a point.

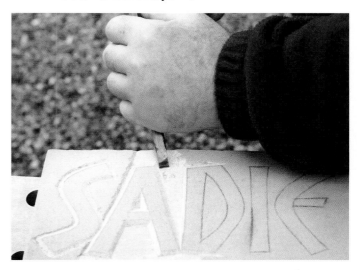

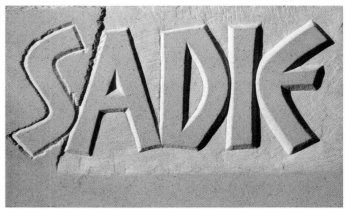

Each letter showing a stage in carving raised lettering – progressively deepening background.

TOP: Carving away the background for raised letters.

ABOVE LEFT: John Neilson, 'Ceaseless Message', raised lettering in Hopton Wood limestone, 2000. 30.5 × 61 × 7.6cm. Text from Elegy No.1, 'Duino Elegies', by R. M. Rilke, translated by Stephen Mitchell, from The Selected Poetry of Rainer Maria Rilke, (1987, Macmillan).

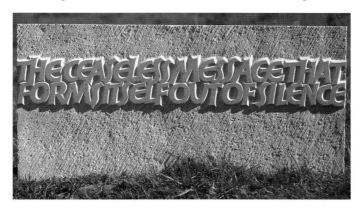

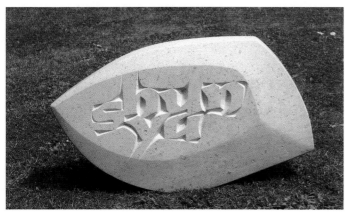

LEFT: Malcolm Sier, 'Shunya', incised background, Hopton Wood limestone, 2005. 30 × 50 × 10cm.

Use of the Technique

There has been a stronger tradition of raised lettering amongst artists and craftsmen letter carvers in the second half of the twentieth century in Germany. However, over the last few decades it has been increasingly used by a growing number of letter carvers in Britain.

The following description by Kristoffel Boudens gives an interesting insight into his approach to lettering:

My initial fascination in the practice of lettering was for classical imperial capitals. My background as an artist-painter however, combined with my interest for unschooled lettering, led me to a fork in the road. I took it. On the one hand I like the use of classical type, like capitals, for architectural jobs and lettering where legibility prevails (form follows function). On the other hand I explore lettering that has roots in painterly composition rather than in writing.

The piece 'Stella Rosita' shows a less typical work because I wanted an explicitly stronger three-dimensionality than I often try for. Originally, I intended to put the stone level so that the hull-shaped letters would contain rain and reflect the sky. But I eventually decided to put the stone upright because in that position the lettering catches better light and offers nicer shadows.

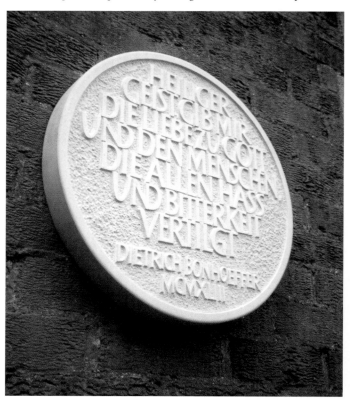

LEFT: Eric Marland, raised lettering roundel, 40cm diameter, 5cm thick, for St Edmund's College, Cambridge. The quotation is a prayer by the German priest Dietrich Bonhoeffer.

Wolfgang Jakob, textured red sandstone headstone in two parts, with raised lettering. 130 × 60 × 20cm.

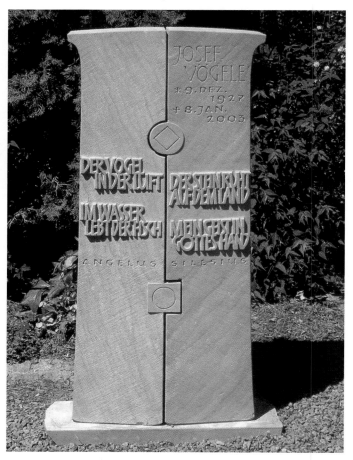

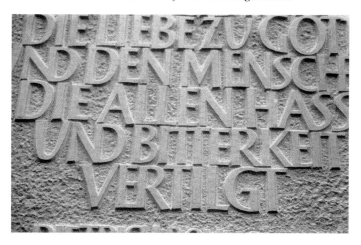

Eric Marland, detail of raised lettering roundel.

It is my conviction that lettering for stone should not imitate calligraphy. If at all it has a link with paper lettering, it should be with type because characters for type and for stone are both built-up rather than being written shapes. Moreover, in stone lettering the building up happens in the drawing and in the carving process. Also, type-related shapes to me are closer in atmosphere to most architecture than calligraphic shapes. I regret that stone lettering throughout its history has so often been content with being the weaker brother of calligraphy or of typography – however pretty the result often was. (Kristoffel Boudens, statement provided to the author).

Another work, illustrated below centre from Incisive Letterwork (comprising Annet Stirling and Brenda Berman)

BELOW RIGHT: Christopher Elsey, 'An honest answer…', blue-black Welsh slate inlaid with Welsh Heather red slate. Gilded border and symbol (36 × 22.2 × 2cm), which relates to the golden rectangle.

BELOW CENTRE: Incisive Letterwork (Annet Stirling and Brenda Berman), 'Searching for the answer…', slate maquette: carved slate column with brass pedestal. 54 × 4 × 4cm.

BELOW: Kristoffel Boudens, 'Stella, Rosita' (names of his daughters), French limestone. 100 × 24 × 10cm.

shows a slate maquette. Their approach is demonstrated in their own words:

Incisive Letterwork is trying to push the lettering to the edge – literally. This four-sided column is one of our answers to the 'standing stone' much in fashion at the moment. We like the idea of using all of the stone, both the letters and the spaces between the letters. The latter are cut at different angles and have different textures. Two sides of the column were quite difficult to carve as they had to be carved into the slate bedding plane. The text becomes more mysterious when you can start reading at any one of the four sides. (Annet Stirling and Brenda Berman, statement provided to the author).

The other images shown here further illustrate how flexible freestanding lettering can be, from the intimate scale of Christopher Elsey's work 'An Honest Answer', to the ultimate freestanding letter in Will O'Leary's 'Big "T"'. The interesting combination of V-incising along the middle of raised letters is also demonstrated here by the work of Michael Harvey overleaf.

One final technique to mention is incised pecking, demonstrated by the pebbles carved by Malcolm Sier. This technique consists of pecking at the stone using a dummy and either a 'point' (see chapter 2 for illustration), or using the corner of a small chisel.

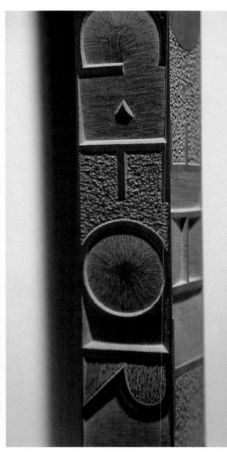

Malcolm Sier, 'Dreams in the dust' pebble, part of a series, incised pecking, 2005. 7cm approx.

Malcolm Sier, 'Dreams in the dust' pebble, part of a series, incised pecking, 2005. 7cm approx.

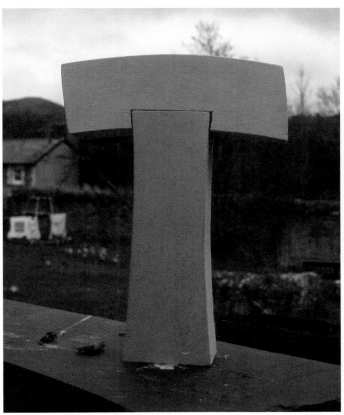

Will O'Leary, 'Big T', Bath stone, masoned in two and slotted together. 68 × 50 × 15cm.

LEFT: Michael Harvey, low-relief lettering on a Portland stone bird bath for the artist's garden. Charlie Parker, the jazz musician, was known as 'Bird'.

Texturing the stone surface: top, textured with a point; middle, textured with a claw; and bottom, left chiselled.

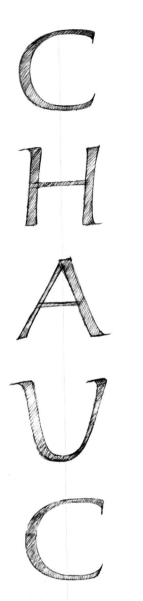

Inscription from the Forum, Rome.

Tom Perkins, 'Chaucer', free rendering of Roman capitals.

Pieter Boudens, lithographic stone. 36 × 11 × 1cm. (Photo: Jan de Mylle)

Drawn Lettering: Roman

Introduction

For the letter carver, the importance of a sound under-standing of drawn letterforms cannot be overestimated. If one intends to learn letter carving thoroughly as a craft, a good starting point is an in-depth study of Roman cap-itals, which from a historical point of view are the fun-damental carved forms of the craft and are still in widespread application today in many media. The recent typeface called Trajan designed by Carol Twombly, based very closely on the Trajan column inscriptional letters, has been very successful and bears testimony to the enduring appeal of these forms.

The equipment needed for drawing letters is very sim-ple. I use an A2- or A3-size layout pad, although others may prefer cartridge paper. One of the advantages of working on layout paper is its semi-transparent nature, which enables you to use it to fine-tune your letters by overlaying a new sheet on the initial drawn letters and redrawing. You can use a sharp HB pencil, though some may prefer a slightly softer pencil such as a B, or a slightly harder one such as an H. A ruler and soft eraser are necessary, and a 45-degree set square and compasses can also be useful.

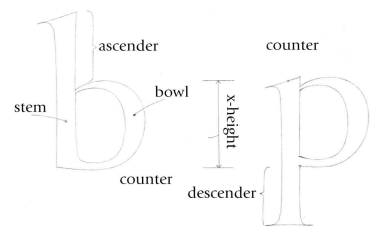

Roman lower-case 'b ,p', indicating the terminology of parts of letters.

Tom Perkins, 'Centre', V-incised Roman capitals in Welsh slate. Part of inscription.

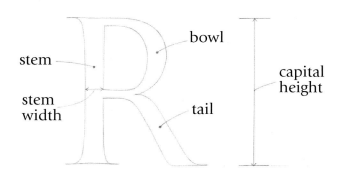

Roman capital 'R', indicating the terminology for parts of a letter.

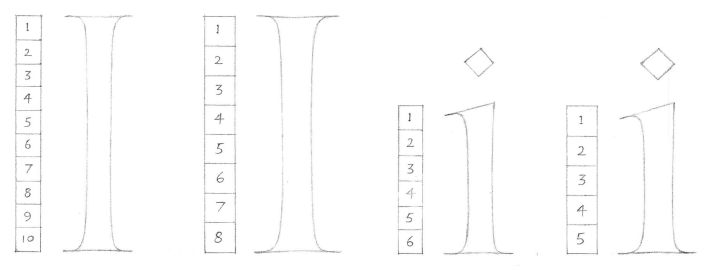

Illustration of stem width to letter height ratio: Roman capital 'I' at 1:10 and 1:8, and Roman lower-case 'i' at 1:6 and 1:5.

Design Considerations

The following considerations are essential when drawing Roman capitals, Roman lower-case letters and numerals: accurate letter shape and proportion; the relationship of stem width to letter height (termed the letter weight); the distribution of weight round the letterform; and the widths of stems, thick and thin diagonals and curves relative to one another. It is important to note these points before proceeding to draw the letters.

Letter Weight

When drawing letters, it is essential to select a suitable weight for letter strokes and this is something that needs to be considered in the context of each individual inscription. The weight, or relative heaviness of a letter, can be determined by the number of times the letter stem width (of an 'I', for example) fits into the letter height. With a heavy letter this will be fewer times and with a lightweight letter it will be more times. For Roman and italic capitals, a normal letter weight would be a stem width to letter height ratio of between 1:8 and 1:10. For Roman lower case and italic lower case the ratio can be around 1:5 to 1:6.

Obviously, softer and more open-textured stones will require heavier-weight or bolder letters, especially if they are required on a smaller scale. Also, choice of letter weight can be affected by whether or not the carved letters are to be painted or left unpainted. Letters in stones where the contrast is poor between the surface of the stone and the cut letter will need to be bolder in order to show up.

Stem Width

The stem width of a particular alphabet at a given letter height (termed the x-height for lower-case letters and capital height otherwise) sets the width for all letter stems, including straight parts of ascenders and descenders (the letters or parts of letters that ascend above the top or below the bottom x-height lines). This stem width can quite simply be marked on a strip of paper and used as a check for stem width as you draw the letters. Thick diagonals are the same width as stems. By dividing the stem width in half you also have a check for straight horizontals and thin diagonals, which, in Roman capitals and Roman lower case, are approximately half a stem width.

Curves

The curved parts of letters at their thickest point are usually made fractionally heavier than the middle of a stem, which, because of a slight concavity (see above), is narrower than the top and bottom. Curves gradate towards their thinnest parts, which are usually made fractionally thinner than half a stem width.

Serifs on Vertical Stems

The top and bottom of thick vertical stems flare out subtly and are terminated with fine serifs, drawn in a horizontal direction. These serifs are subtly shaped – with the sides of the horizontal serifs lifting slightly off the baseline at the

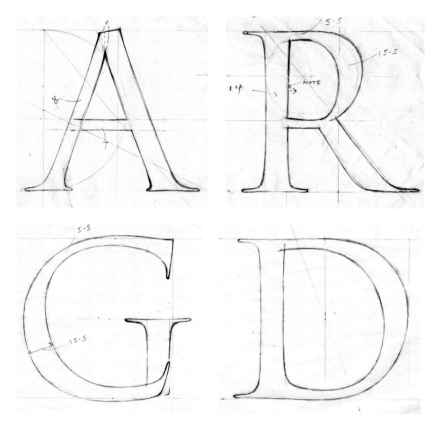

'ARGD', analysis of letters from the Appian Way inscription. For the full geometrical basis of this alphabet by Tom Perkins see Font, exhibition catalogue 1999, published by the Edward Johnston Foundation, Ditchling.

bottom of thick stems, and the middle slightly lifted in a double ogee shape, as illustrated on page 72. The serifs at the top of thick stems follow the same concept, with the sides dipping slightly towards the top line and the middle slightly dipped in a double ogee shape.

Serifs on Horizontal Strokes

Serifs terminating straight horizontal elements of letters are vertical in most cases, or near vertical in some instances such as with bases of Roman capitals 'E' and 'L' (see page 74). Serifs terminating horizontal curved parts of letters, for example on 'C', are similarly vertical or near vertical (according to individual letters and parts of letters). I tend to make serifs on the ends of horizontals slightly convex. At the end of thick and thin diagonal strokes, the fine horizontal serifs are drawn out longer on the outside than the inside of the letter.

These are the main aspects to note; some other details of letter formation can be found under individual letter descriptions and through observation of the diagrams. With experience one can assess the width of a letter in relation to its height, its stem width and other details of formation quite accurately by eye, without having to resort to detailed analysis and measuring. However, it is important to get

these details correct from the beginning, and this can best be achieved by deliberate methods.

The alphabets illustrated here have been drawn freehand, and inevitably in such a process slight variations can occur – and in fact these can lend a certain freedom to the letters. As it is important to learn Roman capitals and lower case thoroughly, I have supplied detailed observations for drawing these letters, and the numerals to accompany them. For drawing subsequent alphabets less detail is given, as similar considerations can be applied to most alphabets. It is important to understand that different designers and craftsmen may approach the drawing of letters differently and there is some leeway in the order of drawing the strokes. Any stroke order suggested is therefore for guidance, and is not a hard-and-fast rule.

Drawn Roman Capitals

The refined capital letterforms of the finest inscriptions carved in Imperial Rome and throughout the Roman Empire offer an excellent basis for the beginner letter carver. As the renowned calligrapher Edward Johnston (1872–1944) (see Bibliography) stated:

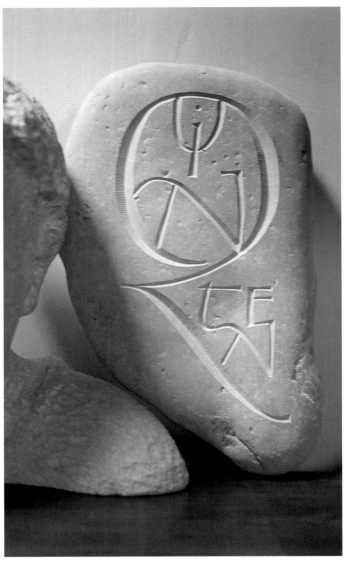

Kristoffel Boudens, 'Quenten', V-incised French limestone pebble, 25cm high.

'R' written with a chisel-edged brush.

Nearly every type of letter with which we are familiar is derived from the Roman capitals, and has come to us through the medium, or been modified by the influence, of the pen.

Roman inscriptional capitals reached their peak of development at the beginning of the first century AD, in examples such as the famous inscription at the base of Trajan's column in Rome (c.113AD). There are numerous other fine examples, but the Trajan inscription is particularly well preserved and contains most of the letters of our alphabet.

Use of the Flat or Edged Brush

Many of the finest ancient Roman inscriptions appear to have been laid out on the stone with a flat brush, which, when held at prescribed angles, produces the correct distribution of weight round the letterform as shown in the examples illustrated. Not all these inscriptions were designed in this way; some would have been constructed using a ruler and compasses. Painting letters with a flat brush is a highly sophisticated skill, not only requiring detailed, accurate knowledge of the letterforms, but a high level of expertise in using the edged brush.

Whilst it is very instructive to acquaint oneself with this brush method, by far the majority of present letter carvers draw the forms in pencil, either on paper (subsequently transferring them to the stone by tracing down), or drawing the forms directly on to the stone, rather than writing them with an edged brush.

Tom Perkins, V-incised Portland stone.

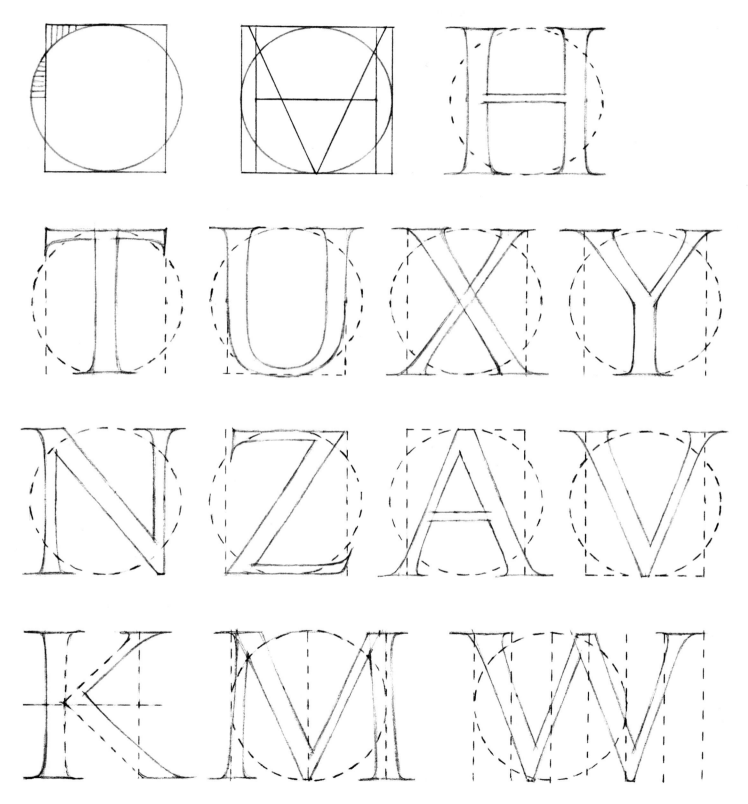

Drawn Roman capitals alphabet in letter formation groups.

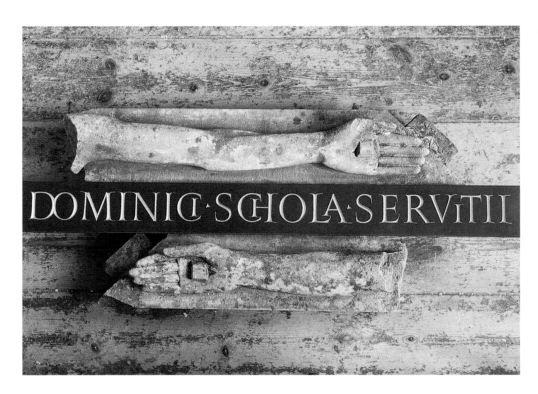

The Cardozo Kindersley Workshop, V-incised inscription over the entrance of Ampleforth Abbey. Welsh slate gilded and lying in Eric Gill's arms of Christ.

Letter Width Groups

Classical Roman capitals follow a recognizable system of letter proportions; that is, the letters have varying widths in relation to their height, and the alphabet can be divided into various width groups accordingly. The drawing on the previous page suggests a stroke sequence that would be useful for a beginner – obviously as you progress you can modify the sequences to suit your own approach.

Group 1: Rectangular Letters – H T U X Y N Z, and A and V

For convenience, this group of letters can be referred to as the rectangular letters, as they fit into a rectangle which has the same area as would a circle of the same height. This rectangle can be obtained by measuring one-tenth of the letter height in from either side of the circle.

The letters shown on the previous page have a height of 4cm (1¼in) so that the rectangle has a width of 3.2cm (1¼in). The letters that fit into this rectangle are 'H', 'T', 'U', 'X', 'Y', 'N' and 'Z'. 'A' and 'V' are made very slightly wider than the rectangle but not quite as wide as the square containing the circle.

To ensure accuracy, all Group 1 letters should be drawn initially with underlying rectangles and circles as illustrated.

DRAWING GROUP 1 LETTERS

The stem width throughout the alphabet is approximately one-eighth of the letter height with a slight concavity on each side.

Letter 'H' can be drawn by drawing the left then right strokes of the left stem, then the right stem, remembering to make the middle slightly thinner than at either end, and finishing by adding top and bottom serifs. It is a general optical principle that if something is to appear at mid-height, it has to be raised slightly, so accordingly the 'H' crossbar is placed with its bottom edge on the centre line. Horizontal strokes are approximately half the width of vertical stems.

Letter 'T' has a stem the same as 'I' and is usually drawn before the top horizontal stroke, which is the same width as 'H' (ignoring the 'H' serifs). Sometimes the crossbar of 'T' is moved down slightly from the top line to visually compensate for the long crossbar and prevent it from appearing taller than other letters. The serifs either end of the horizontal bar are kept more or less vertical and project more below the crossbar than above.

Letter 'U' is the same width as 'H'. The thickness of the curved base at its mid-point is approximately half a stem width or fractionally less, and it gradually thickens out on either side of the letter towards the full stem width. The bottom curve should always cut through the bottom line slightly, to prevent the letter looking shorter than other letters. The tops of the two vertical strokes are completed with serifs as for 'H'.

Ben Jones, 'Cetera', ('The rest are missing'), V-incised Portland limestone.

Letter 'X' across the base is the same width as 'H', but the top part is slightly compressed, thus creating more space in the bottom part of the letter to prevent it looking top-heavy – the same principle applied in raising the 'H' crossbar. 'X', therefore, crosses just above halfway up the letter height. The thick stroke is usually drawn first, the same width as a thick vertical stem. It flares out subtly at either end to finish with fine horizontal serifs. Note the starting and finishing locations of thick and thin diagonals in relation to the underlying rectangle. The thin diagonal is approximately half a vertical stem width and broadens out subtly at either end, finishing with fine serifs.

Letter 'Y' is the same width across the top as the 'H', and the junction of the V-part with the stem is at mid-height. It is important to ensure the diagonal strokes join the stem at the same level either side. Start 'Y' by drawing the short vertical stem to the centre of the height, flaring out slightly at the base and finishing the bottom with a fine serif as for 'I'. Then draw the thick and thin diagonals, which are a stem width and half a stem width respectively, and flare out subtly at the ends to finish with fine, horizontal serifs.

Letter 'N' is the same width as 'H', and is unusual in that the verticals are narrow, being approximately half a thick stem width. Start by drawing the left then right verticals. Note that they are slightly concave, being thinnest at mid-height, and finish with fine, horizontal serifs. The thick diagonal is the same width as a thick stem. The bottom join of the diagonal with the vertical support has a slightly sheared point.

It is important that this is kept narrow – slightly less than the width of the thin vertical stems.

Letter 'Z' is the same width as 'H' at the base, and the top lies slightly inside the rectangle. The thick diagonal is the width of a thick stem, and is usually drawn first, followed by the top horizontal approximately half the width of a thick stem. The open end of the horizontal is flared out subtly, and finished with a fine, slightly inclined, near-vertical serif. The bottom horizontal is then completed, slightly flaring out towards the end and finishing with a fine, slightly inclined serif that can project minimally outside the rectangle – note the subtle rounding off of the bottom corner.

Letter 'A' is slightly wider at the base than 'H', and unlike the 'H' the crossbar is moved down from the centre to balance the spaces above and below it. Start with the left thin diagonal, which is approximately half a thick stem in width, then the thick diagonal, which is a thick stem width. Both diagonals flare out slightly towards the base, and finish with fine, horizontal serifs. Note the chisel top to the 'A'. Finally, draw the crossbar, which is half a thick stem width and is just below centre.

Letter 'V' is the same width at the top as the 'A' base, and projects just outside the rectangle. The thick diagonal is drawn first and is a thick stem width. Then the thin diagonal is drawn, which is half a thick vertical stem width, and both diagonal strokes subtly flare out at the open ends and finish with fine, horizontal serifs. Note the narrow chisel ending at the base junction and that the inside base is slightly off-centre.

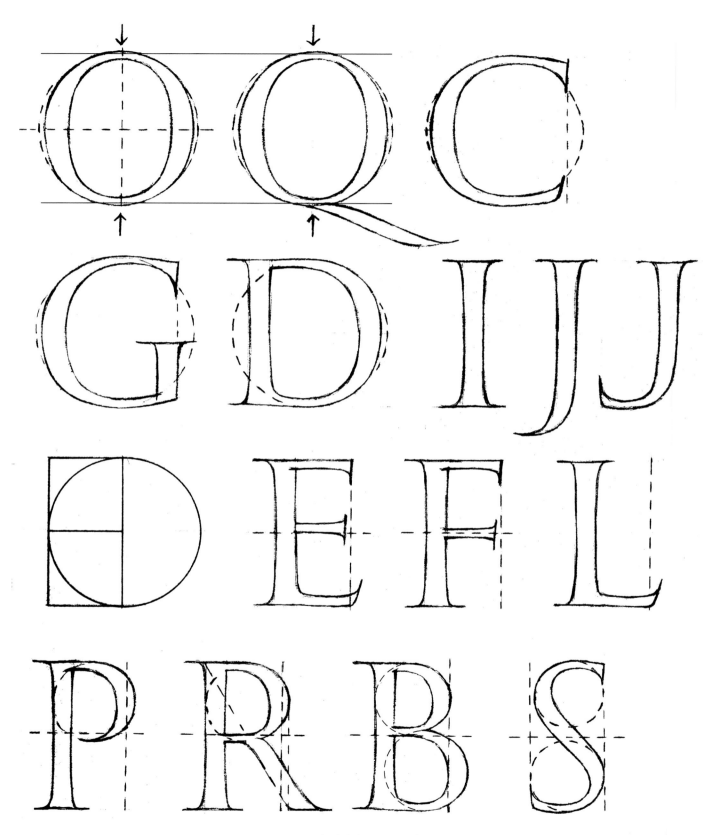

Drawn Roman capitals alphabet in letter formation groups.

Group 2: Circular Letters – O Q C G and D

The outer contours of 'O' and 'Q' are slightly flattened circles; 'C', 'G' and 'D' are in letter width about a thick stem width less than the full circle.

DRAWING GROUP 2 LETTERS

Letters 'O' and 'Q' are started by drawing the outer contour. It is important that these two letters cut the top and bottom lines very slightly, so that they look the same height as the rest of the alphabet. For this reason, it is a general principle that top and bottom curved parts of the letters cut the line at the top and bottom. Although it would be easier to simply follow a circle for the external contour of these letters, the form is considerably strengthened by very slightly flattening the sides.

After the outer contour, draw the inside: this is a slightly squared-off oval, and is placed to create a vertical stress to the letters. That is, the thinnest parts of the strokes are exactly vertically above each other, and the thickest parts are horizontally opposite each other at mid-letter height.

On a curved letter, the thickest part of the stroke relates and is similar to the width at the top or bottom of a thick stem rather than the middle of a thick stem, which is narrower. The thinnest parts of curved strokes are slightly less than half a thick stem in width. Ensure that all curves are subtly gradated from thick to thin.

For the 'Q' tail, draw a line vertically through the middle of the letter. Where this cuts the outer contour of the letter, draw a line at 25 degrees down from the baseline, then draw another line about a thick stem width above it, tapering in slightly where it joins the letter body and flaring out slightly towards the open end of the tail, shaping into a softened curve at the bottom.

Letter 'C' has its outer contour drawn first, as for the 'O' and 'Q', and is a slightly flattened circle, which cuts through the top line and baseline slightly. In this case the width of 'C' overall is just under a thick stem width in from the right edge of the circle, and 2mm in from the left edge of the circle.

The inner squared-off oval has the same vertical axis as 'O' and 'Q', with the thinnest parts vertically aligned and flaring out subtly towards the open ends, to finish with fine vertical serifs. Note the bottom open end is softened on the underside, and stops slightly short of the top. The thickness of the curves is the same as for 'O' and 'Q', and the top and bottom curves are similarly flattened off.

Letter 'G' is the same width as 'C' and the same shape, with the addition of the vertical stem. This is the same width and shape as the top of a thick vertical stem, and its height is halfway or slightly less than halfway, up the letter height. The right side of the stem aligns vertically with the end of the top curve of 'G'. Note the ending in a low point, near the baseline, where bottom curve and vertical stem meet.

Julia Vance, Belltower in graveyard, Kongsvinger, Norway, V-incised in concrete, 2004. 15m high. Architects: Klippgen and Talvorsen.

Letter 'D' is the same width as 'C' and 'G', the right side of the letter being 2mm in from the right edge of the circle, and the left side of the letter being just under a thick stem width in from the left edge of the circle.

The stem is drawn first, and the outer contour of the curve is drawn next, slightly flattening the curve from the circle. The inner curve is drawn last, maintaining a vertical stress as for 'O', 'Q', 'C' and 'G', the width of the curves being the same as the other letters in this group. Note the curved join where the curve meets the stem at the inside base, but that there is not a curved join at the inside top of the letter.

Group 3: Narrow or Half-Square Letters – E F L P R B S and K

These are approximately the width of half the full height square, except 'K', which is somewhat wider. Other subtle differences in width are pointed out under each letter explanation. With the exception of 'L', all the letters in this group are asymmetric with a middle division. ('I' and 'J' are treated separately as they have no significant width.)

DRAWING GROUP 3 LETTERS

Letter 'E' is the width of the half square at the top, the middle arm being slightly shorter and the base arm slightly longer.

The vertical stem is drawn first, followed by the horizontal base arm. The bottom stroke has a slight movement above the baseline immediately under the thick stem, and cuts slightly through the baseline towards its open end, where the bottom corner is rounded off. The serif is inclined out slightly to the right. The bottom stroke of the middle arm is on the centre line, the top stroke is half a thick stem width above it, and the arm flares out slightly towards its open end, finishing with a fine vertical serif. The top stroke of the top arm is straight and the lower stroke of the top arm slightly flares out towards the open end of the arm, which finishes with a fine vertical serif, projecting downwards. All horizontal arms are approximately half a thick stem width.

Letter 'F' is similar to 'E 'apart from the lower arm position, which is lowered by half a horizontal arm thickness. This slightly increases the top space to balance with the open bottom space.

Letter 'L' is the same as the 'E' stem and base arm.

Letter 'P' has the stem drawn first, then the outside of the bowl, which is slightly wider than the half square and slightly flattened from a circle. The bottom of the bowl projects below the middle of the letter height. The inside of the bowl is drawn next, maintaining a vertical emphasis to the stroke. The thickness of the curved stroke of the bowl at its widest point is the same as the thickness at the top of the stem; the thin horizontal of the bowl is the same thickness as the arms of the 'E' (that is, half a thick vertical stem width or a slightly less). Ensure subtle gradation from thick to thin round the curve, which ends in a point a short distance from the main stem.

Letter 'R' has the stem drawn first, as for 'P', then the outside contour of the bowl, which has the same proportion as that for 'P'. The inside contour of the bowl also has a vertical stress, as for 'P'. The bowl joins into the stem with a horizontal element, approximately half the thickness of a thick stem, the top stroke of which is on the mid-line of the letter height, with the lower stroke half a thick stem width or slightly less, below (that is, the same thickness as the top horizontal).

For the 'R' tail, draw a vertical line from the edge of the bowl to the baseline, and join this point by a line to the top left corner of the stem. This gives the lower stroke of the

Michael Rust, headstone, V-incised in Welsh blue-grey slate. Lettering and design incised and painted off-white, churchyard of SS Peter and Paul, Bilsington, Kent. 101.5 × 61 × 7.5cm.

James Honeywood, 'Ne templo…', quotation carved on three faces of column base and 'Ad MM' on middle opposite face, Inner Temple Church, London.

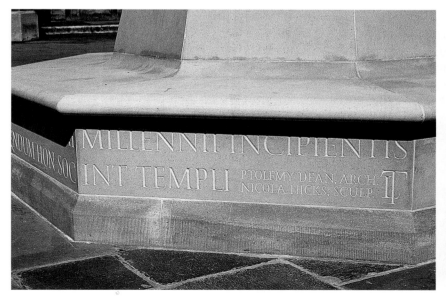

'R' tail. The top stroke is a thick stem width away, and the tail slightly flares out towards the open end, being subtly rounded on the underside and finished off by a fine horizontal serif. Note there is no serif on the inside of the tail.

Letter 'B' also has its stem drawn first, then the outside of the top bowl is drawn (the same shape as for 'P' and 'R' but smaller – fitting into the width of the half square). The inside contour is then drawn with a vertical stress.

The thickness and gradation of the top bowl of the 'B' is related to 'P' and 'R'. Note that the lower stroke of the middle horizontal is on the mid-line of the letter height, and the top stroke slightly less than half a thick stem width above. The inside curve of the bottom bowl of 'B' coincides with the width of the half square, and the outside contour is drawn to make the thickness of the curved stroke of the bowl the same width at its maximum thickness as the top bowl. Note the subtle curve, as for 'D', where the top stroke of the base horizontal meets the stem. All three horizontals are the same thickness – approximately half a thick stem width.

Letter 'S', like 'B', has the top part of the letter slightly less spacious than the bottom part. The diagonal, which is a thick stem width, tapers into the horizontal curves at top and bottom, which are slightly less than half a thick stem width and flare subtly towards the open ends. The ends finish with vertical serifs (descending from the top arm, and ascending from the bottom arm). Top and bottom arms cut slightly through the top line and baseline respectively, in order to make the 'S look the same height as the other let-

Keith Bailey, Portland stone column at Greshams School, Holt, Norfolk (attended by W.H. Auden). 14'x 1'3in square. (Quotation from W.H. Auden by kind permission of Faber & Faber)

ters. 'S' aligns vertically on the right side, whereas on the left the tail projects slightly beyond the top.

Letter 'K' is different from the other stems in Group 3 as it is the right side of the stem that coincides with the left edge of the half square, making 'K' somewhat wider than the other letters in this group.

The stem is drawn first, then the thick diagonal (a thick stem in width), its top stroke starting by touching the stem just above halfway up the letter height. The tail projects beyond the half square, and is very subtly rounded on the underside, finishing with a fine horizontal serif that only projects to the right of the stroke. The thin diagonal for the top of the letter is drawn last, and is half the width of a thick stem. Its right stroke projects just outside the top-right corner of the half square. The thin diagonal finishes with a fine horizontal serif extending to left and, slightly further, to the right.

Group 4: Wide Letters – M and W

'M' is slightly wider than the full-size square. 'W' is made up of two slightly compressed V-shapes.

DRAWING GROUP 4 LETTERS

Letter 'M' starts with a square. Mark the mid-point of the baseline and top line. Draw the thick diagonal (a thick stem width), starting with the left stroke half a stem width inside the top left corner of the square, descending to mid-base. Then draw the thin diagonal (half a thick stem width), starting half a stem width inside the top right corner of the square.

Note that the inside point of the V will be to the right of centre. Draw the thin left support (half a thick stem width), from just inside the top left corner of the square (where the thick diagonal starts), to the bottom-left corner – it flares out slightly towards the base to finish with a fine horizontal serif. Finally, draw the thick right support, the same width as the thick diagonal (that is, a thick stem width). It projects just outside the square at the top right and slightly more at the bottom right as it flares out to finish with a fine horizontal serif.

Note that thick and thin strokes are subtly concave, as for vertical stems, and also that the top horizontal serifs do not project inside the V-part. The two bottom counters (the white space inside a letterform, either enclosed as in 'B' or semi-open as in 'C') should be equal in width.

Letter 'W' is started by drawing a circle and surrounding square, which is divided into four equal vertical strips. A 'V' is drawn that is the width of the first three parts, the thick stroke being a thick stem width and ending with a fine horizontal serif at the top. Then the thin diagonal is drawn half a thick stem in width. The base point is sheared off.

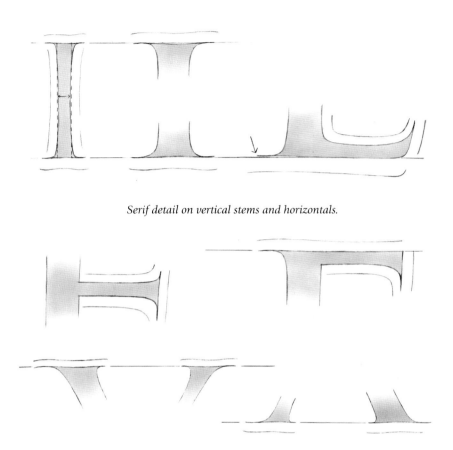

Serif detail on vertical stems and horizontals.

Rubbing of carved Roman capital 'N'.

Serif detail on diagonals.

To draw the second 'V 'for the 'W', add on two more vertical strips to the right of the main square, making the width of the whole diagram six equal parts in total. The left side of the thick diagonal starts halfway across the third section and descends to the end of the fourth section. The top of the thin diagonal of the second 'V' (excluding the serif) starts approximately halfway across the top of section six. Ensure both thick diagonals are the same width as each other and parallel, and both thin diagonals are the same width as each other and parallel. The centre top sheared-off point is wider than the two base sheared-off points.

concavity, which creates a subtle narrowing at the 'waist'. The fine horizontal serifs at top and bottom are subtly curved (see the diagrams of drawn serifs above).

Letter 'J' is the same as 'I' in width, but thins to half a thick stem width at the base, which just cuts through the baseline and slightly flares out towards the open end, finishing with a fine vertical serif similar to the bottom of 'S'.

In the second example of 'J', the stem thins gradually, tapering to a point well below the baseline.

Group 5: Very Narrow Letters – I and J

'I' is a thick stem, its width being approximately one-eighth of its height. 'J' has two forms: one ending like the base of 'S' and just cutting through the baseline; the other having a less marked base curve and cutting substantially through the baseline.

DRAWING GROUP 5 LETTERS

Letter 'I' is a simple stem, with both ends subtly flared, as with all thick stems in this alphabet, thus producing a slight

Drawing Serifs

The diagrams above show serifs close-up, as there are several important details of letter drawing that are difficult to see on the smaller diagrams.

Drawn Roman capitals are also shown right at a slightly lighter weight, and are particularly suited for use in fine-grained material such as slate. The letter width groups are the same as for the bolder capitals, and the drawing details are very similar. The stem width to letter height ratio is 1:10.

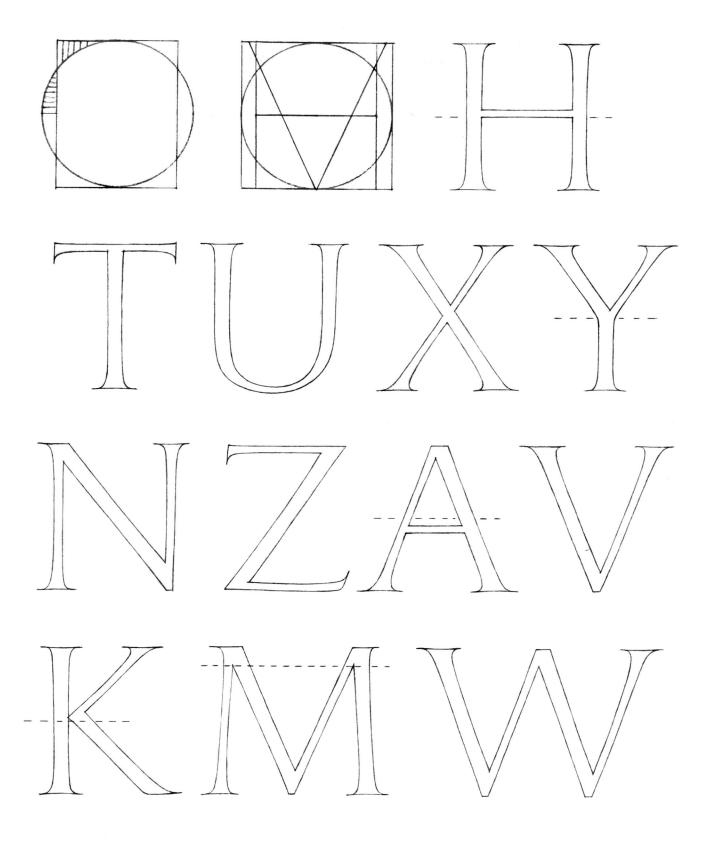

Drawn lighter-weight Roman capitals.

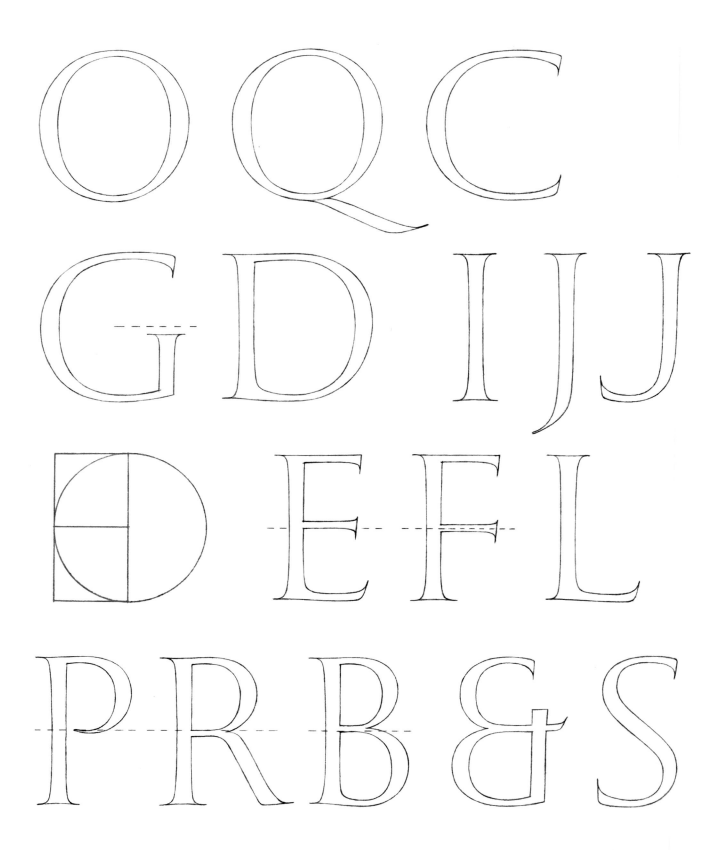

Drawn lighter-weight Roman capitals.

Stone Words

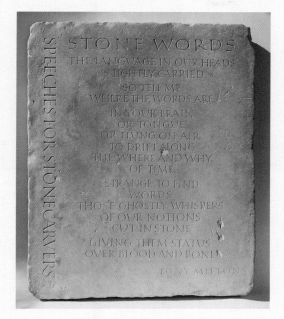

In his own words, Eric Marland explains the evolution of his piece of work using Roman capitals, 'Stone Words', shown illustrated above.

When the poet and children's author Tony Mitton sent me the poem 'Stone Words', along with two others in a series called 'Speeches for Stonecarvers', after seeing my work for the first time, I was thrilled. Not just because the work had elicited such a beautiful and well-considered response, but also because it gave me something to carve on the battered old piece of lithographic stone I had 'rescued' from under a printing press at my old art school where it had languished for many years (as I well knew, as I had to move it to sweep under the press in my role as school cleaner!).

The stone was a bit wider than the poem's rather short lines required so I decided to fill the width by carving the name of the series vertically like the spine of a book. It would have been relatively easy to smooth the face of the stone but I somehow felt its chips and scars seemed appropriate to the text and decided to try to work around them. It was after carving Tony's name at less than three-eighths of an inch tall that I knew it was time for my first eye test. (Eric Marland, statement provided to the author)

About 'Stone Words', the author Tony Mitton said:

I wrote this poem after visiting an Open Studio of Eric Marland, letter carver. I was struck by the contrast between the ephemeral nature of spoken words and their solid durability when carved in stone. The poem expresses this notion. I was especially delighted when Eric showed me the poem itself carved in stone. For me this was an unexpected felicity as well as adding a further curious twist to the work. (Tony Mitton, statement provided to the author)

Geometric Construction of Key Roman Letters

These examples show one way of using geometry as a basis for drawing Roman capitals and investigating their structure. An explanation for the construction of these sample letters should give sufficient information for working out the rest of the alphabet if required. Details of the geometry are given here, other details of letter proportion and shape are the same as discussed previously.

Letter 'B 'is composed of two circles. In order to improve the stability of the letter, the bottom bowl needs to be slightly larger than the top bowl. The squares containing the circles are aligned left and their diagonals cross to give the centres from which to construct the circles.

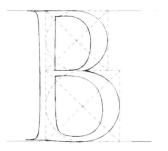

Roman capital 'B' drawn on a simple geometrical basis.

Letter 'G 'has one large circle for the main outline. The inside curve is given by constructing two vertically overlapping circles of the same size. The radius of these is found by first drawing a small central circle with a radius of approximately one stem width. A point on the circumference vertically above the centre gives the centre and radius of the upper circle, and a point on the circumference vertically below the centre gives the centre and radius of the lower circle. The left sides of these two circles provides the line for the inside of the 'G' curve. The outer curve of the 'G' is slightly compressed from the circle.

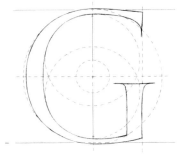

Roman capital 'G' drawn on a simple geometrical basis.

Letter 'M' can be constructed on the basis of a square, with half the width of the square giving the mid-point of the lower point of the V-part. The diagram overleaf shows the alignment of the outer edges of the 'M' supports relative to

the sides of the square, and indicates (with a dotted line) the importance of keeping the points of the counters level.

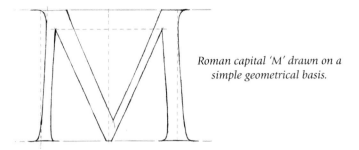

Roman capital 'M' drawn on a simple geometrical basis.

Letter 'O' is constructed like the 'G', with the right and left sides of the two vertically stacked circles giving the right and left inner curves of the 'O'.

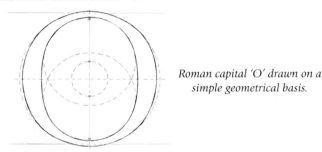

Roman capital 'O' drawn on a simple geometrical basis.

Letter 'R' has the bowl contained inside a square, with sides slightly longer than half the letter height. By extending the edge of the square to the baseline and drawing a line through to the top-left corner, the left-hand line of the tail can be found.

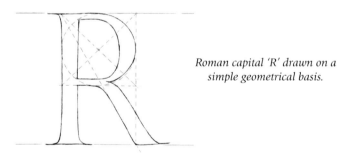

Roman capital 'R' drawn on a simple geometrical basis.

Letter 'S', like 'B', is composed of two circles, with the bottom circle being larger than the top one to improve stability. In 'S', the squares containing the two circles are aligned right, which gives a slight forward momentum.

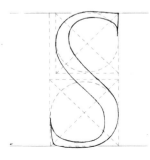

Roman capital 'S' drawn on a simple geometrical basis.

Tom Perkins, 'Easby House', V-incised York stone house sign.

An Alternative Proportioning System

When making formal Roman capitals, proportion is one of, if not the key element. In his writings Formal Penmanship (edited by Heather Child, see Bibliography), Edward Johnston describes:

> …the three abstract qualities … constituting legibility…Simplicity: that is, having only necessary parts. Distinctiveness: that is, having marked features. Proportion: that is, having each part of its proper value. (1971, p.49)

There are many possible ways in which classical Roman capitals could have been proportioned, and, as far as I am aware, there is no original documentary evidence to support any particular system.

Drawn Roman capital 'A' using root rectangles.

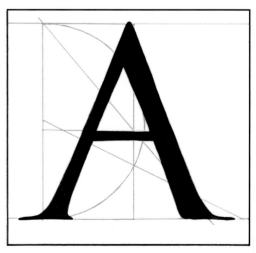

The following is presented as a possible way of proportioning Roman capitals and is a result of my ideas that some of the finest Roman inscriptions, such as the Trajan column inscription, could have been proportioned by being based on a particular root rectangle in combination with the square and the golden rectangle (a golden rectangle can be defined as a rectangle in which the short side can be expressed as one unit and the long side as 1.61803). I have applied these ideas to all the letters of the Trajan column inscription, and the Appian Way inscription (to the children of the freedman Sextus Pompeius), and find that this system fits the letters accurately.

The main point is that if you want to recreate the Trajan Roman letters accurately, this system enables you to do so. Simply writing the letters with a chisel-edged brush – a method most probably used for the setting-out of the Trajan inscription – will only determine how the weight is distributed around a particular letterform. It will not determine, on its own, the fundamental structure of the letter – something that is frequently overlooked.

All the letters of the original Roman alphabet (which excludes 'J', 'U' and 'W' – either the letters themselves, or the forms we currently use for them), I discovered, can be accurately proportioned using the square, golden rectangle and the root-five rectangle (which can be divided into a square plus two golden rectangles), either singly or in combination.

Curiously enough Father Catich, the American calligrapher, letter carver and authority on the Trajan inscription who carried out detailed surveys of it during his studies in Rome in the 1930s, gives the size of the Trajan inscription (including the moulding round the edge) as 4ft 5¾in (1.35m) high, by 10ft (3m) wide. This size for the panel of marble that contains the overall inscription is almost exactly a root-five rectangle. This could be simply a coinci-

dence, but given the preponderance of the root-five rectangle as a key to the proportion of the letters, it seems it may not be purely accidental.

Constructing a Square, a Golden Rectangle and a Root-Five Rectangle

In order to understand how to apply this proportioning system to the letters, one obviously has to know how to construct accurately a square, a golden rectangle and a root-five rectangle.

A SQUARE

Although a square can be constructed, the simplest method is to make a square using a set square, ruler and pencil. When you draw the square it should be the same height as the intended capital height – it is suggested that this should be a minimum of 5cm (2in).

A GOLDEN RECTANGLE

When constructing a golden rectangle, for reasons that will become obvious when applying it to the letters, use a golden rectangle that is arranged laterally and has a height that is half the intended letter height. For construction of a golden rectangle, see the diagram overleaf.

Start by drawing a square, ABCD, with sides the length of half the intended letter height. Join A to C and B to D, to give two diagonals intersecting at the mid-point E. Next, draw a vertical line through E and parallel to AD to give a point at F, which is halfway along the side DC. Using compasses and FB as a radius, draw an arc to the extended baseline at G. Draw a perpendicular from G to meet the extended top line AB at H. The resulting rectangle – AHGD – is a golden rectangle.

A ROOT-FIVE RECTANGLE

To construct a root-five rectangle of the same height as your letters, refer to next page. Begin by drawing a square, ABCD, with sides the same height as your intended letters. Find the mid-point of the side AD at E. With centre E, using compasses, draw a semi-circle on the side AD. Draw a line from E to C, which will intersect the semi-circle at F. Draw a line vertically through F, parallel to the side AD, to give GH. The rectangle AGHD is a root-five rectangle.

Notice that the width of this rectangle is slightly less than half its height. Figures overleaf show how a square can be placed within the root-five rectangle, either at the top or the bottom. This is important for positioning horizontals in 'E', 'F', 'A', 'B', 'P' and 'R'.

Proportioning system for Roman capitals using dynamic symmetry. This diagram is a matrix that holds all the information that the letter maker needs before setting out and proportioning his letters on the stone. It could have been drawn or scratched onto a small spare piece of stone and a scale then made from this with the appropriate measurements transferred onto the scale. Or, alternatively, dividers could have been used to take off the relevant measurements. By referring to 'construction basics' you should be able to decipher this construction quite easily.

Construction of a root-five rectangle in a square.

Construction of a golden rectangle.

Position of the square in the top of a root-five rectangle – as required for letters B,E,F.

Position of the square in the base of a root-five rectangle – as required for letters A,P,R.

A root-five rectangle is a square plus two golden rectangles.

Two golden rectangles, vertically stacked.

Constructing a rectangle composed of two golden rectangles the same height as the letter height.

Trajan Roman Capitals

The letters shown overleaf have a vertical stem width to height ratio of 1:10, demonstrated for example by the letter 'I', and are based on the Trajan column inscription, which has a stem to letter height ratio very similar to this.

For drawing these capitals, the procedure is similar to that already described for Roman capitals, and therefore only major differences will be pointed out here. Note that as with all classical Roman capitals, the horizontal strokes are approximately half a thick stem in width, thick diagonals are a thick stem in width, and thin diagonals can be made to match the thickness of the horizontals, or can be fractionally thicker.

Ideally curves, at their thickest, should relate to the thicker top (or bottom) part of a stem, rather than the thinner middle of a stem, and at their thinnest, should be fractionally thinner than the width of a horizontal stroke.

It is important to note also that in Trajan Roman capitals and the capitals shown overleaf, based on the proportioning system being described, that thick and thin diagonals on the letters 'M', 'N', 'V' and 'W' are not concave in the middle like stems, but have parallel curved sides, pulled slightly downwards, as illustrated.

The Trajan Proportioning System

In this proportioning system, using the three basic forms (the square, the golden rectangle and the root-five rectangle) either singly or in combination, the letters can be divided into five-letter width groups.

LETTERS M, O AND Q: PROPORTIONED ON THE BASIS OF A FULL-HEIGHT SQUARE

Letter 'M' is drawn by finding the mid-point at the base of the square and drawing diagonal lines from that point to the top corners of it, which gives the outer lines for the middle V-shape of the 'M'. Note that all the points are slightly rounded-off, and also note the parallel curves of the V-part of 'M'.

Letters 'O' and 'Q', as with all curved forms, have the top and bottom cutting slightly through the top and bottom capital height lines. If the outer contour of the 'O' or 'Q' was left as a perfect circle, its diameter would be wider than the width of a square, so the sides of 'O' and 'Q' have to be very slightly compressed to fit into the width of the square – this accords with the slightly compressed 'O' and 'Q' of the Trajan inscription. It should be noted that the oval-shaped counter of 'O' and 'Q' is very

slightly tilted backwards, which sets a pattern for the other curved letters.

LETTERS X, L, S AND K: PROPORTIONED ON THE BASIS OF THE HALF SQUARE

This geometric construction can be seen as two smaller squares stacked on top of each other, and also can be called a root-four rectangle.

Letter 'X' is started with the diagonals drawn from corner to corner of the half-square. The diagram overleaf shows that the diagonals diverge slightly from this, beyond the half-square. The weighted 'X' has a slightly smaller top than bottom counter.

Letter 'L' is essentially half-square in proportion. Note that the bottom left-hand serif is slightly raised above the baseline; also note the rounded inside join of the horizontal to the stem.

Letter 'S' has its bottom curve that should fit into the half-square width, and the top of the 'S' is slightly narrower on the left side. This creates more space in the bottom counter and gives the letter a slight forward lean.

Letter 'K' has the insides of its diagonal strokes approximately relating to the diagonals of the top and bottom squares. The strokes should join the stem at a point fractionally above the centre line. The left-hand side of the rectangle coincides with the right side of the stem.

LETTERS F, E, B, AND P: PROPORTIONED ON THE BASIS OF THE ROOT-FIVE RECTANGLE

Letter 'F' coincides with the root-five rectangle, and the lower horizontal arm is slightly narrower. The top of the lower arm is located by placing a square in the top of the root five rectangle.

Letter 'E' is drawn on a similar basis to 'F'. Note that the serif on the bottom horizontal projects slightly beyond the root-five rectangle. As for 'L', note the rounded inside join of base to stem.

Letter 'B' has the outside contour of its top bowl as the width of the root-five rectangle. By placing a square in the top of the root-five rectangle, the level for the top of the middle horizontal stroke is found. The inside of the bottom bowl of 'B' coincides with the width of the root-five rectangle. Note the rounded inside join of base to stem, and also the horizontal serif raised slightly off the baseline, as for 'E' and 'L'.

SQUARE

HALF SQUARE

ROOT FIVE

GOLDEN RECTANGLE

GOLDEN RECTANGLE

ROOT FIVE | ROOT FIVE

Drawn Trajan capitals.

Drawn Trajan capitals.

Letter 'P' is different from the preceding letters in this group, in that the square is placed in the bottom of the root-five rectangle, which gives the depth of the bowl. The root-five rectangle gives the width of the inside counter of the 'P' bowl.

LETTERS A, T, R, H, Y AND Z: PROPORTIONED ON THE BASIS OF TWO GOLDEN RECTANGLES STACKED VERTICALLY

Letter 'A' is started by constructing a root-five rectangle (ABCD) and placing a square in the bottom of it (EFDC) (see page 80, final diagram). The remaining rectangle thereby created in the top of the root-five is a double golden rectangle (ABEF), and by projecting the diagonal from its top-left to bottom-right corner and beyond to the baseline, this locates a point on the baseline from which to draw in the perpendicular HG. This forms a rectangle that is a double golden rectangle, AGDH, as used for the other letters in this group.

Using the top of the square in the base of the root five rectangle, the top of the 'A' cross bar can be located. Note that, as for 'M', the apex is slightly rounded.

Letter 'T' is the width and height of the double golden rectangle. The right-hand serif of the crossbar is kept more or less vertical, and the left-hand serif is slightly inclined.

Letter 'R', like 'A', is started with a root-five rectangle, with a square in the base (see page 80, final diagram). The diagonal is drawn in the remaining top rectangle, as for 'A'. This gives the alignment of the 'R' tail (which is dropped down slightly from this diagonal) and creates a width across the base which is equivalent to the width of 'A' and 'T' (that is, the width of the golden rectangle). The inside of the 'R' bowl coincides with the width of the root-five rectangle.

Letter 'H' fits into the double golden rectangle, and the bottom of the crossbar is at mid-height.

Letter 'Y' has a vertical stem that meets the V-part at mid-height. The form shown on the previous page is drawn without inner serifs.

Letter 'Z' fits the width of the double golden rectangle at its base, with the serif ending just outside. The bottom-left point of 'Z' is raised slightly off the baseline, which gives it an affinity with the horizontal base strokes on 'E' and 'L'. The top horizontal is slightly inside the double golden rectangle. Note the parallel curves of the diagonal.

LETTERS N, V, C, D AND G: PROPORTIONED ON THE BASIS OF THE DOUBLE ROOT-FIVE RECTANGLE

Letter 'N' fits into the width of the double root-five rectangle at its base, but is slightly narrower at the top, as the left support is slightly sloped – this is a vestige of an earlier Roman 'N' that has a more pronounced slope to this stroke. The two supports are here made slightly more than half a thick stem width to give some contrast between thick and thin; the Trajan form has very little contrast between the supporting strokes and the diagonal. The 'N' on the Trajan inscription is very wide, and in a modern design 'N' would probably be fitted into a double golden rectangle, which is slightly narrower. Note the parallel curves of the diagonal.

Letter 'V' fits into the double root-five rectangle at its top. It has a rounded-off point at the base. The serifs on the inside of the 'V' are less pronounced than those on the outside. Note the parallel curves of both diagonals.

Letter 'C' fits into the double root-five rectangle, and the bottom serif is inclined and slightly inside the line of the top serif. Remember to incline the counter slightly backwards, as forr the 'O' and 'Q', and to keep the top and bottom curves subtly flattened and cutting slightly through the top line and baseline.

'Letter 'D' also fits into the double root-five rectangle. Note the rounded-off join where the curve meets the stem base, and the slight lift of the serif off the baseline as for 'E', 'L' and 'B'. Keep a slightly tilted inside counter, as for 'O', 'Q', 'C' and 'G'.

Letter 'G' is similar to 'C' with the addition of the vertical stem, which finishes at mid-height. Note the low join of the base curve to stem, and the slightly tilted inside counter.

OTHER LETTERS

Letter 'I' obviously has no appreciable width.

Letters 'J', 'U' and 'W' were not present in these forms in the original Roman alphabet and these are suggested possibilities:

- ■ Letter 'J' can be fitted into a root-five rectangle at its base.

- ■ Letter 'U' can fit into a double golden rectangle. The verticals can be made one full stem width thick, or as shown, with the right-hand side narrower.

- ■ Letter 'W' is here fitted into a square with a root-five rectangle added onto the right-hand side. The diagonals are all parallel curves. All of the apexes are slightly rounded points.

For information about proportioning systems for Roman capitals different from the one detailed here, see Grasby, 2002 (details in Bibliography).

Diagram to show 'sliding' the scale across to determine letter width.

B C = C D

Paper or card scale bar for ascertaining proportions during construction. All the key points can be located with this scale. This sometimes means using AD twice in order to obtain a square, or AB twice in order to obtain the width of 'T 'or 'H'.

Drawing Trajan Roman Capitals Using a Simple Scale

These letters are the same proportions as just explained in the alternative proportioning system, but are instead drawn by using a simple scale. Although this gives an accurate result, it does not provide the understanding of letter proportions that the alternative proportioning system gives. The sample letters illustrated using the scale bar give a guide that is useful for many of the other Roman capital letters of the same alphabet not demonstrated.

Take a strip of paper long enough to mark half the letter height on it (the two outside marks on the strip). Measure back from the right-hand mark a stem width (one-tenth of the letter height), and then mark the centre of this stem width, which gives the four marks on the scale bar. To complete the alphabet by this method, refer to the letter group diagrams for the alternative proportioning system (see page 82, 83) to find the key points on each letter for applying the scale bar.

Using the scale bar to determine the width of letters and points of division within letters. Roman capital 'S'.

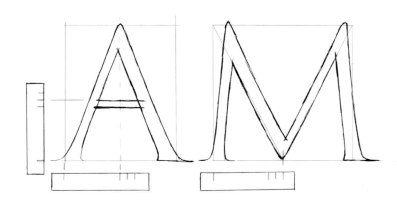

Using the scale bar, Roman capitals 'A,M'.

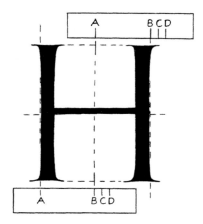

Using the scale bar, Roman capital 'H'.

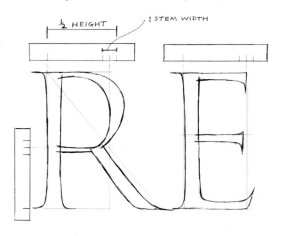

Using the scale bar, Roman capitals 'R,E'

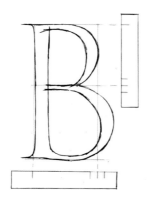

Using the scale bar, Roman capital 'B'.

Using the scale bar, Roman capital 'G'.

Drawn Modern Sans Serif Capitals

These capitals are particularly useful for letter carving and other applied lettering, as they have the elegance of classical forms combined with a contemporary feel. The sans serif capitals illustrated are two of many possible modern drawn capital forms.

It may be helpful to compare the letters in a single line for both alphabets. One consists of more static, classical Roman capital shapes, the other is a development based on a flared 'O' form, shown constructed later on. This gives a dynamic to the basic 'O' form. Other curved letters and curved parts of letters are adapted to work with this 'O' shape as necessary; they are therefore not strictly related to the 'O' but have an affinity with it.

Note that the capitals based on the flared 'O' lean forwards slightly, and that the horizontal strokes move upwards slightly to the right. The 'C', 'G', 'S' and 'U' are based on a parabolic shape; these factors help to create a dynamic or sense of movement to the letters.

The letter width groups are the same as for classical Roman capitals. To draw the classically proportioned

The Appian Way Inscription

Roman capitals alphabet based on the Appian Way inscription, Rome.

Also illustrated above is an alphabet based on the memorial inscription to the Children of the Freedman Sextus Pompeius on the Appian Way, Rome, dated the first or second century AD.

These are proportioned in a very similar way to the Trajan capitals, the main difference being that they are a heavier weight, having a stem width to letter height ration of 1:8.

The 'B' is based on a half-square rather than a root-five rectangle, thus making a slightly wider letter, which is necessary as otherwise the weight impinges too much on the top bowl. The 'A' has got an angled cut-off top, and the 'M' and 'N' have serifs – all features of the Appian Way inscription.

sans serif capitals, note that the stem width to letter height ratio is approximately 1:10, and that 'horizontals', thin diagonals and thin supports of 'N' and 'M' are approximately half a stem width in thickness. As for classical Roman capitals, the straight strokes are drawn with slight concavity at the waist.

To draw the more dynamic variation, the stem width to letter height ratio is also approximately 1:10; the thin horizontals, diagonals and thin supports of 'N' and 'M' are approximately half a stem width; and straight strokes are waisted. Though the 'O' can be geometrically constructed

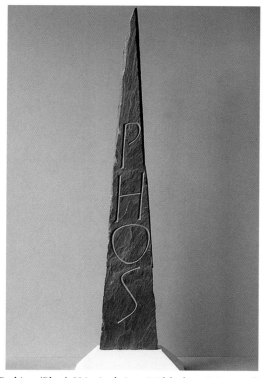

Tom Perkins, 'Phos', V-incised riven Welsh slate. Private collection.

'R, Q, E': drawn dynamic capitals.

Richard Kindersley, Keele University, Staffordshire, new entrance with 70cm letters carved into brickwork and dyed in situ.

AABBCC
DDEEGG
HHKKMM
NNPPQQ
RRSSUU
TTVVXX
YYZZ

Comparison of monoline Roman capitals and monoline modern sans serif dynamic capitals.

IHTEFL
VAYKN
ZXWM
OQCG
DU&JJ
PRRBS

Drawn sans serif capitals alphabet.

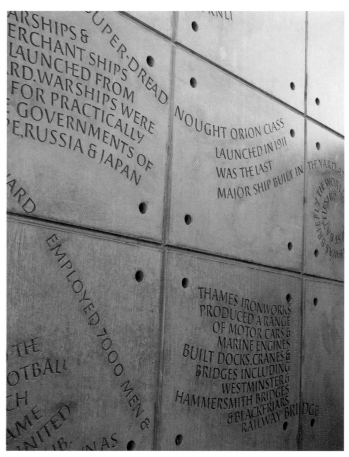

Richard Kindersley, London Underground Jubilee Line. Public arts commission for Canning Town station. Carved concrete inscriptions celebrating local history, flowing down three levels of the station.

Drawn dynamic capitals alphabet.

Construction of dynamic 'O' shape by Tom Perkins.

(see right), these letters have all been drawn freehand. Points to note in particular are that the 'O' has three thin points, and the weight is lifted towards the top half of the letter, subtly gradating towards the thin points. Other letters with curves relating to the 'O' are 'B', 'D', 'P' and 'R'. Other letters with curves – 'C', 'G', 'S' and 'U' – have a more parabolic shape. The 'S' can be seen as two parabolas on top of each other, going in different directions. For the remaining letters, the proportional structure is basically classical Roman.

Flared 'O' Shape

Interestingly, this flared 'O 'shape forms the geometrical basis of a number of stone circles, as discovered by Alexander Thom over a lifetime's research described in Megalithic Sites in Britain (see Bibliography).

In his book Pi in the Sky (see Bibliography), Michael Poynder says that the flattened-circle type 'B'

…uniquely embodies the Pythagorean paradigm of three worlds. This is formed by three circles whose circumference pass through each other's centres.

Such examples as 'Castle Rigg' (Keswick, Cumbria) and 'Long Meg and her Daughters' (Cumbria) are described in A Book of Coincidence by John Martineau (see Bibliography).

The diagram above shows one way of constructing the

'Spanish', drawn heavyweight dynamic capitals.

'Foundation', drawn dynamic capitals.

'Rus in Urbe', drawn dynamic capitals.

flared 'O'shape, arrived at after study of various stone circle geometrical construction possibilities shown by Thom and Martineau.

It is also possible to design a capital alphabet based on a compressed and squared flared 'O' form. As with the full, flared form above, the curved letters and parts of letters relate to the 'O', but require slight modification to produce satisfactory forms.

It has also been of interest to me to note that similar flared 'O' shapes, arrived at intuitively, have appeared in contemporary sculpture, notably in the work of Barbara Hepworth, as seen in 'Pierced Form' (Epidauros), 1960, which forms part of the permanent exhibition at her studio in St Ives, Cornwall.

The examples above show sans serif capital letters relating to the dynamic 'O' shape used in wording.

Drawn Roman Lower Case

The Roman lower case in use today in typography and applied lettering derives from Renaissance Humanist minuscule, and since the Renaissance the design of the letters has gone through many adaptations, resulting in a wide variety of Roman lower-case typefaces. The hand letterer has many possibilities open to him in creating subtle variations for use in letter carving.

Kevin Cribb, 'Platanus Orientalis', V-incised Welsh slate. In the Fellows' garden, Jesus College, Cambridge, 1989. 49 × 56cm.

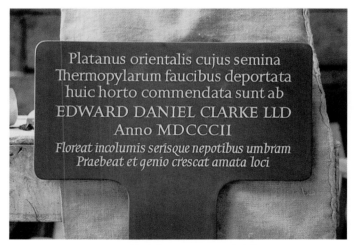

Kevin Cribb, 'Platanus Orientalis' slate.

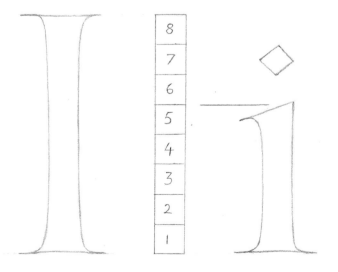

Diagram showing the height relationship of Roman lower case to Roman capitals.

Height of Letters

The height relationship of Roman lower case to Roman capitals can be found by dividing the capital height into eight equal parts, the relationship being 5:8. This gives a lower-case stem width, such as in the letter 'i', that fits five times into the lower-case letter height.

The body height of any lower-case letter is referred to in typography as the x-height. The origin of this term is due to the fact that in type, the traditional Roman lower-case 'x' has horizontal top and bottom serifs coinciding with the top and bottom lines, giving a clear indication of the letter height.

A more simple method of obtaining the lower-case x-height is to divide the capital height into three equal parts and make the lower case two-thirds of the capital height. This gives a slightly higher lower-case letter body in relation to the capitals, which is not quite so satisfactory to my eye as the first relationship.

DRAWING ROMAN LOWER CASE

It has already been pointed out that when first learning to draw Roman capitals, it is advantageous to use an underlying geometrical structure to learn accurate forms and proportions. This structure only works accurately for letters that are relatively lightweight, that is, with a stem width to letter height ratio of between 1:8 and 1:10. Once letter weight becomes heavy, the weight prevents the letterforms from fitting into the underlying geometrical structure of the circle, square, rectangle or half square.

One can also draw the lower-case letters with the aid of an underlying geometrical structure if their weight is light; that is, also with a stem to letter height ratio of between 1:8 and 1:10.

However, this would make them appear rather lightweight for carving, and the lower-case alphabet shown right has therefore been drawn freehand. In order to draw these letters accurately freehand it is important to have a sound understanding of letter weight and its distribution round the form, letter proportion, and other aspects of related form, which are explained here for the individual letters.

The stem width to x-height ratio shown here is 1:5, in order to make stems the same weight as the Roman capitals. Note that lower-case stems have the same subtle concavity as Roman capitals. When drawing letters it is logical to draw left strokes before right to facilitate letter spacing though, to some extent, stroke order is a matter of individual choice. Letters with stems on the left of the letter (such as 'b' and 'h') are generally started by drawing the stem. Letters with stems on the right side, such as 'd' and 'q' would start with the bowl. Letters such as 'v', 'w', 'x' and 'y' would start with the drawing of the thick diagonals. For the tops of 'o' and 'g', either the outer circular contour or the inside oval can be drawn first.

Letter 'o', along with 'i', is for most alphabets a key form for drawing the rest of the letters. Here the 'o' has a circular outer contour, not slightly flattened like the capital 'O', because it is a necessarily heavier weight when lower case, and flattening the 'o' sides would necessitate narrowing the counter, which would make the letter look too squashed. The lower-case 'o' has a vertical stress; that is, the thinnest parts are vertically above one another, and

Jack Trowbridge, 'Edward Johnston' plaque. Aberllefenni blue-black Welsh slate. Fixed to the wall at the site of the Johnston studio in Lewes Road, Ditchling, Sussex. Commissioned in 1979 by the Ditchling Handworkers' Guild. 45cm diameter. (Photo: Michael Ockenden)

Tom Perkins, Pembroke College, Cambridge, V-incised and painted Welsh slate roundel (detail).

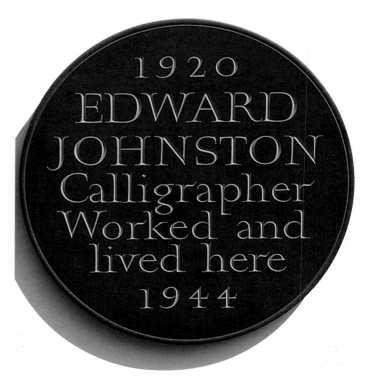

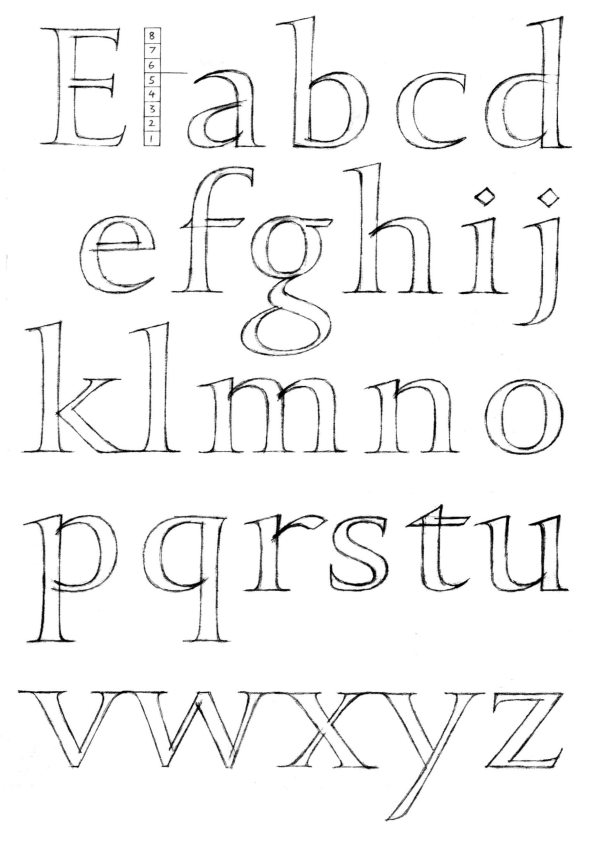

Drawn Roman lower-case alphabet.

the thickest parts are horizontally opposite each other at mid-letter height.

The counter is a flattish-sided, smoothly flowing squared-off oval. The top and bottom of the letter marginally cut through the top and bottom lines to prevent the 'o' from looking smaller than the rest of the alphabet. The 'o' is subtly gradated from thick to thin parts.

Letter 'i' is a stem width thick, maintaining the subtle concavity present in the Roman capital stems. It has an angled serif at the top, and a thin horizontal foot serif. I have made the dot diamond-shape as this is easier to carve than a circular dot. The dot is placed midway between the top of the x-height and the capital height, though there is some flexibility here.

Letter 'l' is a stem width thick, with an angled top serif, and the letter is slightly higher than a capital. Letters or parts of letters that ascend above the top x-height line are termed 'ascenders'.

Letter 'a' has a width approximately four-fifths of its height, with the bowl being slightly more than this and the top slightly less. The vertical is a stem width thick, tapering to a point at the top left and finishing at the base with a fine horizontal serif to the right. The diagonal of the bowl starts thin, two-thirds up the x-height, gradually widening out to reach its greatest width – slightly more than a stem width – below the centre of the bowl, tapering to a point where it joins the stem. The shape of the top and bowl relate to the origin of the form, written with the broad-edged pen during the Renaissance, as shown below.

Letter 'b' has an ascender, which as for all letters with ascenders is just over capital height, with a slanting top serif. The width of the letter is almost as wide as the x-height. The stroke of the bowl reaches maximum width, which is slightly more than a stem width, at halfway up the x-height and tapers to a point where it joins the stem at the top. It tapers to less than half a stem width at the base, slightly flaring out to join the stem.

Letter 'c' is slightly narrower than 'b', reaching its maximum width at halfway up the x-height. The main curve is fullest at this height also, tapering to a point at the bottom right, and tapering into the top curve to just under half a stem width, flaring out subtly at the end, to finish with a fine vertical serif. The top and bottom open ends align vertically.

Letter 'd' is the same width and height as 'b', the bowl being the same shape and proportion but reversed and upside down.

Letter 'e' is slightly wider than 'c', due to the weight top right. It is practically as wide as it is high. The base tapers as for 'c', the horizontal stroke is approximately half a stem width thick, and lies just above centre. The top right side joins the horizontal, and in order to give a balance, is the same width as the left side of the 'e' at the same level.

Letter 'f' is the same height as the other ascenders and the vertical is a stem width thick, tapering above the x-height gradually towards the point where it curves into the horizontal top, and it then flares out subtly, ending in a fine vertical serif. The width of the 'f' top is just over two-thirds of the x-height. The top of the horizontal crossbar is on the x-height top line, and is approximately half a stem width thick. Note that it is rounded off on its underside as it ends.

Letter 'g' has a circular top bowl with a width approximately four-fifths of the x-height. Although similar in shape to the 'o', it is smaller and sits well above the baseline. The horizontal 'ear' is just under half a stem width thick and should not extend beyond the bottom oval bowl, which has a width of just under one and a quarter times the x-height.

The diagonal stroke connecting the top bowl of the 'g' to the oval bottom bowl is thin – less than half a stem width – gradually thickening to a stem width as it curves to form the right diagonal of the bottom oval bowl. This stroke tapers into the thin, horizontal base curve, which flares out to form the left side of the base oval, reaching its maximum weight halfway up the oval.

Roman lover case 'a' written with a broad-edged nib.

Tanja Bolenz, 'Cefntrenfa', V-incised and painted Welsh slate house sign, 1993. 7.5 × 50cm.

The thick diagonal is a stem width, flaring out subtly at either end to finish in fine horizontal serifs. The thin diagonal is half or slightly less than half a thick stem in width, and flares at either end to finish with fine horizontal serifs.

Letter 'y' is the 'v' form with the thin diagonal extended down to the descender line and slightly flaring out to finish.

Letter 'z' is the same width as 'h' and 'n'. The thick diagonal is a stem width, with the thin horizontals half a stem width or slightly less, flaring out subtly towards the open ends to finish with fine serifs (the top serif descending vertically, the bottom serif ascending at a slight outwards angle). The top serif lies just inside the bottom left point, and on the right side, the bottom serif projects slightly beyond the top point.

Variations

As for Roman capitals, the letter weight selected for lower case lettering will be affected by different design situations and different types of stone. The letters illustrated on P92 are at a lighter weight than those in the previous alphabet, and the stem width to x-height ratio is approximately 1:6, which relates to the lighter-weight Roman capitals (with a stem width to letter height ratio of approximately 1:10). The details of the drawing on P92 are similar to those explained for the bolder lower-case in the drawing details already described.

Modern sans serif lower case on P93 can be used to accompany sans serif capitals, or on its own. The alphabet shown has a stem width to letter body height ratio of approximately 1:6. Thin horizontals and diagonals are approximately half a stem width. Straight strokes are slightly concave in the middle. Drawing this alphabet is substantially the same as drawing the Roman lower-case letters.

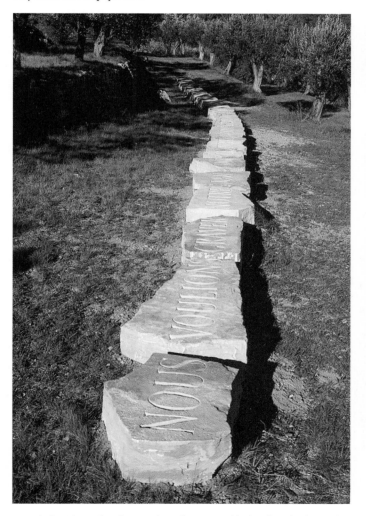

Nicholas Sloan, 'Declaration', 25 large, raw blocks of Purbeck Royal, bearing between them an inscription from Jules Michelet, 1789: 'nous voulions graver sur la pierre du droit eternal sur le roc qui porte le monde l'invariable justice et l'indestructible equite'. 1997.

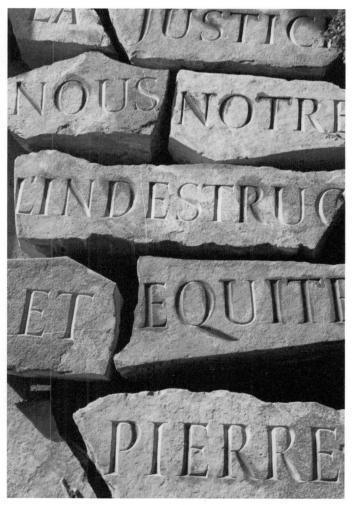

Nicholas Sloan, detail of 'Declaration', unassembled blocks awaiting transport.

Tom Perkins, V-incised Welsh slate sign for the Crafts Study Centre, Farnham, Surrey. 2m high, 2004. (Illustrated by kind permission of the Crafts Study Centre, University College for the Creative Arts)

6

Drawn Lettering: Italic

Italic Capitals

Italic capitals are a forward-sloping, compressed version of Roman capitals, and can be used on their own or in conjunction with italic lower case – in the latter situation, the forward slope would match the lower case. If used alone, there is some leeway in the selected slope, and they can also be used nearly upright. Those illustrated overleaf have a forward slope of approximately 5 degrees. The stem width to letter height ratio is approximately 1:10, with straight stems being slightly concave at the waist. The width of letters varies, and letters can be grouped as for Roman capitals.

Group 1 : Rectangular Letters – H T U X Y N Z and A and V

These letters have a width at their widest point of approximately two-thirds of their height. Note that 'A' and 'V' are slightly wider, to compensate for their tapering form. The thickness of the horizontal strokes is approximately half a stem width.

Group 2: Curved Oval Letters – O Q C G and D

These letters fit into a sloping rectangle, with the 'O' and 'Q' having a width approximately four-fifths of the letter height. Although I have not designed these capitals with the use of an edged pen or double pencils, the incidence of thicks and thins in this example (see overleaf) has an understood calligraphic influence, as has the italic lower case – both the formal, and to a greater extent, cursive versions.

'Lady': example of drawn italic capitals from a memorial.

'William': drawn italicised capitals, generous letter spacing.

QUARE PREVIOUSLY NAMED ST PAUL
ALLED BY THE PEOPLE OF SHEFFIELD
NS & WAS DEDICATED AS SUCH ON
N 6TH AUGUST 1985 IN THE PRESENC
USHA. SURVIVORS OF THE ATOMIC DE
HE CITY OF HIROSHIMA · IT WAS RE
BRATION OF THE SECOND MILLENN
EDEDICATED IN THE NAME OF PEA
ECEMBER 1998 BY THE CHUR
BLESSED ARE

Tom Perkins (assisted by Gareth Colgan), V-incised Cumbrian green slate dedication plaque, Sheffield Peace Gardens, Sheffield City Centre, 1998. 100 × 200cm.

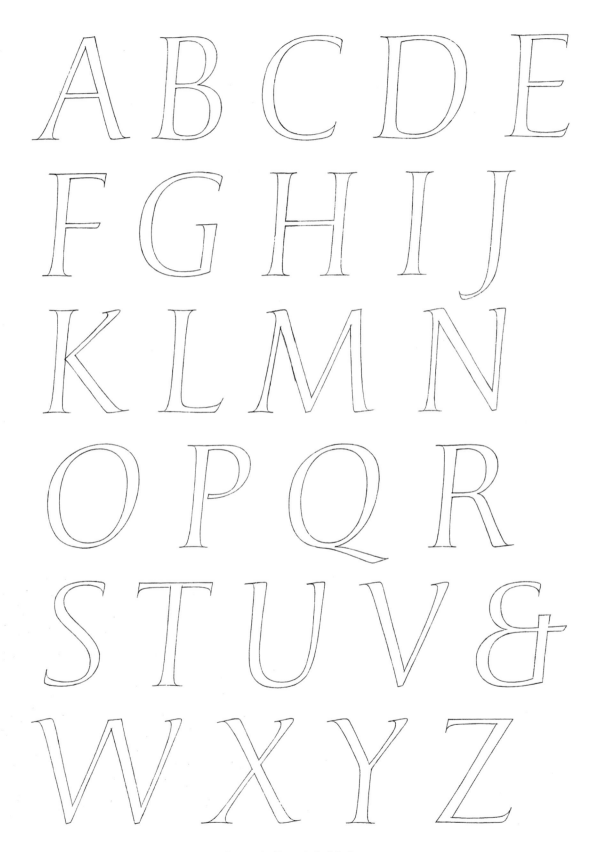

Drawn italic capital alphabet.

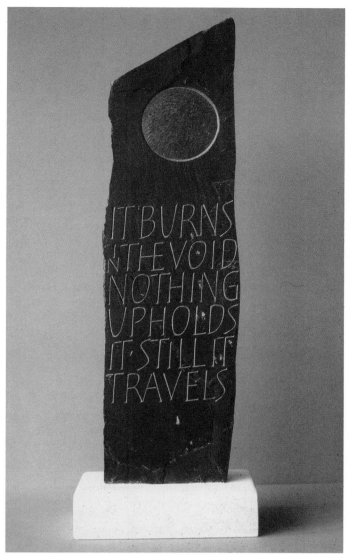

Tom Perkins, 'It burns in the void…', V-incised riven Welsh slate, 1993. 60 × 20cm. From a poem by Kathleen Raine. (Reproduced by kind permission of Brian Keeble, the Golgonooza Press)

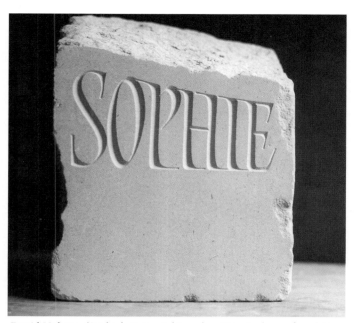

David Holgate, 'Sophie', memorial to a dog, V-incised on a found piece of Portland stone, 2003. 30 × 20 × 15cm.

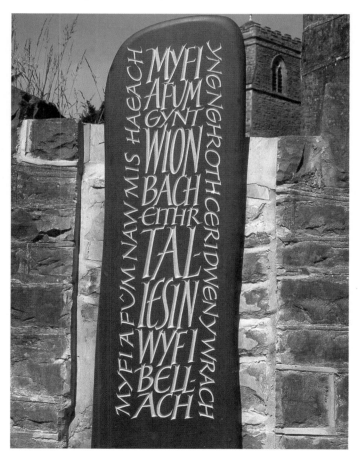

John Neilson, 'Taliesin', V-incised and painted Welsh slate. The text, in Welsh, tells of the legend of the birth of poet Taliesin. Located in Llanfair Caereinion town centre. Commissioned by Fforwm Llanfair Caereinion, 2000. 142 × 43 × 6cm.

The tail of 'Q' is best kept at a fairly shallow angle. In this example, 'O' and 'Q' have a somewhat squared-off oval shape (that is reflected in 'C', 'G' and 'D', which are made slightly narrower than 'O' and Q'), as with the Roman capitals.

Group 3: Narrow Letters – E F L P R B S and K

These letters have a width of approximately half the letter height. The 'R' and 'K' tails project beyond this width. Curved parts of these letters are somewhat squared off, relating to the 'O'. Note the different levels of letter 'middles', as for Roman capitals.

Group 4: Wide Letters – M and W

The width of the 'M' base is the same as the letter height, and the top right is sheared off but could have a serif as the top left if preferred. Discounting the fine serif, the bottom counters should be of equal width. 'W' has a width at the top of approximately one and one-third times the letter height. The sheared top join in the middle of the letter has the same shape as the 'A' top, and the serifs on the top left are slightly angled, as for 'V', 'X' and 'Y'.

Group 5: Very Narrow Letters – I and J

'I' sets the pattern for all the stems, having a slight concavity in the middle. 'J' descends slightly below the baseline, ending in a small serif, which I have inclined slightly outwards out of preference.

The capitals described here provide a useful alphabet for much letter carving work. They also give a basis from which one can experiment with more personal letterforms, as demonstrated in the alphabet illustrated opposite based on a compressed, dynamic 'O', in the examples of carved work P99 by John Neilson and David Holgate, and also in Chapter 8.

Drawn Formal Italic Lower Case

Italic lower case is very useful for the letter carver, either in conjunction with Roman or italic capitals or on its own. Characteristics of italic include lateral compression and forward slope – to begin with, 5 degrees is ample. The stem width to x-height ratio is approximately 1:5. Thin diagonals are approximately half a stem width, and curves at their thickest point are similar in width to the tops and bottoms of stems. Ascenders are slightly more than a capital height, and descenders are a similar distance below the baseline. Formal italic has similarities with sloping Roman lower case, whereas cursive italic, illustrated later, is based on a more quickly written form.

To draw these letters, other points to note are that the counters of 'b', 'd', 'g', 'h', 'n', 'p', 'q' and 'u' are approximately the same width, 'm' counters are slightly narrower, and the 'o' counter is slightly wider. Asymmetrical arches spring from high up the body height. The curved sides of letters such as 'b', 'c', 'd', 'e', 'g', 'o', 'p' and 'q' are parallel to the slope of the alphabet, that is the slope of the stems, and an imaginary line down the centre of the 'v' parts of 'v', 'w', 'x' and 'y' would also be parallel to the slope of the alphabet. Note also that

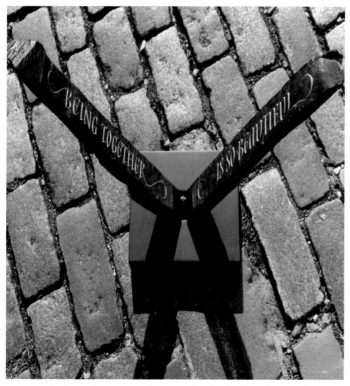

David Holgate, 'Being together…', V-incised Welsh slate, as found, 1998. Split and mounted on sprung hinges. This was a 'love' piece, normally closed. To read the text you had to open the piece, which then closed itself. 60 × 9 × 7cm.

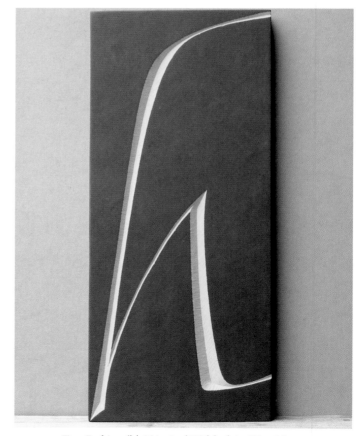

Tom Perkins, 'h', V-incised Welsh slate. 30 × 13cm.

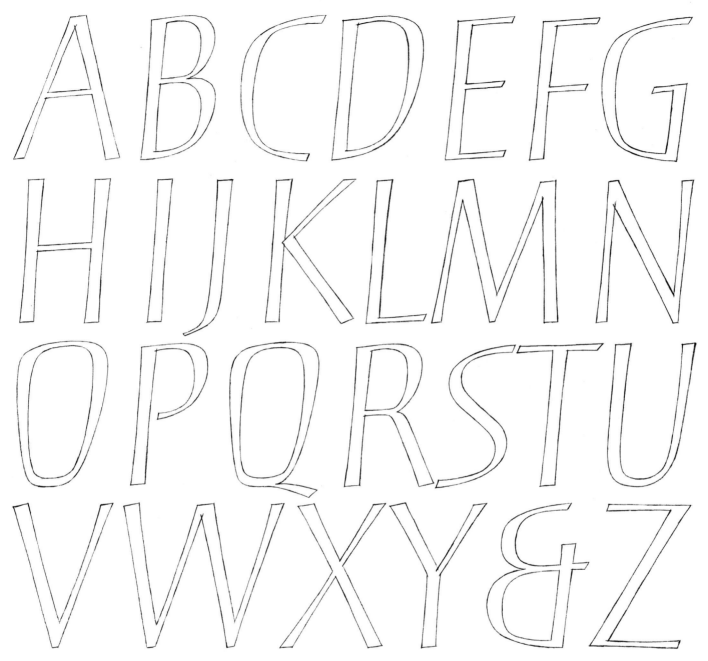

Drawn compressed and squared-off dynamic capitals.

Tom Perkins, V-incised Welsh slate opening plaque for Boots Millennium Sculpture Park. (Commissioned by Boots plc through 'Art for Work Ltd.')

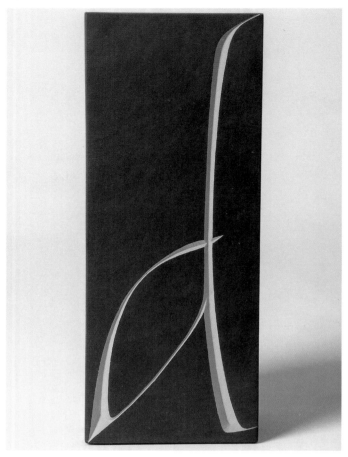

Tom Perkins, 'd', V-incised Welsh slate. 30 × 13cm.

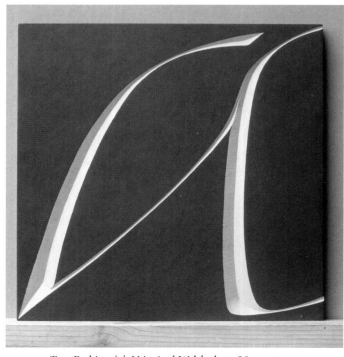

Tom Perkins, 'a', V-incised Welsh slate. 20cm square.

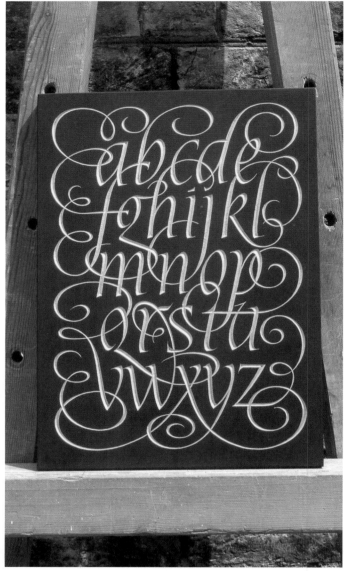

The Cardozo Kindersley Workshop, flourished V-incised and gilded alphabet in Welsh slate.

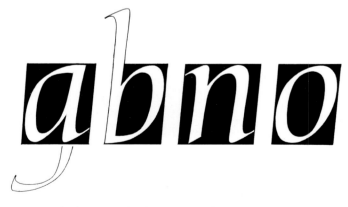

Drawn italic lower-case key letters 'a,b,n,o', reversed out to emphasize the shapes of the counter spaces.

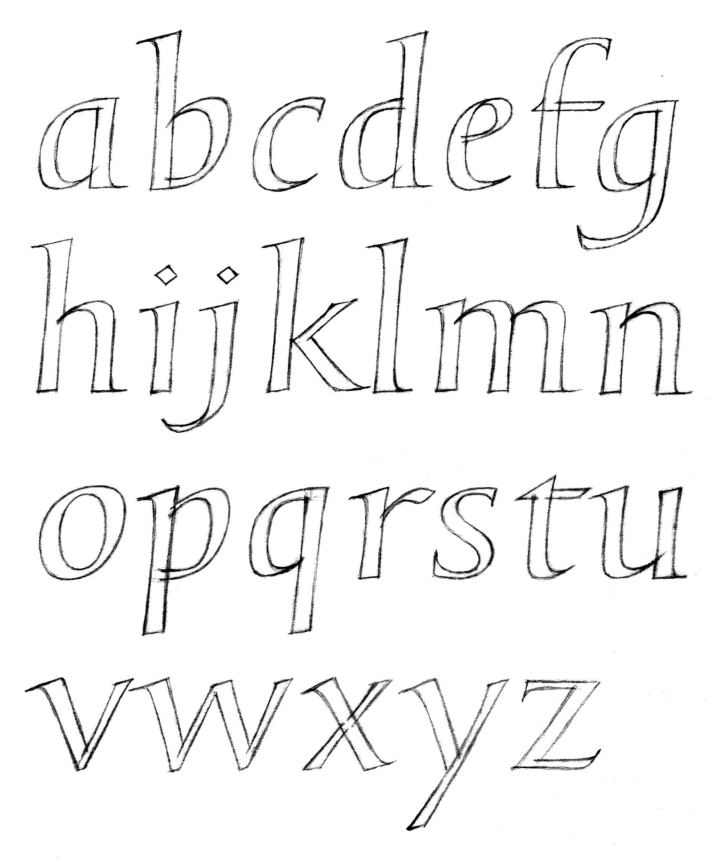

Drawn formal italic lower case.

abcdefghijklmnop

45°

Edged-pen italic lower-case alphabet.

qrstuvwxyz

Study Centre was provided by enerous benefactio from The Rayne Foundation and

Tom Perkins, detail from V-incised Welsh slate circular plaque

of The Executive

'of The Executive', part of inscription, drawn italic lower case.

Cursive Italic

The cursive italic shown overleaf, in addition to the lateral compression and forward slope of the more formal italic, has more flowing arches, which spring from approximately two-thirds of the way up the body height. The stem width to letter height ratio is approximately 1:6. As for formal italic, thin diagonals are approximately half a stem width and curves, at their fullest, similar in width to the tops and bottoms of stems. The letters can be drawn directly with a single pencil, following the alphabet illustrated overleaf and referring to guidelines for formal italic.

horizontal serifs have only been drawn on the final foot of arched letters 'h', 'm' and 'n' in order to leave the inside of the letters clear, though serifs could be drawn there also if preferred. The bases of 'i 'and 'r' have been drawn sans serif for preference. The right side of the 's' and left side of the 'z' have an alignment similar to the slope of the alphabet.

Drawn Formal Italic Sans Serif

The sans serif lower-case formal italic illustrated opposite has a letter stem width to x-height ratio of approximately 1:6, and would be used either alone or in conjunction with sans serif capitals – either based on classical Roman proportions, or compressed. To draw these letters, the main characteristics are similar to the formal italic letters with serifs. There are a few minor differences, such as the alternative form of 'e', as illustrated.

Use of the Edged Pen or Double Pencils

Though not essential, it is helpful to have an underlying knowledge of calligraphy, particularly for drawn italic, where such knowledge is very useful in understanding the letter shapes and distribution of weight round the form.

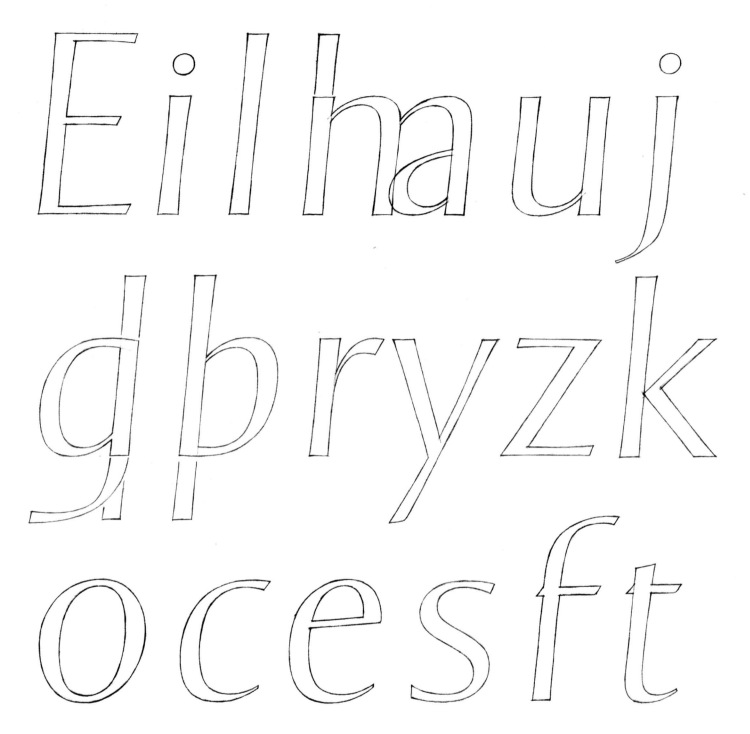

Drawn sans serif formal italic.

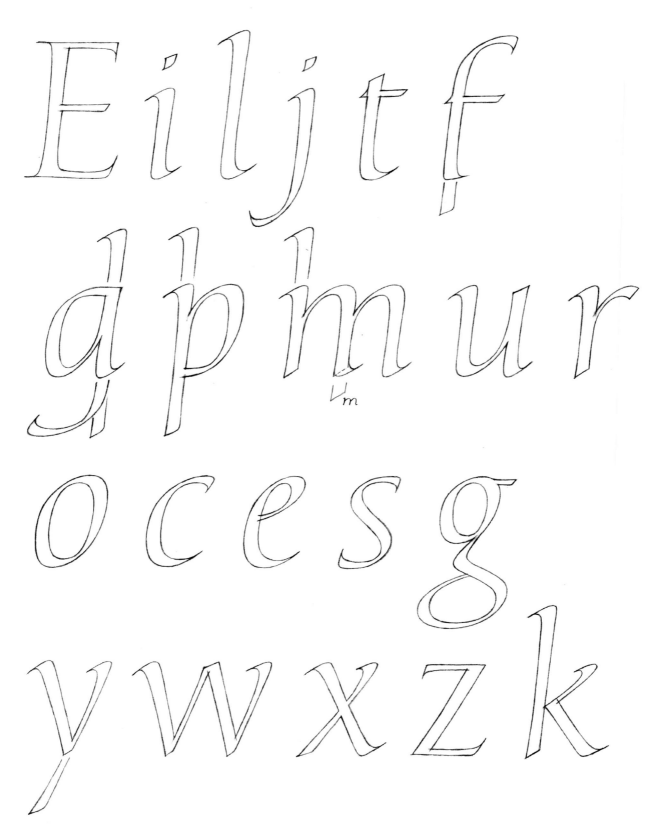

Drawn lighter-weight cursive italic.

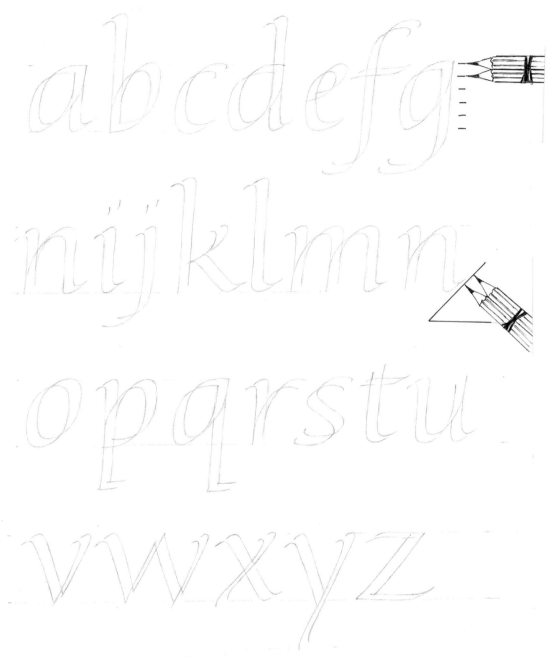

Double pencils italic lower-case alphabet.

The pen alphabet illustrated has an x-height of five nib widths (note that the nib edge is at 90 degrees to the horizontal line for measuring up the nib widths, as shown). The shapes made by the edged calligraphy nib can be duplicated by the use of double pencils: two pencils taped together with points parallel and held at a prescribed angle to the horizontal. (Note that the tips of the double pencils need to be at 90 degrees to the horizontal line for measuring up the x-height, which is five nib widths as for the pen alphabet.)

The sides of the pencils may need to be shaved down to bring the pencil points close enough. The distance between them should be equal to the width of a thick diagonal at right angles to the pen angle (40-45 degrees for italic). To find how far apart the pencil points need to be, divide the proposed letter height by five.

Given some knowledge of basic italic forms, double pencils will give a basis that can then be drawn over with a single pencil, and details modified for carving according to individual preference.

Sketches for monogram 'mw'.

THE
SECOND MILLENNIUM
OF CHRISTIANITY WAS
CELEBRATED HERE ON
THE SECOND DAY
OF JANUARY
2000

A thousand years earlier
Prior Aldwyn of Winchcombe
re-established monastic life
at the ancient sites of
Durham, Whitby and York
on his spiritual pilgrimage
to Northumbria in 1074
"This good and modest man"
died April 12th
1087

Eric Marland, Millennium tablet, V-incised and painted Welsh slate.

'Seems not…' drawn italic variation used on inscription for Boots Millennium Sculpture Park herb garden.

Adaptations to Double Pencils Letters

From the double pencils italic shown on P107 I have made the following modifications to give suitable forms for carving:

- The stroke endings and serifs at the top and bottom of letters such as 'a', 'b', 'd', 'h', 'i', 'j', 'k', 'l', 'm', 'n', 'p', 'q', 'r', 'u', 'v', 'w', 'x' and 'y' have been drawn at a slightly shallower angle than 40–45 degrees, as this looks preferable for lettering on this scale. The double pencils were not held at a shallower angle when making the alphabet in the first place, since the letters would have then been too heavy.
- The base of 'f' I have made even flatter as it makes the letter, with its projecting crossbar, appear more stable.

Other subtle adaptations and things to note include:

- Thickening up the thin curved strokes, such as where the arches of 'b', 'h', 'm', 'n', 'p' and 'r' leave the stem, the base turns of 'a', 'd', 'g', 'q' and 'u' where they join the stem, and also in 'f', 'j' and 's' where curved strokes meet.
- Sides of straight strokes such as stems and thin diagonals – particularly those in 'x' and' y' – have been drawn slightly concave.
- There are two possible forms of 'g', and the 'g' consisting of two ovals should have more space in the bottom than the top.

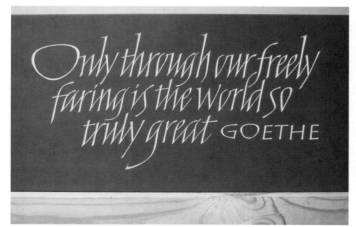

Tom Perkins, 'Only through our freely faring…', V-incised and painted slate, 1998. Quotation from Goethe. 20 × 41cm.

Personalizing Your Work

After acquiring a sound basic drawn italic for carving, there are many possibilities for creating your own more personal letterform variations through altering letter weight, slope, width, degree of softening or angularity, and perhaps combining softened and angular forms as shown in some of the examples in this chapter. The section previous illustrating letter variations with capitals indicates one approach for designing drawn letters for carving, and calligraphy can also make a fruitful contribution towards the design of your own forms.

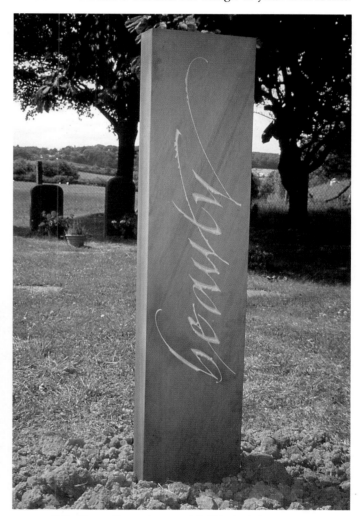

Julia Vance, 'Beauty', memorial, V-incised slate, 2004.

John Neilson, 'Desnuda està la tierra' ('bare is the earth'). V-incised and painted Welsh slate, 1996. Text in Spanish from a poem by Antonio Machado. 183 × 20 × 3cm.

7

Drawn Lettering: Letter Spacing and Numerals

It is of great importance to ensure that the spaces between letters are equal in area, to produce an even pattern of space between and within the letters along the text line. In Optical Letter Spacing David Kindersley (see Bibliography) defines good letter spacing as:

> …quite simply, that each letter should appear to be exactly in the centre of its two neighbours. To me this is the only criterion, I do not believe that it requires any further justification. Put another way, any letter should occupy a passive position between its neighbours. (p.6)

Tom Perkins, V-incised Welsh slate headstone to Jack Jones. Cut by Gareth Colgan. Commisioned through Memorials by Artists.

'SPACE': correctly spaced Roman capitals.

'HIOCE': incorrect spacing of Roman capitals.

Roman Capitals

Though the letter spacing principle is the same for each alphabet, the actual inter-letter area has to be found for each, and this bears a relationship to the letter widths in any given alphabet. Even letter spacing is not achieved by making letters equidistant; that is, by measuring the same distance from the edge of one letterform to the edge of another.

The first diagram showing 'H', 'I', 'O', 'C' and 'E' above shows incorrectly spaced Roman capitals, spaced by measuring the same distance between letters, and demonstrates that this method does not work. Clearly, 'H' and I' appear considerably closer together than 'O' and 'C'; careful examination will also show that 'H' and 'I' are also slightly closer than 'I' and 'O' and 'C' and 'E' – the latter only appear to have a similar inter-letter area to 'H' and 'I' due to the dotted vertical line.

The diagram showing 'H', 'I', 'O', 'C' and 'E' overleaf displays Roman capitals spaced more evenly. This pattern is

'HIOCE, AVIS, LITRA': correct spacing of Roman capitals.

'LA RA TY': spacing of awkward Roman capital combinations.

'mioci, via, riky': correct spacing of Roman lower case.

found by first measuring the width of the space inside 'H' (the counter), and making the distance from 'H' to 'I' slightly less, which creates an area that is similar but slightly less than the area inside 'H'. This inter-letter area is slightly less than the area inside the wide letters and slightly more than that inside narrow letters, and therefore harmonizes with the range of letter widths in this alphabet. Obviously, any such fit is to some extent subjective: one could make the 'H' to 'I' distance slightly less, though if this is too tight then you will find difficulties when trying to space awkward letter combinations such as 'R' and 'A', 'C' and 'T', 'T' and 'T', or 'L' and 'L'.

Having found the 'H' and 'I' area as discussed, in order to create an equal area between letters you will need to space two letters with adjacent straight sides (such as 'H' and 'I', or 'I' and 'H') furthest apart. The straight side of a letter that is adjacent to the curved side of a letter (for example, 'I' and 'O', or 'O' and 'I') should be placed slightly closer, and two adjacent curved sides of letters closer still. The arrowed dotted lines represent an even measure, which is the 'H' to 'I' distance, and you can see that most letters, apart from straight ones (which are equidistant) have to overlap this to create an equal inter-letter area.

It is important to recognize that when you have open-sided letters such as 'C', 'L' and 'T', you have to imagine a line within the letter, as shown in the diagram above, in order to correctly assess the placement of the adjacent let-

ter and avoid over-spacing. The eye registers part of the space within the letter with the inter-letter space, and it is for this reason that over-spacing may occur. It is this visually registered area that needs to be equal to the area between 'H' and 'I'. The words show various letter combinations and the amount of spatial overlap that is needed to create even-looking spaces. The diagram explains the principle, and once this is understood and the 'H' to 'I' area is established, the spacing then has to be judged by eye for the various letter combinations.

Accurate letter spacing will require considerable practice and experience to master. It requires a shift of perception from looking at the letters only, to looking at the contained space within and the space between the letters – sometimes referred to as negative space – and trying to get these as balanced as possible. Very often, good spacing will appear as bad spacing where this shift in perception has not occurred, and where letter spaces are still being gauged as equal measurements between letters rather than equal areas. The 'LA RA TY' diagram above shows some letter combinations that are awkward to space and need to be kept close.

The same principles can be applied to spacing any alphabet; the distance between two adjacent straight sides of letters – which sets the spacing pattern – has to be assessed for each.

John Nash, V-incised Welsh slate roundel.

Number '6' has a width approximately two-thirds of its height. The full-height curve is the same as for the narrower '0', that is, at its maximum it is slightly wider than a thick stem width. The half-height curve is the same as for '3' and '5', and the top of the inside counter coincides with the centre line. The top flares out slightly to finish with a fine vertical serif.

Number '7' has a width two-thirds of its height. The diagonal is a thick stem width and projects slightly to the left of the horizontal top, which is half a stem in width, and flares out slightly to end with a fine vertical serif.

The alternative design for '7' has a thinner diagonal – just over half a thick stem width. The horizontal for this version is slightly thicker to maintain a contrast. As for '3', the form of '7' used is a matter of personal preference.

Number '8' has a width three-quarters of its height at its widest point across the base, with the top being slightly narrower. All curves at their fullest are just over a thick stem width, the thick diagonal being a stem width. The thin diagonal and other thin parts are approximately half a stem in width.

Number '9' has a width of approximately two-thirds of its height. The main full-height curve is the same as for the narrower '0', tapering to a point at the bottom left, as for '3' and '5'. The half-height curve relates in size and shape to the '6'. The inside base of the enclosed counter comes to approximately the mid-height of the numeral.

Numbers can also be based on other 'O' shapes, as, for example, the dynamic 'O' shape. The examples show a selection of dates using ranging numbers, based on various 'O' shapes. Where numbers are used with sloping letters, the numbers can be sloped to match. These can be both ranging and non-ranging, depending on whether they are accompanying sloped capitals or sloped lower case, and are usually compressed.

Teucer Wilson, York stone memorial to John Vacher, approximately 120 × 45 × 15cm thick at base, with rounded edges and deeply incised carving. Commissioned through Memorials by Artists.

Drawn date: 2000 sloping, slightly compressed ranged numerals.

Drawn date: 1896, widely spaced, slightly sloping ranged numerals.

Drawn date: 1907–1988, sloping ranged numerals.

Drawn date: 18.2.1914, sloping, ranged numerals based on dynamic 'O' shape.

Drawn date: 1936–1939, sloping, heavyweight ranged numerals based on dynamic 'O' shape.

Drawn date: 14 March 1980, squared-off, ranged numerals.

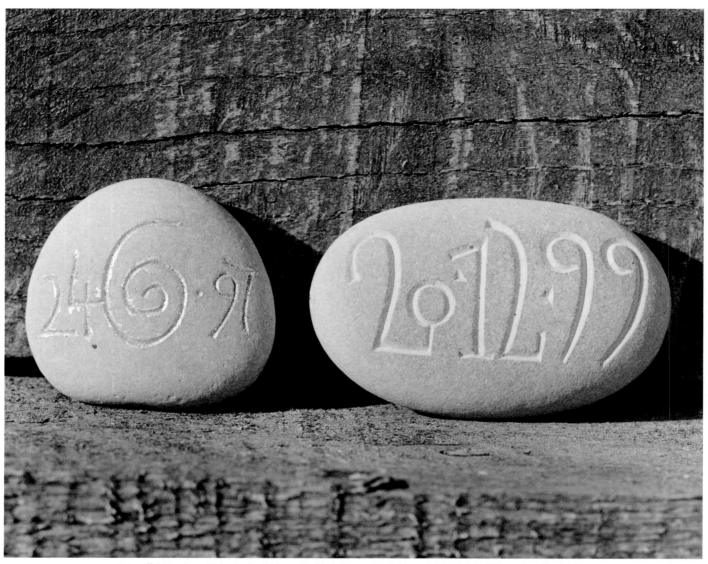

Kristoffel Boudens, V-incised pebbles with birth dates, 24.6.91 and 20.12.99. (Photo: Jan De Mylle)

DRAWING NON-RANGING NUMERALS

Non-ranging numerals are usually used in conjunction with lower-case letters, as they have parts that ascend and descend and therefore relate to lower-case letters more suitably than ranging numerals.

While there are many similarities of form to the ranging numerals, there are a few noteworthy differences. Numerals '1', '2' and '0' fit between the x-height lines of the lower-case, while uneven numerals '3', '5', '7', '9' and '4' align at the top with the x-height and descend below the baseline to the descender line. Remaining numbers, '6' and '8', sit on the x-height baseline and ascend to the capital height.

When drawing numerals, as for letterforms, the height to width relationship should be observed, either by measuring with a ruler or marking on a strip of paper. Also, the relative thickness of strokes should be observed. This is based on stroke width relative to stem width, and the stem width must first be established – on an average-weight letter the stem width to letter height ratio is between 1:8 and 1:10. Thick diagonal strokes are a stem width thick, straight horizontal strokes are usually approximately half a stem width, and thin diagonals are the same or slightly thicker than horizontals. Curves at their maximum point are generally made very slightly fuller than the middle of stems, and at their thinnest part very slightly less than a horizontal stroke.

Number '0' is in some way differentiated from lower-case 'o' in type design, sometimes by making it monoline. In the context of inscriptional work I prefer to keep the design the same as the lower-case 'o'.

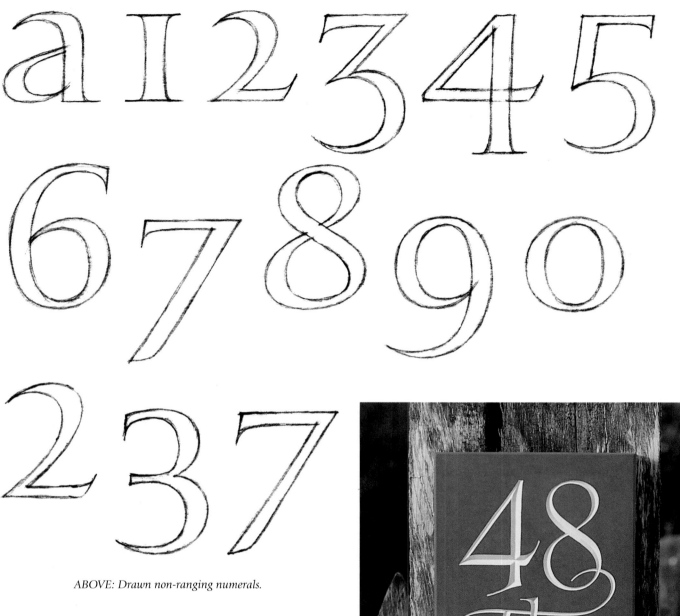

ABOVE: *Drawn non-ranging numerals.*

RIGHT: *Keith Bailey, V-incised and painted Welsh Slate.*

Drawn sloping ranging numerals.

Drawn sloping non-ranging numerals.

Number '1' is a stem width thick, with a flat top to differentiate it from the lower-case letter 'i', which has an angled top.

Number '2' in typography normally fits between the x-height lines. However, when using it on a larger scale, as in letter carving, I prefer to use a taller '2', intermediate in height between the lower-case x-height and the capital height, as shown on the bottom line of the diagram opposite.

Number '3' has two possible forms, as with the ranging numerals, one form with a flat top and one with a curved top.

Number '4' has the bottom of its horizontal sitting on the x-height baseline.

Number '5' is the same as for ranging numerals in proportion, aligning at the top of the lower-case x-height.

Number '6' is the same as for ranging numerals, aligning with the capital height.

Number '7' has two basic forms, as for ranging numerals, both aligning with the top of the lower-case x-height, one with a thick diagonal and one with a thinner diagonal – for the latter, the horizontal needs to be slightly thicker to compensate.

Number '8' has the same proportions as for ranging numerals, aligning with the capital height.

Number '9' has a slightly taller top bowl in the non-ranging numeral than in the ranging numeral, and aligns with the top of the lower-case x-height.

Sloping non-ranging numerals, as shown can be used in conjunction with italic lower case.

Drawn examples showing use of ranging numbers with capitals, non-ranging numbers with Roman lower case, and sloping compressed non-ranging numbers with italic lower case.

Memorial by Christopher Elsey

Christopher Elsey, V-incised Cumbrian green slate memorial to Dixon.

The design of numbers can be adapted as appropriate to the particular design situation. The numbers shown in the 'Dixon' stone are freely drawn, with some angular features, reflecting angularity in some of the letterforms, varying in height and incorporating vertical movement to reflect the movement of the letters.

Tom Perkins, 'In the beginning…', V-incised Welsh slate, 1980. 102 × 25cm. Private collection.

8

Designing Letter Variations

Tom Perkins, 'Verbum…', detail of V-incised Welsh slate inscription.

Experience of working with Roman capitals, lower case and italic so that one has begun to appreciate the concept of related letterforms, will make any designing of letterform variations more likely to succeed. The illustrations in this chapter show a variety of possible 'O' shapes, and some examples of related letters, which should give some stimulus for designing your own alphabets for carving.

Determining Letterforms

The first column of the diagram above illustrates the three primary geometrical forms – the circle, the square and the equilateral triangle. The circle is clearly the basis of the classical Roman letter, that is the 'O', and other related letters. When designing an alphabet, deciding on the basic 'O' form, which then sets the pattern for other curved letters, is

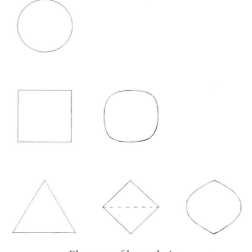

Elements of letter design.

Spontaneously designed group of letterforms.

123

Tom Perkins 'As light…', detail of V-incised lettering on three sides of fireplace surround, Hornton limestone.

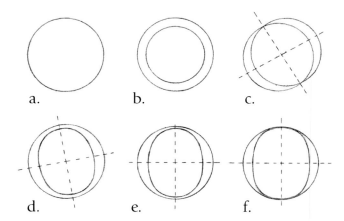

Weight distribution around 'O' forms.

clearly a crucial starting point. The other letter of importance is the 'I', which gives information about the shape of the stems and any terminations or serifs.

Taking the circular 'O' form as the norm, there are two basic variations that can be applied to create alternative forms. These are squaring or making a more angular form. Clearly, a square or a triangle as they stand, as an 'O' form, are not very useful shapes for designing formal letter variations, whereas two triangles placed as shown in the middle of line three, are more suitable, especially when the sides of the diamond shape are curved to give a mandorla form at the end of line three, which gives a more familiar basis closer to an 'O' shape. A modified square with the corners rounded off, as shown on line two of the diagram, also provides a better starting point for designing formal letter variations. These forms can further be modified, through lateral compression, to produce additional possibilities as demonstrated later.

designs and referred to as 'Old Face', is shown at (d). Note that the axis of tilt in drawn Roman capitals tends to be rather less than in the calligraphic form, and the thin strokes are slightly thickened.

Observe what happens to the distribution of thick and thin strokes when the oval inside the circle is moved round to a vertical position as shown at (e). This echoes the development in type design in the eighteenth century known as 'Transitional', when the 'O' was rationalized, as there was no reason to maintain the tilted axis derived from the edged tool.

In type designs such as Bodoni from the early nineteenth century, known as 'Modern Face', the difference between thick and thin strokes is accentuated and the change from thick to thin is much more abrupt, as shown at (f). When designing your own forms, knowledge of these weighting options is helpful.

Distribution of Weight

Having established three shapes that make a useful basis for formal alphabet design, derived from the primary geometrical forms of square, circle and triangle, the next step is to decide on how the weight is distributed round the form.

The diagram above illustrates the skeleton circular 'O' form (a), and a weighted monoline form (b), that is, an even thickness of stroke. This of course could be any chosen weight – light, medium or bold. The next 'O' form, c, shows a circular Roman capital with typical calligraphic weighting, as made by an edged pen (or flat brush), with the writing edge at a 30-degree angle to the horizontal, giving a variation of stroke thickness round the form.

The 'O' imitated in drawn lettering design by placing a tilted oval inside a circle, as seen typically in early type

Developing Letterforms

The diagram opposite illustrates that once you have selected an 'O' form and a certain pattern of weighting, other curved forms can be developed out of this shape. The same procedure can be applied to the design of lowercase forms.

This diagram shows a sequence of 'O' shapes in their monoline and weighted forms. The first column shows a basic monoline form, the second column shows one possible way of weighting these basic forms. The third column shows compressed and sloped monoline basic forms, derived from the forms in the first column. The fourth column shows possible weightings for these forms. Also shown in the diagrams are some additional letters based on three of the 'O' shapes, a variety of compressed 'G' forms, and some upper- and lower-case possibilities used in words (see page 126).

Sequence of monoline and weighted 'O' shapes.

Tom Perkins (assisted by Gareth Colgan and Malcolm Sier), V-incised and painted inscriptions in Ancaster limestone. Commissioned by The Boots Company plc through Art for Work Ltd for the Millennium Sculpture Park, Beeston, Nottinghamshire. 100cm high. (Text by kind permission of John Fairfax, poet)

Three 'O' forms and related letters.

Row of seven compressed capital 'G's, showing possible variations.

'movers': drawn words illustrating capitals and matching lower case based on different 'O' shapes.

Serif Design

We have already seen that the 'O' is one key letter in designing an alphabet, and the 'I 'is the other.

The diagram shows a number of possible serif forms for 'I' and other related letters. These can be used on upper- and lower-case forms.

Part a shows what is referred to in typography as an unbracketed hairline serif. This is not very suitable for carving in stone but would be possible with great care, and in material such as Welsh slate. Heavier unbracketed serifs, which would be possible to carve, are shown at b and c. These are referred to as slab serifs.

A traditional Roman capital serif, referred to in typography as a bracketed serif, is shown at d. Examples of how this serif can be made progressively heavier are shown at e and f.

Sans serif stem endings (that is, without serifs) are shown at g, h and i – g has parallel stem sides; h has stem sides that flare out gradually towards the end of the stem; and i flares out the same as h but with a slightly angled finish, and is used with the more dynamic modern capitals.

More subtle variations are shown at j, k and l – j shows a slightly heavier serif than the straightforward Classical Roman capital shown in d. This is useful for larger-scale Roman letters or when working with softer stone. A variation of j is shown at k, where the serifs flare out slightly towards the ends; l is similar to k but the ends of the serifs are rounded. This requires considerable skill and would not be suitable to carve in softer stones.

Slightly more decorative possibilities are shown at m, n and o – m is referred to typographically as a Latin serif; n is a further possibility, with no particular name; and o is referred to as a Tuscan serif. The 'I' form illustrated at p

a. b. c.

d. e. f.

g. h. i.

j. k. l.

m. n. o.

p.

Diagrams showing different serif designs.

Tom Perkins, V-incised inscription in Greek, on rough slate boulder.

shows how you can have a half-serif on one side of the stem facing in opposite directions.

This is not meant to be an exhaustive range, merely a suggestion of some basic examples plus a few subtle variations. There are numerous possibilities, which you can find in type catalogues or on memorial stones by observation.

Experimenting with Letter Design

When experimenting with letter design it is a good idea to freely and loosely sketch the forms, trying ideas, rather than attempting to draw the letters neatly in the first instance. The refining and careful drawing can come at a later stage once the forms have been found. The following illustrations show both freely and precisely designed letter variations.

The 'Christos' design illustrated overleaf was freely drawn, combining upper and lower case instinctively. A later stage of letterform design, where refinements were made and the letters carefully drawn, is shown in the diagram of three 'R's and squared-off lower case. The freer approach is fruitful when sketching out designs as well as when exploring letterforms.

The 'R S A M D' drawing overleaf for a large carved sign shows not only carefully designed letters but detailed consideration of their layout, as they run over several courses of stone blocks, and their placement with reference to vertical and horizontal joints, is crucial.

The letterforms in the 'but the eyes' text show how the dynamic capitals can be further varied by introducing adapted uncial forms, extending some horizontal crossbars as ligatures.

The 'e', 'f', 'g' and 'h', designed by Jack Trowbridge, are part of a whole alphabet he has been working on and further demonstrates the inventive possibilities with letterform design.

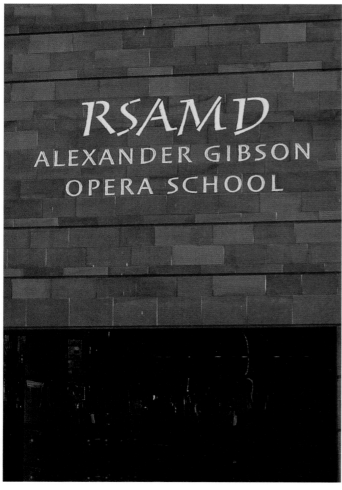

'RSAMD' full inscription, Tom Perkins (assisted by John Neilson, Gareth Colgan and Tanja Bolenz), V-incised and painted red sandstone sign for the new opera school at the Royal Scottish Academy of Music and Drama, Glasgow, 1998. Lettering 75cm and 25cm high.

'Christos', preliminary sketch for carving, using hybrid letterforms

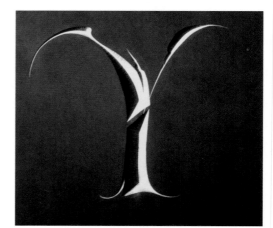

'RRR baegn', squared-off letterform variations of Roman capital, italic capital, bold Roman capital and squared-off lower case.

Julia Vance palm tree 'Y', V-incised in Ardesia slate, 1996.

'RSAMD': drawn dynamic capitals superimposed on courses of stone, part of inscription for the Royal Scottish Academy of Music and Drama, Glasgow.

'but the…', detail of design for carving green slate boulder using dynamic hybrid letterforms.

Tom Perkins, V-incised Cumbrian green slate boulder.

*Jack Trowbridge, rubbing of the letters 'efgh' part of 'Kernow' alphabet, an ongoing project
with a view to grit-blasting.*

Wolfgang Jakob, limestone memorial in two parts, with V-incised and tinted lettering. The parts are placed apart to allow light to fall through. 110 × 50 × 15cm.

9

Guidelines for Designing Headstones and Plaques

The design possibilities for these items are very wide ranging and depend much on the individual preferences of the designer and client. Whether a formal inscription on a smooth slate or stone is required or a freer letterform and layout, perhaps on a riven slate or stone, some suggestions about selection of letterform and placement within the space may be helpful, especially to the beginner.

Layout and Design

Before describing some individual design possibilities for headstones and plaques some general comments about layout and design, with these items in mind, may be helpful.

The main consideration is a successful relationship of text to space, and good design resolution depends on the satisfactory interplay of the following factors: layout (text position in relationship to the shape and size of the stone), lettering scale, weight, style and lateral texture. Much depends on whether an object is being made for oneself, perhaps to exhibit, or whether an item such as a headstone or plaque is being made for a client, where their preferences need to be taken into consideration – as must churchyard or cemetery regulations.

Tom Perkins, V-incised Welsh slate headstone.

Tom Perkins, V-incised Welsh slate headstone (by kind permission).

Initial Design

Whatever the inscription you are designing, it is helpful to start by making thumbnail pencil sketches of design possibilities; in this way a free flow of ideas is encouraged. At this stage, the options for the shape and dimensions of the stone will usually be very fluid, thus allowing many design options.

If the work is a commission the most favourable possibilities can be selected from these initial sketches and worked into a more finished scale design (usually around one-quarter to one-third of full size if it is for a client), through a process whereby considerable refining and adjusting may be required. If it is a commission, I generally only send one design to the client for comment.

At this first thumbnail design stage there are occasions when the client specifies, or an architectural setting strongly suggests, a particular shape of stone and in this situation the designer has to fit the text layout to the particular shape. In other instances, where one may have a freer hand with the overall shape of the stone, one can try a variety of thumb-

nail sketches with the text – by observing natural line breaks, giving emphasis to text where appropriate and trying different styles, sizes and weights of lettering.

As well as the obvious device of centring lines, other possibilities include aligning the text on the left- or right-hand side, or aligning to both edges (but this is more difficult to achieve, particularly if maintaining uniform letter spacing). Also, there are asymmetrical or more free-form layouts – the latter offer a wide range of possibilities but it is best to master the simpler centred layouts first.

Try to avoid putting words such as 'of' and 'and' on their own lines, particularly on a wide inscription. Not only can they appear uncomfortable in a wide space but this gives undue emphasis to unimportant words.

Finished Scale Drawings

When considering lettering style, weight and size, it is important to discern a hierarchy of information. Having decided which wording needs emphasis, and having tried various lettering styles, sizes and line breaks in the thumbnail sketches, the next step is to make more complete scale drawings of the preferred design or designs, establishing a satisfactory relationship between styles, sizes and weights of lettering. Some pointers in making decisions may be helpful to the novice.

Five rough thumbnail designs for headstones.

Jack Trowbridge, V-incised memorial to Duncan Grant.

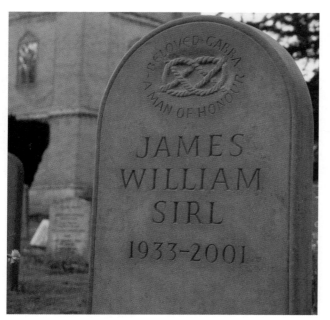

Christopher Elsey, Hornton limestone headstone, V-incised and painted. The colouring of the lettering reflects the Elizabethan church tower in the background. 100 × 54cm. Commissioned by Memorials by Artists.

Use of Roman Capitals

For a formal look, Roman capitals are always a safe choice, either for an entire plaque or headstone, or just for prominent information – for example the name on a headstone, or the name of the building, or the person unveiling a plaque. Roman capitals retain their formal look if the interline space is not too cramped, though this is very flexible. A starting point might be half the height of a capital.

Obviously one would try the letters at normal weight first. This is usually satisfactory, but in some instances it may be preferable to use a different weight of letter. A bolder weight might be necessary in a softer stone, which makes carving smaller letters easier. The client or designer might prefer a bolder weight for a variety of reasons.

When using capitals for prominent information, it may be problematic if the chosen design has one name per line (as is a frequent layout on headstones) if one or more of the names are very long and will not fit comfortably on the line at the preferred letter size. One solution is to use smaller-size Roman capitals for the whole name, in order to accommodate the long line. However, if this would look too insignificant, then a compressed form such as italic capitals is a possibility, whereby the lettering could be condensed whilst retaining a reasonable size.

If a contrast in style as well as size is required for other information, either smaller capitals or a lower-case Roman or italic can be used – consideration of the line length has a bearing on whether a narrow or wider letterform is chosen. Italic is useful for saving lateral space, or a condensed Roman lower case – whichever looks most suitable in the particular design context.

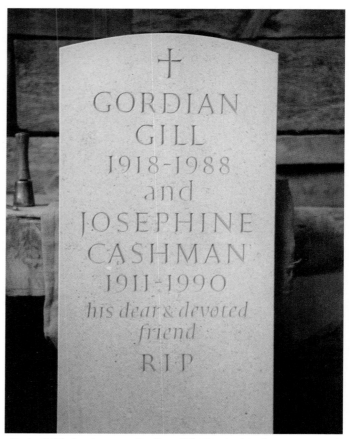

Kevin Cribb, headstone to Gordian Gill, V-incised Nabresina. Located in Speen churchyard, Buckinghamshire, 1991. 83 × 46cm.

Often, headstones and plaques are designed entirely in capitals or using a combination of capitals and lower case. Another possibility, however, is to design an entire inscription using lower case alone, either in one size or more than one, which is more usual.

Line Spacing

In any use of lower case (especially italic), line spacing is obviously affected by the length of ascenders and descenders. As a guide, an italic with reasonably long ascenders would require an interlinear space of roughly one and a half x-heights, whereas with shorter ascenders and descenders on an italic or a Roman lower case it could be kept to approximately one and a quarter x-heights.

You can either keep the interlinear spacing even throughout the inscription, regardless of styles and sizes, or, use varying interlinear space to differentiate various pieces of information. For example, the space between the names and the line with the dates on a headstone could be slightly wider than the space between the names (or the space between more than one line of dates).

It is quite usual to have a quotation of a line or more to round off the design on a headstone, and there is often a reasonably generous space left between this quotation and the preceding information.

When using less formal capitals in headstone or plaque design, a close vertical texture with minimal interlinear space often works well. Such a close-knit texture with less formal-looking lettering can have less conventional margins. The lettering can go quite close to the sides of the stone, particularly if most lines of the inscription are justified or nearly so. Alternatively, such a blocked inscription using less formal capitals can look well-balanced if it is surrounded by plenty of space (see the following Figures f and g).

Tom Perkins, V-incised plaque.

Headstones

In any situation where you are working for a client, it is obviously important to arrange a meeting to ascertain a clear picture of the kind of artefact they want. Major considerations will include: the shape and dimensions of the stone (and for this cemetery or churchyard regulations should be consulted); type of slate or stone; the surface of stone – smooth, riven or textured; any preference for a particular type of letterform; formal or informal layout; and whether space is to be left for an additional inscription at a later date. Much time can be wasted at the design stage if you do not get a clear idea of any client preferences first.

The thumbnail sketches illustrated, show a range of possibilities, without any design or financial constraints, and use fictitious wording. With the exception of Figures a–d the lettering style has been kept the same to show a few of the many of different design options possible using the same style of lettering – in this instance, sans serif compressed capitals with a pointed 'O' shape and angular curves through the alphabet to relate.

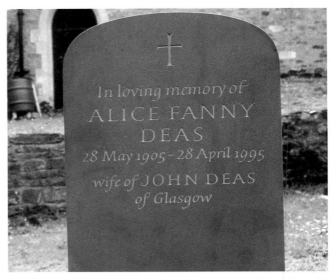

Tom Perkins V-incised green slate memorial commissioned through Memorials by Artists (by kind permission).

Example Designs

ROMAN CAPITALS

Figure a opposite shows the most straightforward option. This centred layout could equally well apply to a stone with a straight or less curved top. The name is the most important aspect of the inscription and is therefore given prominence with use of capital letterforms, which could be bold weight.

Formal Roman capitals have been selected for this design, with approximately half a capital height as the interlinear space

Tom Perkins, V-incised Welsh slate headstone in italic.

a.

Thumbnail headstone design using Roman capitals.

between the two names – this is a good starting point. The exact size of the lettering for the names will depend to a large extent on the length of the names. A particularly long name may dictate a fairly wide stone to accommodate it at a reasonable letter size if Roman capitals are used, or, if a narrower stone is preferred, compressed capitals or a large-scale compressed lower case such as italic can be used, as discussed earlier.

With this formal type of layout sufficient side margins should be allowed to prevent the inscription looking cramped; this reinforces the classical look of the whole inscription. The use of capitals allows a good contrast with the word 'Remember' at the top, which could be in italic or Roman lower case. An alternative for 'Remember' would be to use formal Roman capitals, smaller than the name, but the italic lower case chosen here gives a softer look to the design. The dates are approximately two-thirds of capital height. If the dates included the months, these would probably be in the same lower-case script as 'Remember' and either similar size or smaller.

The scale of the cross does not swamp the inscription and is placed near enough to the text to form an integrated whole. The space between the cross and first line of text should not look cramped or too generous – the latter might weaken the overall design. The whole design is centred and starts fairly high up the stone, which is a good location even with a short inscription.

b.

Thumbnail headstone design using formal italic.

FORMAL ITALIC

Figure b bottom left demonstrates the use of italic for the entire wording, with a centred design and approximately one x-height of interlinear space between the three lines of italic. 'Remember' is at a smaller scale than the rest of the inscription to accommodate the length of the word, and also because it is less important in the hierarchy of information and makes a good design contrast. The numerals are the same size as the initial capitals of the names, to relate satisfactorily, and there is minimal interlinear space. They thereby form a fairly dense design block, which relates to the solid cross design at the top.

The cross could be raised from a dished-in circular background or could be V-incised, with the outline of the circle also V-incised. The interlinear space between the name and the first line of the date is the same as between the rest of the inscription, but if there were descenders on the italic of the last name then the space might need to be slightly increased. The top of the stone has a 'lancet window' shape.

c.

Thumbnail headstone design using cursive italic.

CURSIVE ITALIC

Figure c illustrates another design using italic for the entire wording. This example is a more cursive and individual style of italic. The relative scales of first word and names are similar to those in Figure b and the interlinear space between the names is minimal, which gives a dynamic feel to the design. The interlinear space between 'Remember' and the name is about one x-height, to differentiate the two types of information, which improves this particular design, making a tension between the space and the compact block of the following lettering. The reasonably large interlinear space between the names and dates, again, adds to the design tension; the minimal interlinear space between the dates gives a strong block, echoing that of the names. The size of the dates is similar to the initial capitals. Margins are fairly tight at the top and sides to add to the dynamic quality of the lettering and layout.

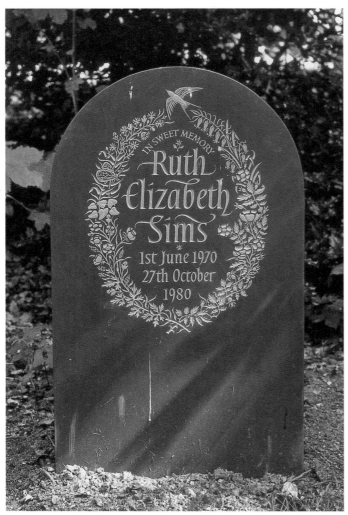

Ieuan Rees, V-incised Welsh slate memorial for Ruth Simms.

d.

Thumbnail headstone design using italic and italic capitals.

e.

Thumbnail headstone design using compressed capitals running up the left side of the design.

ITALIC AND ITALIC CAPITALS

Figure d above like Figure a shows a classical design, here using italic capitals rather than Roman but with quite wide inter-letter spacing, which adds to the formality of the design. The interlinear space is approximately half a capital height throughout the design. This is uniform because the use of smaller-scale formal italic at the top (also with wide letter spacing) and smaller-scale numerals for the dates is sufficient to differentiate these two lines of information from the names. The top and side margins are quite generous to enhance the formality of the design and the top corners of the stone are rounded off to soften the outline.

COMPRESSED CAPITALS RUNNING UP THE LEFT

Figure e above right illustrates a less conventional text layout than on the majority of English headstones. Such a

design very much depends on the client's view of less formal formats. Roman capitals or uncompressed sans serif sloping capitals could be used, instead of the compressed capitals illustrated; the text could run to more than one line if necessary, following this layout idea.

The compressed, slightly forward-sloping sans serif capitals give a contemporary feel, enhanced by this layout, and make a marked spatial contrast between the tight lateral pattern of the lettering and the emptiness of the rest of the stone. Uncompressed capitals would create less of a spatial contrast in the design due to increased space within the text line. The proximity of the lettering to the left edge of the stone is a deliberate design choice, though it could be positioned slightly further away if preferred.

There are a number of further design variations possible with this layout. It could work equally well with a shorter first line and a long second line, preferably in smaller-scale capitals, extending the full height of the stone.

f.

Thumbnail headstone design using compressed capitals in a square layout, filling the top area of the stone.

g.

Thumbnail headstone design using compressed capitals in a small square.

h.

Thumbnail headstone design using compressed capitals on an asymmetrically shaped stone.

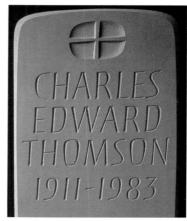

Tom Perkins, V-incised York stone headstone to Charles Thompson.

COMPRESSED CAPITALS IN A SQUARE LAYOUT

Figure f above also displays less conventional use of space, by taking the lettering as near to the edges of the stone as possible. The scale of lettering is affected by the length of any one name, and with this sort of design the letters can be compressed laterally as much as necessary. The stone has purposefully been kept narrow, the aim being to fill a square shape, but an oblong shape could be adopted with longer text.

As with Figure a, a contrast in scale between the name and other details has been used – 'Remember' and the dates being the same size as each other, giving a unity to the design. The zeros in the numbers have also been made angular to harmonize with the capital 'O' shape.

Where a text line does not fill the lateral space it has been centred. Though the name 'Peter' could have been drawn the same size as 'Hoskins' and would have filled the line more, it has been drawn slightly smaller using an intermediate size of lettering to add subtle variety, and also, the spaces either side of the name add some contrast and interest to the design block.

The aim of this design is a close texture of lettering, both laterally and vertically, and to this effect the interlinear space has been kept to a minimum. The tight texture makes a good contrast with the clear space on the rest of the stone.

COMPRESSED CAPITALS IN A SMALL SQUARE

Figure g above illustrates the same lettering layout as Figure f, with the relative sizes of lettering the same but the scale reduced, the text block forming a strong focus surrounded by generous space. The relatively high position on the stone means the shaped top and the lettering block hold together as a strong design unit.

The small cross symbol, located approximately two-thirds of the way down the stone, acts as an anchor to the design but is small enough not to detract from the inscription. The slightly curved sides of the stone add a further subtlety to the overall design.

COMPRESSED CAPITALS ON
AN ASYMMETRIC STONE

Figure h above displays a left-aligned text layout, with close interlinear texture (as in Figures e and f). The asymmetry of the layout echoes and harmonizes with the asymmetry of the overall stone shape, this being further accentuated by the cross symbol being offset to the right side (which gives a contrasting tension with the left-aligned text).

As the cross is small in scale, it can be reasonably strong in weight. The circular shape containing the cross reflects the soft curve at the top of the stone. The whole design is kept fairly high on the stone, making a satisfactory contrast between the text and open space below. The side margins can be relatively narrow but with sufficient space to contrast with the tight textural inscription.

rather than being a separate element and vying with the text (which it might at this scale if it was placed further away).

With roughly two-thirds of the stone filled by design and one-third empty there is an interesting use of space. Side margins are reasonably tight, bringing tension to the inscription, with the top margin being slightly more generous in order to balance with the space at the bottom of the inscription.

COMPRESSED CAPITALS WITH LARGE CROSS BELOW TEXT

Figure i below shows an upward-flaring asymmetrically shaped stone with a flaring bevel to the edges. The contrast between the widening bevel and narrowing stone towards the base gives design tension, and the widening of the bevel towards the top right corner of the stone gives an extra dynamic to the shape at the top. The inscription is left-aligned, as in Figure h, but the lettering is larger scale whilst still retaining the relative contrast of scale within the inscription.

The large cross, contained in a circle, is lightweight to harmonize with the lightweight letterforms and to avoid being over-dominant. Owing to its scale, it gives a below-centre focal point. Its light, spacious look does not detract from the inscription and, as it is placed tight to the base of the inscription, it bonds with it as an integrated design unit

COMPRESSED CAPITALS WITH A CIRCULAR STONE TOP

Figure j below left exemplifies an overall shape reminiscent of Celtic cross stones. The base and top would probably be separate stones dowelled together and could be from either the same or different types of stone.

The placement of the centred, vertically close-knit inscription at the base of the stone makes for a good design balance with the weighty cross at the top of it, which could be V-incised or raised from a dished-in background. The stone, being wider at the base, easily accommodates the words with satisfactory line breaks. The lightweight symbol in the centre, occupying about two-thirds of the height of the main stone, gives a spatial contrast with the filled space above and below, with the division of vertical space in the main stone between text and symbol approximating to golden section proportions. The horizontal line of this symbol reaches to the sides of the stone, giving a strength and stability to the design. The shape of the curved bowl of this symbol has been designed to relate to the curves of the letters.

i.

Thumbnail headstone design using compressed capitals, with large cross below text.

k.

Thumbnail headstone design on flared base using compressed capitals.

j.

Thumbnail headstone design using compressed capitals with circular stone top.

l.

Thumbnail headstone design using compressed capitals. Cross-shaped stone.

DESIGN ON A FLARED BASE USING COMPRESSED CAPITALS

Figure k opposite illustrates a stone with a horizontal emphasis sitting on an outward-flaring base. The layout of the inscription has similarities to Figure e, with the text adhering to one long edge of the stone and running from end to end.

In this design, because of the extra space created by the base stone, some further design feature is called for in the top stone, and the large-scale lightweight cross fulfils this purpose and reflects the light weight of the lettering (and therefore does not conflict with the inscription).

This cross could be raised, with a dished-in background, or V-incised. There could also if necessary be additional wording on either side of the cross: such wording would preferably be in the same style of capitals but small enough to contrast with the main text line, and with a good space between the main line and further text.

COMPRESSED CAPITALS ON A MASSIVE CROSS-SHAPED STONE

Figure l opposite shows an asymmetrical cross-shaped stone, with incised flaring and tapering lines down the centre of each arm. The small-scale lettering makes a marked contrast with the massive nature of the main stone and forms a strong focus due to its central location and density of texture. The circular shape containing the inscription creates a tension with the cross outline. 'Remember' is drawn in a curve to fit it into the circular shape, and the dates are curved to echo this. The names are centred. Space within the inscriptional area is minimal and this density contrasts well with the spaciousness of the cross.

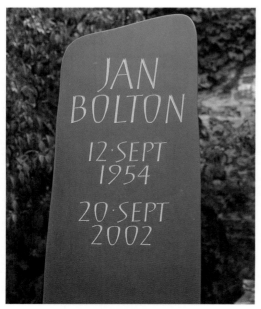

Tom Perkins, V-incised Welsh slate headstone to Jan Bolton (by kind permission).

Plaques

The nature of the plaque will be influenced by the specifics of whether its location is inside or outside, the type and function of the building, and designer and client preferences. The wording used for the following designs is fictitious, and the illustrations show a variety of layout and design options using the same wording.

The first stage, as for any inscription, is to start with thumbnail sketches of design ideas, selecting those that work best for further development. Circular or oval plaques, usually to commemorate the opening of a building, are often requested by clients, and it depends largely on the nature of the wording as to whether or not it will divide up satisfactorily into these shapes. If there is sufficient wording, and providing the nature of the content allows for splitting it up in to two texts, then one of the texts can be arranged round the circle or oval while the main inscription is in the central space. I usually try most inscriptions in a rectangle in both directions to see which design works best, and in a circle or oval if requested.

Example Designs

ITALIC FOR A CIRCULAR OPENING PLAQUE

Figure a below shows wording that gives a satisfactory result on a circular stone. The most important information (in this case the name) has been drawn the largest, in italic as even the compressed forms of italic capitals would have made the line too long, and if the names had been split into two lines then 'Janet' would have been too short to be a line in the middle of the overall layout. The form of italic used here has some personal modifications, with a mixture of angular and softened forms.

a.

Design in italic for circular opening plaque.

As well as the lines making a satisfactory shape within the inscription, suitable line breaks are also of prime importance in the meaning and reading of it. Occasionally, even where a client specifically requests a circular plaque, the wording will not break up satisfactorily and other design options have to be pursued. Sometimes a request for a slight adjustment to the wording can solve such a design problem. In deciding on the sizes of lettering, consideration needs to be given to adequate side margins whilst ensuring the text fills the stone in a satisfactory way.

This inscription has been drawn using three sizes of italic. 'Member of Parliament for East Grinstead' has also been drawn in italic, but approximately half the size of the name, in order to fit the wording with suitable line breaks. The rest of the inscription has been drawn at approximately two-thirds the size of the name – large enough to have a satisfactory presence on the stone and fill the space adequately, and sufficiently smaller than the name to create contrast. 'This' has been drawn the same size as the name, as otherwise it would not fill the lateral space sufficiently, and it harmonizes well with '2005' on the bottom line, both in size and word length. The restrained flourish makes the top of the inscription sit harmoniously against the curve of the circle.

As this inscription is entirely in italic the interlinear spacing has been kept uniform throughout the inscription, and adequate to allow clearance of ascenders and descenders, which have necessarily been kept restrained. This interlinear spacing is tight enough for the design to adhere well in a vertical direction. Note that if certain adjacent lines look too open due to lack of ascenders and descenders, then the interlinear space in such locations may need to be closed up slightly.

When used in conjunction with lower-case letters, numbers are usually non-ranging (as shown here). Whether the inscription is in a rectangle, circle or oval, the bottom margin is generally slightly more spacious than the top margin to prevent the inscription from appearing to fall out of the bottom of the design.

FLOURISHED ITALIC AND CAPITALS FOR AN OVAL PLAQUE

Figure b displays an oval design, combining a modified style of italic for most of the text in combination with sloped capitals to bring out the importance of the name. The use of a wide capital form is to make a long line to prevent the layout from forming an upside-down triangle. The whole design is centred, which is useful for accommodating different line lengths, and the interlinear space of four-fifths of the capital height is uniform throughout the design. This is generous enough to accommodate the ascenders and descenders of the italic, whilst being close enough to hold the design together satisfactorily in a vertical direction.

b.

Design using flourished italic and capitals for oval plaque.

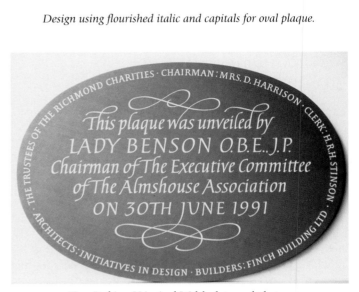

Tom Perkins, V-incised Welsh slate oval plaque.

Tom Perkins, V-incised circular Welsh slate plaque.

c.

Design using dynamic capitals for rectangular plaque.

d.

Design using free stone shape and informal capitals for plaque.

When designing inside an oval or circle, flourishes are useful to fill out the shape, and for this it is helpful to have a calligraphic background. Renaissance writing manuals, such as Arrighi's La Operina, are a good source for flourish design.

DYNAMIC CAPITALS FOR A RECTANGULAR PLAQUE

Figure c consists of a vertical, rectangular format. Making satisfactory line breaks is a principal requirement of any design and where this results in lines of different but not too dissimilar lengths, a centred layout usually works well. This format could have been designed entirely in italic, or a combination of capitals and italic (or Roman lower case). An adapted form of sans serif capital has been used to show a different design possibility.

The size of the name was established first, by taking the longest name and drawing this as large as possible while retaining adequate side margins. The interlinear space between names is approximately half of a large capital height. A capital size approximately two-thirds of the size of the large capitals was chosen for the remainder of the inscription, and a uniform interlinear spacing retained throughout.

If different styles of lettering are used in one inscription, the interlinear space between different styles will almost certainly need to be slightly increased. '2005' was drawn the same size as the name, which otherwise would have made a very short line and would not have balanced well with the full top line. Making it larger also gives a little extra design contrast and relates it to the name in the inscription, thus binding the design together.

Side margins have been considered both in the light of the longer top lines and surname, and of the shorter lines of the rest of the inscription, allowing enough space at the sides to set the inscription off in its space and preventing the longer lines from looking too tight to the edges of the stone.

INFORMAL CAPITALS FOR A FREE-FORM SHAPE

Figure d illustrates a free-form shape with a close vertical texture of dynamic, sans serif capitals that harmonize with this. The variation in line lengths, resulting from a consideration of text meaning and layout, gives an interesting dynamic to the centred design, as does the tight vertical spacing. The short final line provides a good base to the layout and is reflected in the short line of the first name.

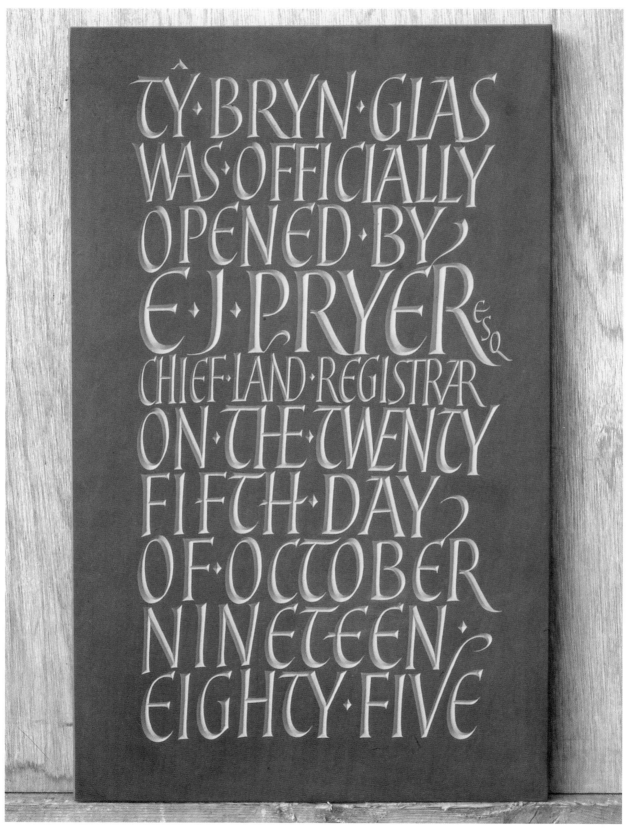

Ieuan Rees, slate opening plaque, for Ty Bryn Glas
(Tax Office, Swansea), 92cm tall.

Design using compressed informal capitals for narrow, vertical plaque.

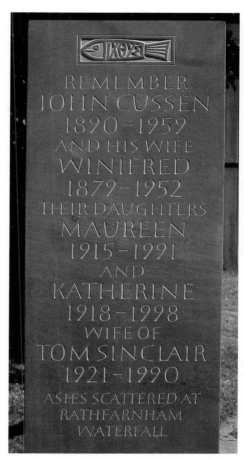

Headstone in Cumbrian greenslate, 1170 × 480mm. Gareth Colgan, 2000.

Gareth Colgan, V-incised opening plaque for Fingal County Hall, Cumbrian green slate, 2000. 24 × 64cm.

The surrounding space is enough to set off the textured block but not so much that it floats within the stone, which in this particular instance would not be a satisfactory solution.

COMPRESSED INFORMAL CAPITALS FOR A NARROW, VERTICAL PLAQUE

Figure e shows another option with a close vertical texture, this time with the laterally compressed letterforms reflecting the tall,

narrow stone. The name is slightly larger than the rest of the inscription, with the length of the surname in this particular set of wording determining maximum size, as the design would be less satisfactory with one line projecting too far to the right.

The left margin is almost left-aligned, and short words have been moved slightly to the right for overall design balance. The short first and last lines, being of similar length, help to unify the design, while the slight variation in line lengths makes for interesting use of space on the right-hand side. As is usual with a vertical rectangular design, the bottom margin is more generous than the others.

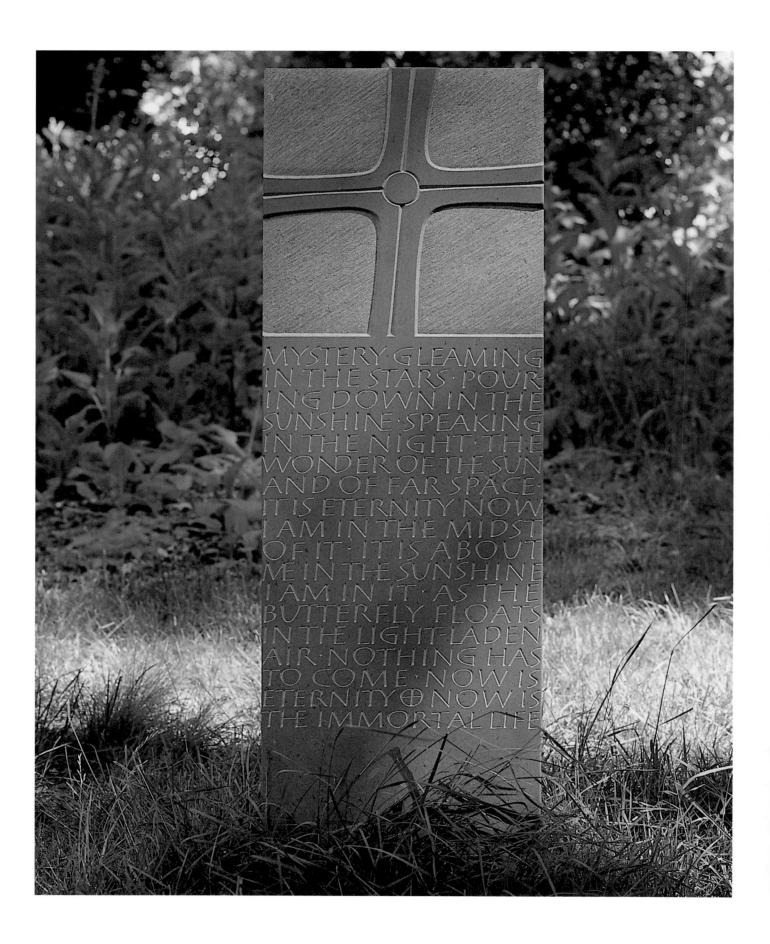

MYSTERY GLEAMING
IN THE STARS · POUR-
ING DOWN IN THE
SUNSHINE · SPEAKING
IN THE NIGHT · THE
WONDER OF THE SUN
AND OF FAR SPACE ·
IT IS ETERNITY NOW
I AM IN THE MIDST
OF IT · IT IS ABOUT
ME IN THE SUNSHINE
I AM IN IT · AS THE
BUTTERFLY FLOATS
IN THE LIGHT-LADEN
AIR · NOTHING HAS
TO COME · NOW IS
ETERNITY ⊕ NOW IS
THE IMMORTAL LIFE

10
Making an Inscription in Stone

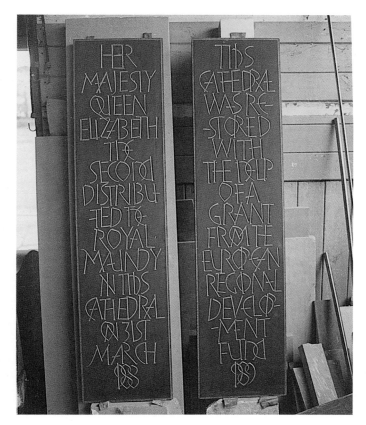

Charles Smith, V-incised lettering on Lichfield Cathedral inscriptions, placed either side of the great west doors. Each slate 133 × 32cm. Commissioned to commemorate the distribution of the Royal Maundy and European funding for repair works.

Opposite: *Tom Perkins, 'Mystery gleaming…', V-incised inscription in Cumbrian green slate, 1998. Text by Richard Jefferies (by kind permission of the Richard Jefferies Society). 92 × 30cm.*

The design process starts with the text, either from the client or text chosen for personal work, perhaps to exhibit. Check the copyright situation for any published text. A high proportion of letter carving work is by commission and you need to obtain as much information as possible from discussion with the client about their requirements before embarking on the design process.

If an inscription is to be placed in a specific architectural context it is important to visit the site, take photographs and note down any relevant information, including measurements at the site, so that questions of appropriate materials, the scale and shape of the object and style of lettering are given proper consideration.

If a stone is required for a memorial, ascertain any client preferences as to size, shape, type and colour of stone, type of letterforms and the surface of stone (whether polished or riven). Each diocese has a set of regulations for memorial stones and a copy should be obtained from either the Diocesan Advisory Committee for churchyards, or from the local council for cemeteries, to find out any restrictions on the size, type and thickness of the stone and other relevant considerations, such as the fixing method.

Thumbnail Designs

Obtain a clear typewritten copy of the text from the client and bear in mind any client preferences. Start by making initial layout sketches to find satisfactory line breaks for the text. These layouts can be arranged within a surrounding overall shape, which is rectangular either in a horizontal or vertical direction – or the layouts can be arranged in a square, circular or oval shape. Alternatively, if a natural,

uncut piece of stone or slate is required an idea of layout can be given but an accurate design might have to wait until an actual piece of material had been found.

Generally speaking, it is best to avoid very long and very short lines in the layout and also it is better to emphasize the top of the inscription rather than have it appear to be bottom heavy. Consider giving emphasis to the most important information – often a name – by making it larger or in a different style, or both.

Five thumbnail sketches for memorial design.

Scale Drawing

After trying a few thumbnail sketches, select the most promising idea and begin to work this into a more finished layout, usually at around one-quarter size. The scale should be indicated on the drawing and the wording checked before sending it to the client, keeping a copy of the drawing yourself.

The advantage of making a scale drawing is that this can be prepared much more quickly than a full-size drawing, and is therefore less time-consuming, and if drawn accurately enough can still give a prospective client a good indication of the finished article. It can be helpful to the client if you draw a full-size letter beside the design.

Cost

An estimate of the cost should be sent with the scale drawing. Consider which of the following elements are relevant:

■ Site visit.
■ Scale drawing.
■ Drawing up the full-size drawing and transferring to the stone.
■ Cost of material plus its collection and delivery.
■ Carving.
■ Painting or gilding.
■ Delivery and fixing.
■ VAT (if applicable).

Aspects to cost up with extreme care are the cost of the materials and the delivery and fixing.

Cost of Materials

If the material is being delivered by the supplier to you or delivery is being arranged by the supplier, the charge for this must be taken into consideration. If you are collecting the material

Tom Perkins, 'A Celebration of English Music', top of inscription, V-incised and painted Portland limestone.

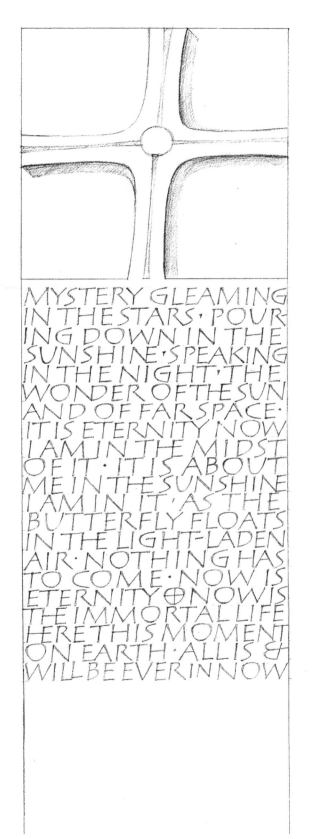

*'Mystery gleaming…', scale drawing made at one-third of full size.
Quotation from Richard Jefferies.*

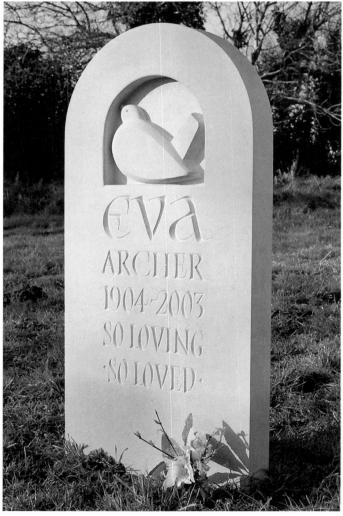

*David Holgate, headstone to Eva, V-incised lettering plus deep relief
carving, Portland stone, 2004. 95 × 46 × 7.5cm.*

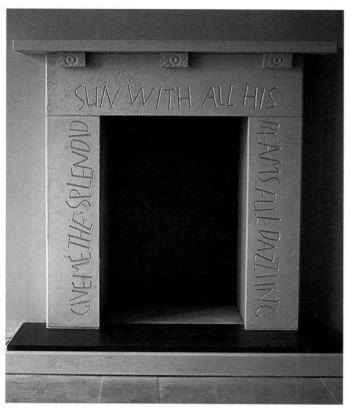

Charles Smith, V-incised and gilded lettering in Ancaster limestone and Welsh slate, around fireplace, 2004. 'Give me the splendid sun', by Walt Whitman. 116 × 114cm. (Illustrated by kind permission of Peter Hartley)

intensive. Ensure you cost in the time that you will be spending on this aspect of the process.

Cost of Delivery and Fixing

If you are delivering the stone to the client the charge will obviously depend on distance, and in some cases, whether you have to hire a vehicle.

The fixing charge will depend on the size of the stone and how many people the fixing will necessitate – usually one or two – and the type and complexity of the fixing method. Check the height at which the stone is to be fixed and give consideration to issues such as accessibility and provision of scaffolding.

Note that in the case of large stones, or complex fixing methods, fixing may have to be undertaken by a specialist firm – full details should be supplied to them and quotes obtained, as this can be a very costly aspect.

Making the Full-Size Drawing

After the scale drawing and cost have been approved by the client, the material can be ordered. If you are working to a deadline, check availability as some stones can take months to obtain. If ordering by telephone, fax or internet also give the supplier written confirmation of the order to prevent any ambiguities.

The next step is to draw the inscription out at full size. My own preferred method is to draw the letters out freehand, usually with each line of text on a strip of layout paper, and the drawn letters are then transferred to the stone (see the house name project on page 163).

Before doing this it is safest to first take a strip of layout paper the height of the stone and to mark the measurements on it with dots for the top margin and the top and bottom of each line of text, which will give you the interlinear spaces as well, and the bottom margin. Tape this onto the stone to check that the text lines and margins fit the stone as planned before ruling up the lines on the stone and tracing down the lettering a little later, after the next stage.

yourself, some charge should be allowed for your time.

If the material is to be circular, oval, or in the case of a headstone perhaps to have a shaped top, establish the exact cost when ordering if the supplier is providing the stone ready-shaped. Check if the cost of the material is inclusive or exclusive of VAT.

I usually use circular and oval stones shaped by the supplier. For shaped headstones, it varies as to whether I shape them myself and or get them shaped by the supplier. It is useful to provide the supplier with an accurate full-size drawing, or preferably a card template, for oval stones and the top shape of headstones, plus measurements. If you are shaping the stone yourself, as with the top of a headstone for example, this can be quite labour

'Presence of' detail of inscription: carefully drawn letters for transferring to the stone for carving (original letter height 5cm).

Removing Scratches from the Stone Surface

Before tracing down lettering, any scratches on the surface of a smooth stone should be removed by rubbing down with wet-and-dry paper, around 320 grade (used dry), for superficial scratches (see 'Gilding an Inscription'). A coarser grade, around 180 (used dry) may be needed initially for deeper scratches, working gradually towards finer grades. The wet-and-dry sandpaper is used wet if there is more generalized scratching over the whole surface, and also to finish off sanding on slate.

An alternative for use on stone, or on badly scratched slate, is aluminium oxide paper, which is very hard-wearing and available in fine, medium and coarse grades (selected according to the degree of scratching to be dealt with). This is used dry.

Tracing Down the Inscription

To trace down the lines of drawn letters, rule up double lines for each line of text, using the measurements on the paper marker strip. Mark down the left and right sides of the stone before ruling up, using a sharp white crayon on dark stones and pencil on paler stones. Then you can transfer the inscription to the stone. For beginners, it is safest to trace the whole inscription down at the same time to avoid layout errors.

Carving can either commence with the bottom line, as carving from the top may result in drawn letters lower down the inscription being rubbed out as you carve, or it can start with the top line – but be sure to cover up the rest of the traced letters with a sheet of paper taped on with masking tape for protection. My preferred way is to trace the top line down and carve it, then to trace down each subsequent line and carve it.

Tom Perkins, 'Princess Theatre', V-incised and painted Welsh slate, commissioned by Dame Stephanie Shirley, for Prior's Court School, Thatcham, Berkshire.

Having ruled up, to transfer either the complete inscription from one piece of paper to the stone, or to transfer a line of text from paper to stone, cut out small triangles with a craft knife at intervals of approximately 15cm (6in) on the top and bottom pencil lines of each line of lettering (see the house name project on page 163).

Next, fix the whole inscription, or alternatively a strip of lettering, down onto the stone with small pieces of masking tape either side and along the top and bottom of the paper as necessary (retaining an opening to be able to insert a sheet of carbon paper), checking the alignment of the top and bottom pencil lines of each line of lettering and those on the stone through the cut-out triangles.

Place a sheet of handwriting carbon paper between the lettered layout paper and the stone and trace the letters down using a hard pencil, such as 3H (alternatively, as I do, you can use a worn-out ballpoint pen for this, which is very effective). As you reach the edge of the carbon sheet. move it along the line.

The wording should be checked before commencing any carving. The most thorough checking method is to read out the wording from the stone letter by letter along each line whilst a second person looks at the printed text.

Gilding an Inscription

Gold leaf can be used on a wide variety of artefacts that incorporate letter carving, lending an opulent effect where appropriate. Gilding also enables an inscription to show up better in a situation with low lighting, such as in an old church, and ornamental features such as sunburst designs on sundials can be

Tom Perkins, V-incised and gilded roundel, 1994. 9cm diameter.

Letter Carvers and their Work

The following two descriptions give some insight into the approach of three letter carvers to their illustrated works.

Here, Ben Jones comments on his inscription 'Anagrams of Angered':

Anagrams have been used throughout history. Some people have found philosophical meaning in them and others just find them fun. Using alternating wide and narrow letters helps to fit the text into a square and make a pattern. Each word being made from the same few letters as the others helps add structure. There is another anagram of 'angered' not used here. The very coarse stone was roughly bolstered and the letters deeply trench cut with a fine chisel. The narrow 'N's with their delicate junctions were carved first in case of disaster. The corners of the block were rounded off slightly to help protect them. (Ben Jones, statement provided to the author)

The following description by Helen Mary Skelton gives an interesting insight into the development of her work 'The Prayers We Say':

During the Iraq War in spring 2004 I heard Dr. Jonathan Sacks, the Chief Rabbi, speaking on BBC Radio Four's 'Thought for the Day'. At the end of his three minutes he said these words: 'The world we build tomorrow is born in the prayers we say today'. They seemed so very apt and I was moved to jot them down. At the time I was preparing for an exhibition and asked the Rabbi's permission to carve his words in slate. I had very little time and no slate to speak of except an offcut. For speed I 'scratched' the first eight words with a tungsten scribe and carved the rest. I wanted an architectural feel to the piece and left in construction lines. Also. a suggestion of chaos side by side with resolution was important to me.
 A couple visiting the exhibition commissioned me to make

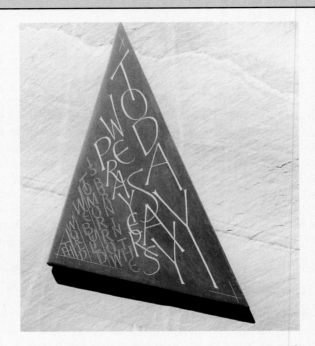

another, larger version, leaving the design to me but specifying the type of letters they would prefer. As you can see it became a very different work, which I hope is an improvement, with a simpler approach: 'world' and 'prayers' and the dots are all gilded – this was for emphasis. The shape at the bottom made by the last four words is intended to resemble a mouth. There is a residual hint of the architectural theme of the first version but it has become an entirely different interpretation. I very much enjoyed making this piece and thank the clients for giving me such a free hand. (Helen Mary Skelton, statement provided to the author)

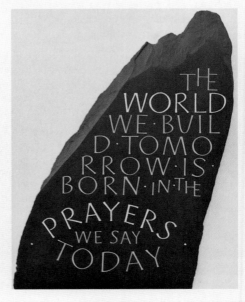

Kevin Cribb, V-incised and gilded sundial, Delabole slate. Located in Cornwall. 61cm diameter.

Tom Perkins, V-incised and gilded Cumbrian green slate sundial. 60cm diameter.

enhanced by its use. It is not always necessary to gild the whole of an inscription, sometimes using small amounts of gilding to highlight certain words or motifs can be very effective.

Other kinds of durable metal leaf such as palladium and platinum may also be used where a silver colour is preferred to gold.

Preparation Before Gilding

It is important to ensure that you are working in the most favourable conditions for gilding. Avoid working in a draught as a still atmosphere is necessary for controlling loose gold leaf, but ensure adequate ventilation in the room. The atmosphere is best when it is on the damp side – in summer, early morning is suitable.

The stone or slate should be dust-free – incised letters can be cleaned out with a brush. Before gold size is applied to the incised letter as a mordant for the gold leaf, it is beneficial to apply a base coat of red oil-based paint; this increases the richness of the colour of the gilded letter. This step may be omitted if gilding on slate, but all porous stone will need to be sealed with oil colour.

To prepare the red ground colour, mix some red oil-based paint with some Le Franc's 3-hour gold size – an oil-based varnish – in the proportion of 3:1, ensuring that the mixture is not too thick.

It is important to note that all porous stones such as limestone and sandstone will spoil if oil colour is allowed to get on the surface, so paint must be carefully kept within the edges of the V-incision when applied. As slate is non-porous, it is all right if the red base coat is brushed out over the edges of the V-incision, as surplus paint can be easily removed when dry by sanding with wet-and-dry paper of around 400 grade after

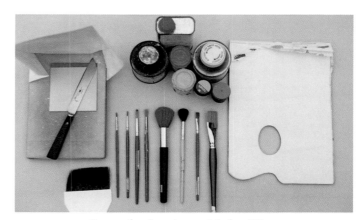

Range of tools and materials for gilding.

gilding. Note that this is only if the slate is fine-rubbed: if it is a riven surface, the red base coat will have to be applied carefully, keeping within the edges of the V-incision.

The red base colour is applied with a No. 2 synthetic brush. Ensure that you do not get built-up areas of paint at the bottom of the V-incision by using a second brush, without paint, to scrape out any excess. After painting the inscription, leave to dry – if possible, for two or three days at least.

Applying the Gold Size

When the red ground has dried, the gold size can be prepared as follows. Mix 3-hour size with Humbrol yellow enamel in the proportion of 3:2, making sure the prepared mixture is not too thick – test by dipping the brush into the mixture to see if it flows smoothly off the brush when lifted out. If needed, add a small amount of white spirit and stir well.

Use the same method to apply the gold size as for applying

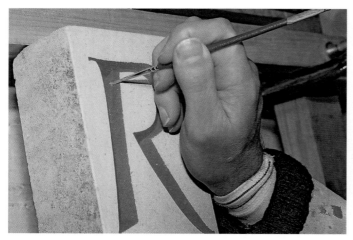

Sealing porous stone before applying size.

Cutting the loose gold leaf on a gilder's cushion.

Applying the gold size.

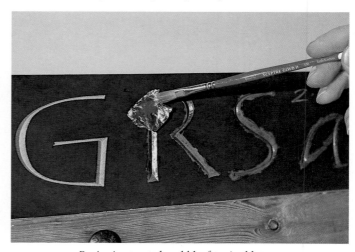

Beginning to apply gold leaf to sized letters.

the red ground (using a separate No.2 synthetic brush). Ensure there is no build-up of size in the bottom of the V-section by first brushing out excess size from the brush onto a paint palette before painting the incised letters. Remove any surplus size that does accumulate in the bottom of the V-section with a clean, dry brush. At the same time that you start applying the size, paint a test patch for drying on the corner of your palette.

If you are gilding a large number of letters, you should leave time breaks every now and again if using a 3-hour size (as applying the gold leaf takes longer than sizing) or use a longer-setting size (such as a 24-hour size).

Applying Gold Leaf

Having finished painting in the gold size, clear up and prepare the first leaves of gold while you wait for it to get to the right tack for gilding. To test for this, use your knuckle on the patch of size on your palette and when you get a pull on your knuckle the size is ready to gild. In warm weather this will be

before three hours and in cold, damper weather a little longer.

Take a book of loose gold leaf of 23–24 carat for external work and 22 carat for internal situations. Holding the spine of the book, open it from the back to expose the first leaf of gold and press down on to a chamois leather gilder's cushion. Repeat, laying a second leaf of gold on top of the first.

With the gilder's knife, which should not be too sharp or it may cut the chamois cushion, lay the edge of the blade across the leaf, push it forward slightly and cut the leaves into three strips. Then make three cuts in a horizontal direction to produce nine roughly equal sections.

Using a clean No. 4 synthetic brush, pick up one section of gold by first rubbing the bristles on the nape of your neck to create static. Once the gold is on the brush apply it to the V-cut letter and gently push it into the V-cut, repeating until the letter is covered. Apply more gold to build up more layers of leaf before fully pushing the gold into the V-incision with a No. 2 gilder's mop.

Now leave for a day before applying more pressure with the gilder's mop to brush out excessive gold. Use the gilder's mop also to give a burnished finish.

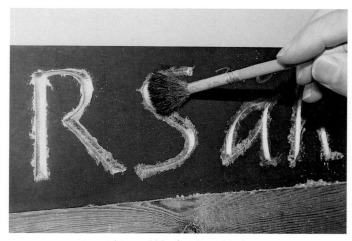

Burnishing gold leaf with a gilder's mop.

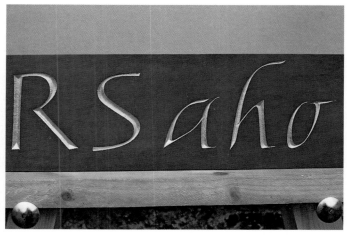

Completed gilding.

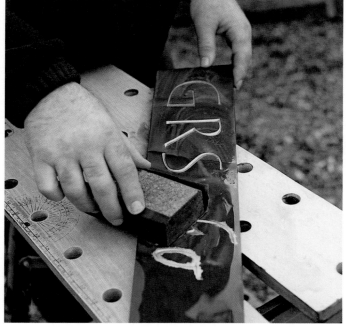

Cleaning off surplus size and gold from around lettering with wet-and-dry sandpaper.

Finishing

If you have painted the red ground and size beyond the edges of the V-incision on a non-porous, smooth-surfaced stone, the surplus needs to be cleaned off, preferably after allowing at least three days. Do this by placing a piece of 400-grade wet-and-dry paper round a cork sanding block and, using it with water, sand over the surface of the inscription. It is important to then clean off the slate slurry with running water and cotton wool.

The gilded cross on the illustrated work by Christopher Elsey above right, demonstrates another possible finish to the gilding – the effect of distressing the gilding with wire wool to expose the red base coat.

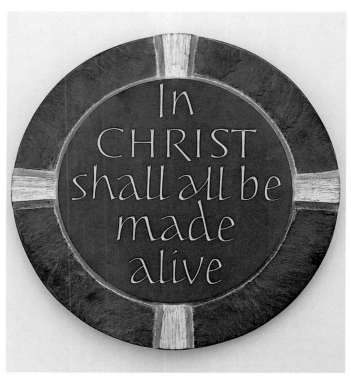

Christopher Elsey, 'In Christ…', V-incised and gilded riven Welsh slate roundel with fine-rubbed centre. Gilding on cross distressed with wire wool to expose red base coat. Diameter 25.5cm. Text from 1 Corinthians 15:22.

Solving Problems

- If the gold leaf does not adhere to the size, the size or the atmosphere may be too dry (or it may be too windy if gilding outside).
- If the gold covers the size but the finish is poor, this may be due to the gold size being too thick and collecting at the bottom of the V-section. Scrape out the gold-covered size and start again.

Viewpoint on Carved Lettering

The 'Namaste' slate shown here was carved by furniture maker, wood and stone carver Martin O'Brien, and designed and gilded by the well-known American calligrapher and letterer John Stevens, who offers some interesting thoughts on carved lettering and the process:

I first became interested in carved lettering in the late 1970s. At that time, I was a signwriter (and lettering junkie) and carved lettering was a natural extension of that trade. When I visited England in 1978 and saw carved lettering based on classical forms (rather than the late nineteenth-century, wild-west forms, common to the signs in the USA at the time), I was elated. I saw the influence of Gill everywhere. I had been studying Gill's typeface Perpetua quite carefully and had recently seen Joanna. I recognized a quirky, stylistic unity that was so pleasurable in what were supposedly utilitarian letterforms (that is, they had personality yet still held the strength and grace of the best letterforms).

I was discouraged by the trend of US shop fronts competing with ugly, bigger and bolder lettering and generally wrecking the cityscape. It was a trend that was counter to everything that interested me and what eventually led me to give up the sign business and become a calligrapher/designer.
I was developing as a 'graphic aesthetician' and wanted to have a say. How could people want crap, I wondered … a perplexing question. Could they not see? I think, looking back, that this was my entry into the design realm and teaching. I read many books which dealt with the 'Problem of Art' and asked the questions: What is beauty? What is good form? How does a society or culture decide this? What is taste? Was it society's need to see a lot more of what they have already seen? Was fear or vision in charge of people's decision making? Inspiration, or apathy? I could see that education had a direct impact on people's taste but it was not a guarantee of quality. I believe intent may be one of the most powerful determinants. Simple, humble expressions seem to have stood up to time better than grandiose demonstrations have.

Lettering designed properly for monuments and buildings is a hard sell here in the USA. Committees often miss the mark as they become entities wanting to make a statement of their own and many times lose sight of the problem. In my opinion, consensus cannot really create or imagine: the committee's function is usually 'being all things to all people' and failing miserably. They usually just chop things down to a comfort level that the lowest common denominator can deal with, as they collect input and options. This is where Martin and I have run into a lot of

John Stevens (design and gilding) and Martin O'Brien (carving), 'Namaste', incised and gilded slate.

dead ends. We try to get architects and planners interested in our collaborations that will include lettering. We are currently working on an altar table. Sadly, a 'what's the difference?' attitude permeates the landscape and I am afraid that the computer has given the uninitiated the belief that they already know. Everybody is an amateur 'expert' typographer thanks to the PC. People in the USA especially don't understand or are completely unaware of the possibilities in beautifully designed and executed public lettering. I also think people in the USA are afraid of words that appear on anything other than a page of a book or magazine. The calligrapher Edward Johnston wrote that 'good work will create the demand' and I really see that as our only option at this time. Martin and I believe that if we are 'turned on' by this approach, then someone else must eventually be also.

I am thankful that this work is continuing in the UK and Europe and I hope it flourishes. To me, there appears to be a creative trend in the UK where the expression of the individual artisan is being honored and this lends an authentic, special or unique quality to the work, as opposed to the cookie-cutter, quasi-imitative type/computer approach. It is a breath of fresh air.

Words are part of our landscape. I would rather they be beautiful, thoughtful and natural expressions of our best intentions and qualities, properly integrated with the surroundings, rather than apathetic – or worse, derivative, dehumanized, commercial messages to be passively consumed. (John Stevens, statement provided to the author)

Painting a V-Incised Inscription

There is no doubt that in many instances V-incised letters will show up better when painted, and for most inscriptions painting is recommended. The contrast between the incised letters and the surface of the slate, for example, is almost entirely lost when the slate is wet. For memorials, providing the client is informed that the contrast may be lost when the stone or slate is wet, then painting is a matter of individual choice.

Obviously, the larger the letters are and the more deeply they are incised, the better they will show up, but carving letters large is not always possible. Much also depends on the lighting conditions. For interior inscriptions the ideal lighting is a directional light, such as a spotlight, that rakes across the surface of the stone so that there is a clearly contrasting light and shadow within the letters.

Tom Perkins, V-incised and painted italic 'b'.

Type of Paint

To paint a V-incised inscription, the type of paint used depends on whether the inscription is to be interior or exterior. For interior inscriptions you can use water-based paints, such as acrylics or designer's gouache, as well as oil-based paint such as Pliolite-based masonry paint, which dries matt and is very durable.

Even for an interior inscription note that it is important to consider whether or not it will be placed in an area where damp may be a problem, as this could make water-based paint unsuitable. Oil-based paint is used for most inscriptions, especially for external ones.

If you need to mix colours, smaller quantities are available in various matt oil-based paints, which can be mixed with the pliolite-based paint. Gloss paint is harder wearing, but matt appears more sympathetic with the stone or slate.

Preparing to Paint

Ensure the V-incised letters are dust free by cleaning them out with a brush. Mix enough paint for the whole inscription – small plastic film containers with snap-on lids are good for this purpose and around half a container of paint is usually adequate for most small to medium-sized inscriptions. Paint may need to be thinned: use water for acrylics and gouache, and for oil-based paint mix thoroughly with a small amount of turpentine or white spirit to make the paint flow more easily.

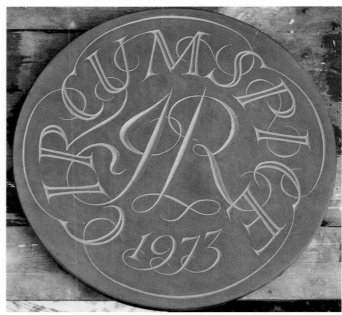

Reg Bolton, 'Look around you' in Latin, with (R) Roy and (J) Julia and 1973 (the year they started work on their garden at 'The Laskett', Herefordshire). V-incised Welsh slate, for Sir Roy Strong, painted blue and yellow, their favourite colours. Approximately 70cm diameter.

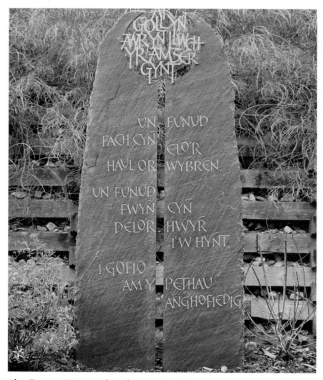

Alec Peever, V-incised and painted Welsh slate and fret-cut bronze, Oxfordshire, 2001. Quotation from Waldo Williams. 150 × 60cm. Private collection.

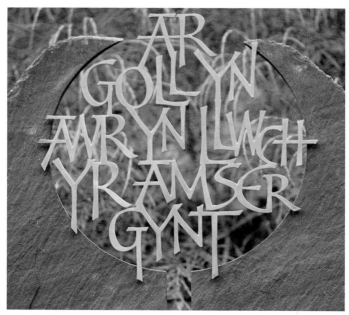

Alec Peever, detail of painted Welsh slate and fret-cut bronze lettering.

The Cardozo Kindersley Workshop, Welsh slate whatnot with flourished, V-incised and painted italic alphabet and V-incised and gilded Latin quotation, with 'Shiva'.

Careful painting of incised letters.

Flood painting of incised letters.

Kristoffel Boudens, 'Non possumus non loqui' ('We cannot not speak'), V-incised and painted old Burgundy limestone floor tile. 18 × 25 × 9cm.

Tom Perkins, V-incised and gilded sign for 'Twinings Teapot Gallery', Norwich Castle Museum, commissioned by Norfolk Museums and Archaeology Service.

For painting the V-incised letters with oil-based paint the options are painting one or two coats with a stone sealant followed, when dry, by one coat of oil-based paint. I have found one coat of good quality, oil-based matt paint such as pliolite to be adequate in most instances.

Painting the V-incised Letters

For painting the incised letters a pointed brush is used (a No.2 brush is suitable for letters 2–5cm or ¾–2in high). On porous stones you need to paint carefully, keeping within the edges of the V-incision. For non-porous stones and fine-rubbed slate, painting precisely does give the most accurate result but is time-consuming and exacting, and flood painting the letters – painting less precisely, and beyond the edges of the V-incision – is adequate.

If flood painting, any chips should be marked with a pencil (or white crayon on dark stones or slate) so these places can be avoided and painted precisely afterwards. Surplus paint round letter edges as a result of flood painting can be removed, once the paint is thoroughly dry, by sanding the surface of the whole inscription with 320-grade wet-and dry-paper wrapped round a cork sanding block, used with water. If you are unsure which stones are suitable for flood painting it is advisable to obtain a small sample of the stone and to carve a letter and try flood painting it, removing the surplus paint as described to check if the process works satisfactorily on the particular stone.

It is worth mentioning that inscriptions carved in porous stones such as limestone and sandstone can be flood painted if the whole surface of the stone is covered with a layer of clay slip prior to carving. It is advantageous if a darker colour slip is used on a pale stone and vice versa. The clay slip is painted onto the surface of the stone with a decorator's brush and allowed to dry thoroughly before the inscription is traced down and carved. When the paint is thoroughly dry the clay slip is removed by hosing down the stone and rubbing with 400-grade wet-and-dry paper. Again, it is advisable to try this method on a sample piece of stone first.

Whether painting precisely or flood painting incised letters, ensure that surplus paint does not accumulate in the base of the V-incision.

Though painting the letters of a carved inscription may be appropriate in many instances, some of the examples illustrated show a combination of painted and gilded finishes. On both small-scale and large-scale works the two techniques can provide a striking contrast.

Simple Fixings for Inscriptions

Metal Dowels

A simple method of fixing small and medium-size works of carved lettering onto walls, such as house numbers and names and plaques, is by means of metal dowels and epoxy resin.

The dowels should be made of a non-ferrous metal such as stainless steel, aluminium or brass. Metal dowel can be obtained in different diameters from good tool shops. For most small and medium-sized plaques dowels of 10–12mm (⅜–½in) diameter are adequate.

In addition to smooth metal dowel, you can obtain threaded metal dowel (studding), which tends to give a better 'key' with the bonding material but it is more expensive. You can give an improved key to smooth dowel by making a series of shallow cuts with a hacksaw over the surface of the dowel.

PREPARING THE DOWELS

To fix a plaque by use of metal dowels you need to ascertain how many dowels to use and of what diameter; this will depend on the size and thickness of the plaque. For small plaques, approximately one foot square or less, two dowels should be sufficient, set about one-quarter of the height of the plaque down from the top. Larger plaques may require four dowels, set in from each corner. Again, the required diameter of dowel should relate to the size and thickness of the plaque. Cut the dowel into the required lengths – on average this will be somewhere around 50–65mm (2in–2⅗in) in total length (that is, 30–50mm (1⅕–2in) projecting from the surface of the stone or slate, plus 15mm (⅗in) to go into the stone or slate.

MAKING A TEMPLATE

The first stage is to place the plaque face down on a sheet of mount board on a clear work surface and draw round it. Remove the plaque and cut out the mount board template. This is then soundly secured to the back of the plaque by taping it to the edges with masking tape.

Next, check the front of the plaque and mark the top of the mount board template with the word 'top'. Then mark the positions of the centres of the holes to be drilled to accommodate the dowels, measuring the location of the holes accurately. Using the corner of a chisel, the centres of the holes can be pierced into the mount board template. (See 'Fixing the Plaque' for use of the template)

FIXING THE DOWELS INTO THE PLAQUE

The holes are then drilled in stages, using progressively larger drill bits. First, take a hand drill with a 5mm (³⁄₁₆in) bit and drill a small hole approximately 3mm (⅛in) depth into the stone through the template, then remove the template. How far you drill into the stone or slate depends on its thickness. For example, for a plaque of 2.5cm (1in) thickness, you would drill no more than 15mm (⅗in) into the stone or slate. To prevent exceeding required depth, wrap a strip of masking tape round the drill bit 15mm (⅗in) from its point and drill no deeper than the lower edge of the masking tape.

For the following stages an electric drill is used, taking an 8mm drill bit, again wrapping masking tape round 15mm (⅗in) from the point of the bit and drilling as before. Then take a drill bit slightly larger than the diameter of the dowel – for example a 10mm (⅜in) dowel would require an 11mm drill bit – and mark with tape and drill as before.

Once the hole has been drilled out to the required size, clear as much dust out of it as possible. Check that the dowel will fit into the hole easily to the right depth, and drill it out a little more if necessary.

Initial drilling through the template and slate with a hand drill.

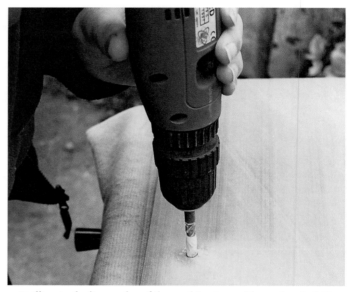

Drilling to the lower edge of the masking tape with an electric drill.

Glued-in dowels.

Here, Gary Breeze's description of his work 'Pastoral Poem' gives some indication of the amount of thought that goes into such a work. 'Pastoral Poem' was the central piece in a body of work called 'Musaeum' first shown at Roche Court Sculpture Park in 2004.

Clearly inspired by the 'Rosetta Stone' it brought together two themes recurrent in my work; dialect and translation. In line with the other pieces in the collection it bore a catalogue number, 24, and the museological caption:
'Slate tablet bearing a single text written in two different scripts; East Anglian at the top and Greek at the bottom. h.60cm, w.25cm. d.4cm. The text is a pastoral poem lamenting the poet's own inability to 'read' the natural world around him. The Greek version gives the key to much of the lost dialect of East Anglia and is written in iambic metre used by all the Greek tragedians; the equivalent of English blank verse but with six feet to the line instead of five. The poem was written by Gary Breeze and translated by Colin Sydenham.' (Gary Breeze, statement provided to the author)

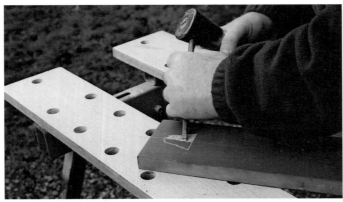

Removing slate over the whole keyhole plate area.

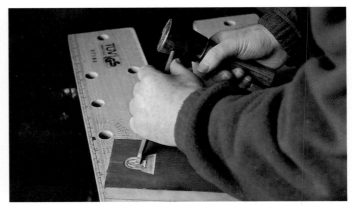

Deepening keyhole area.

Deepening keyhole area, partly carved.

Glued-in keyhole plate.

Jon Gibbs, number 11, riven Cornish Trebarwith slate, which has a characteristic brown staining resulting from oxidised iron ore in the stone. 20 × 20cm.

Mix up epoxy resin on a small piece of mount board or hardboard and fill each hole using a metal spatula. Push each dowel fully into the hole. This will displace the excess resin from the hole, scrape this away with the metal spatula and check with a set square that the dowels are vertical before the epoxy resin sets. Styrene-based adhesive works well but can set quite quickly, depending on the specific type. It can be as quick as ten minutes, so it is advisable to mix up a small amount in advance and test it for setting time.

FIXING THE PLAQUE

In order to attach the plaque to the wall you need to position the template in the required location. It is vital to ensure that the side of the template marked with 'top' is against the wall and not visible – it is important to have the template this way round to ensure accuracy. Tape the template securely to the wall with masking tape, or small masonry nails if tape will not stick. Check the top of the template with a spirit level.

To drill holes, start with a hand drill with a 5mm diameter bit and drill approximately 6mm (¼in) into the wall. If the wall presents a very hard surface to drill into you will have to start with a 5mm drill bit in an electric drill. Next, use an 8mm drill bit in the electric drill and mark it with a strip of masking tape approximately 3mm (⅛in) more than the dowel length projecting from the stone or slate, and drill into the wall. Repeat the process using an 11mm drill bit.

Clear dust from the holes with a metal spatula and offer the plaque up to ensure it will go flat against the wall. If it does not, drill out the holes further, and offer up the plaque again. Once you have ensured the plaque dowels will fit into the drilled holes satisfactorily, clear dust from the holes, mix up the epoxy resin as before and fill the holes with the resin on the metal spatula, pushing a good quantity into each hole swiftly and repeat as necessary. This does require some practice. Offer up the plaque and push it firmly into position and hold there until the resin sets. You can tell when this will be from any resin left on the mixing board. Before it sets, clean the resin off the spatula.

Keyhole Plates

Keyhole plates can be fitted into the back of an inscription to hang on a screw in the wall, and are suitable for small and medium-size work. The main advantage of this method of fixing is that inscriptions can be easily detached from the wall, which may be particularly suitable inside (or outside in a domestic situation).

Inscriptions on thin slate, particularly in a vertical format, should only need one keyhole plate. Inscriptions in a lateral format, or heavier-weight vertical inscriptions, would need two keyhole plates. These can be bought in a variety of shapes and sizes. For small to medium inscriptions keyhole plates of around 3cm (1³⁄₁₆in) high are suitable.

FIXING THE KEYHOLE PLATE

To fix a keyhole plate, first decide on its placement on the back of the inscription. If one keyhole plate only is to be used, it needs to be near the top and centred laterally. Draw a line down the centre on the back of the inscription and locate the keyhole plate at the required level on this line. Scribe around the keyhole plate with the corner of a chisel. Next, scribe a mark the same shape, 2mm (¹⁄₁₆in) outside the first shape, then with a 5 or 6mm chisel and dummy, edge in around the outside line (that is, make half a V-cut all the way round).

Next, holding the chisel flat, chip out the slate or stone within this shape to a depth of around 2mm (¹⁄₁₆in), at the same time going round the edges several times to make them more vertical. Test the fit of the keyhole plate in the recess so that the surface of the plate is flush with the surface of the slate or stone. Chisel out further and re-fit the plate as necessary.

The next step is to deepen the area of the keyhole itself. Place the keyhole plate into the recess, and, using the plate as a stencil, draw the shape of the keyhole on the slate or stone in pencil. Remove the keyhole plate then deepen the keyhole area only and widen it out slightly. Replace the keyhole plate in the recess, and try the screw-head through the plate and keyhole. If necessary, remove the keyhole plate and deepen the keyhole until you have removed sufficient depth of slate or stone for the screw-head to fit.

Remove the plate and score the underside of it with the tip of a tungsten chisel to give it a 'key'. Mix and put epoxy resin sparingly into the recess, avoiding the deeper central keyhole slot that will accommodate the screw-head. Put the keyhole plate into the recess and scrape away excess epoxy resin with a metal spatula.

If the keyhole plate has holes for small screws you can additionally drill out resin from holes with a hand drill and fix in the screws, but this is not usually necessary. When the resin is set you can rub away any excess surrounding the keyhole plate with 240-grade wet-and-dry paper.

David Holgate, 'Old School House', V-incised and painted Welsh slate, set into brick wall, 2003. 15 × 760cm.

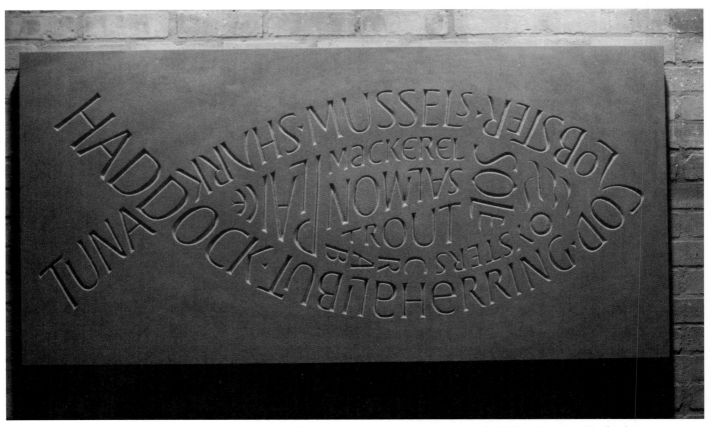

Richard Kindersley, pavement stone carved in St Bees red sandstone, placed near the old Fish Market, Ayre, Scotland.

11

Projects

Designing and Carving a House Name

A simple and useful project for the beginner letter carver is to design and carve a house name. It is best to have a smooth or fine-rubbed surface to the slate or stone because it is easier to draw or trace the lettering down on a smooth surface and easier to make carved letters with well-defined edges. A relatively soft material such as Welsh slate or Portland stone is recommended for the inexperienced. The thickness needs to be around 25–30mm (1–1¼in) for slate, as this is a strong material, and around 3.5–5cm (1⅜–2in) for Portland stone.

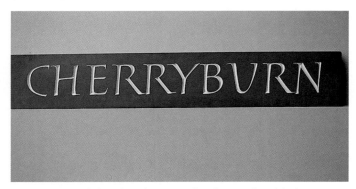

Tom Perkins, 'Cherryburn', V-incised and painted Welsh slate sign.

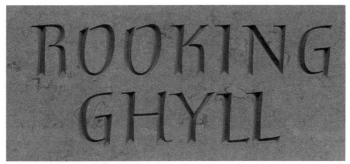

Tanja Bolenz, 'Rooking Ghyll', V-incised and painted Italian limestone house sign, 2003. 25.3 × 41.8 × 1.8cm.

Thumbnail design in italic.

Thumbnail design in dynamic capitals.

Thumbnail design in italic capitals.

Thumbnail design in flourished italic.

Thumbnail design in Roman capitals.

First Design Stage

Start by making thumbnail sketches of possible layouts and decide on the design, which for this project would be likely to be in either one or two lines, depending on the particular house name, and on design preference.

For 'Sycamore House' I decided to design the words in two lines and to demonstrate the use of sans serif capitals, as they are easier to carve for a first project than lower-case, or capitals with fine, classical serifs.

The size of the inscription and the style and size of lettering need to be decided. I designed these letters to be carved at a height of 6cm (2⅜in), with an interlinear space of 3cm (1⅛in). I would recommend a minimum height of 5cm (2in) for the novice, as letters at this height will be easier to carve.

Drawing for house sign project.

Second Design Stage

At the next design stage, with a small amount of wording such as a house name, the design can be drawn full size. With longer inscriptions it is advisable to make a scale drawing, a quarter or a third of full size. Rule up accurately on detail or layout paper and draw out the lettering, one name per line, not worrying at this stage about accurate centring.

To make adjustments to letter spacing or layout, for example centralizing the layout better if wording is on more than one line, re-trace and adjust using layout paper, which is thin enough to see through.

If using capitals, allow an interlinear space of between half and one capital height, according to preference, unless you want a close vertical texture with no interlinear space. For lower-case letters, more interlinear space is required to give clearance for ascenders and descenders.

Kevin Cribb, house name plate, 14 St Mary's Street, Ely. V-incised Welsh slate, 1993. 7.5 × 50cm.

Tom Perkins, 'Chetwynd House', V-incised and painted Welsh slate sign.

Decide how much space you want around the inscription – for this it may be useful to have four strips of card, each approximately 60 × 5cm (2ft×2in), to place as a 'frame' round the lettering. Generally you need a wider bottom margin than top to prevent the inscription appearing to fall out of the bottom of the slate or stone. Side margins should be equal in area to each other, and are usually more generous on a horizontal than a vertical format. Avoid too much surrounding space as the inscription may look rather ineffectual, particularly with formal letters, unless it forms a denser texture through close line spacing. For 'Sycamore House' the Welsh slate is 24 × 66 × 2cm (9 ½ × 26 × ⅜in).

Preparing the Stone or Slate and Ruling Up

Having ordered and obtained the slate or stone, remove any scratches – which are more visible on slate than stone – by rubbing the surface of it with water, using 320-grade wet-and-dry paper round a cork sanding block (see method illustrated on p153). In Portland and other stones scratches can be removed with a fine-grade abrasive paper – aluminium oxide paper is very effectual, and comes in different grades.

Slate ruled up ready for tracing down the inscription.

Tracing down the inscription using handwriting carbon paper.

Aligning top and bottom lines of the inscription, through the cut-out triangles, with lines ruled on the slate.

Ensure the surface of the slate or stone is clean and dust-free, measure, mark down both sides of it and rule up lines for the lettering (with a hard pencil on light-coloured stones and a sharp white crayon on slate). Draw a central line down the slate or stone. A strip of layout paper is useful at this stage, with the top and bottom margins, letter height and interlinear space for each line of text marked along its edge for transferring these measurements down both sides of the stone or slate before ruling up. Check that the lines are the correct distances apart and parallel.

Before tracing down the lettering, cut small triangles out of the layout paper with a craft knife, at approximately 8cm (3in) intervals along the top and bottom lines of each row of lettering. Tape the text at intervals with pieces of masking tape onto the slate or stone, and, through the cut-out triangles, check that the guidelines drawn match up with the guidelines on the paper.

With a short inscription of only one or two lines, the whole design can be taped onto the slate or stone from one piece of layout paper. With longer inscriptions, it is preferable to cut the text into lines, taping on and tracing one line at a time. Using a piece of handwriting carbon paper – which can be obtained in different colours – place it face down onto the slate or stone under the text and using a hard pencil trace down the lettering. Before

continuing tracing, check that the first letter shows up adequately. Move the carbon paper along as necessary and trace all the text.

Carving

Check the spelling of the inscription letter by letter. For longer inscriptions in particular it is best to check this with a second person, with one reading out from printed text and one checking the lettering on the stone.

If you have traced down the whole text, carve the lowest line first to prevent rubbing out the traced letters on the other rows, or, if starting carving with the first line, cover up the rest of the text by taping on paper to protect it (or trace and carve one line of text at a time). To carve, select a chisel the width of a thick stem, and ensure that you stay within the letter outlines. For details of carving individual strokes see the section on carving techniques in Chapter 4.

Finishing

Once it has been carved, the inscription may be left with the plain carved finish, or alternatively can be painted or gilded (see Chapter 10 for more on this). Prior to careful painting or gilding, clean lines from porous stones with 320- or 400-grade wet-and-dry paper round a cork sanding block, using very light pressure and without water. (Removing lines after painting may damage the paint.) With soft stones take care when using abrasives to remove lines, as otherwise you may damage or efface some of the finer carved detail of the inscription such as serifs – on some stones a soft eraser may be adequate to rub out pencil lines.

Slate and non-porous stones can be flood painted and lines can be removed with 320-grade wet-and-dry paper, used with water, after painting. For fixing see Chapter 10.

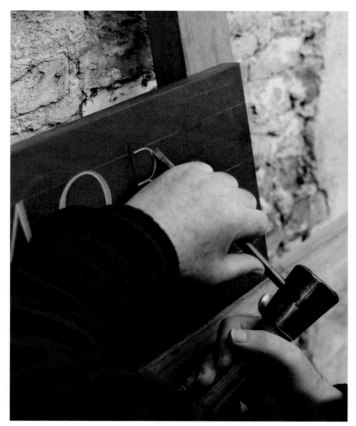

Carving right side of the 'R' bowl.

Close-up of 'R', partially carved.

Kevin Cribb, 'Springwell Place', V-incised and painted house sign.

Completed 'Sycamore House' sign.

Reg Bolton, 'Wellbrook Manor', V-incised Welsh slate house sign, painted off-white, gilded border incorporating brass fixing screws. Approximately 20 × 46 cm. For Mrs Griffith, Peterchurch, Herefordshire.

Tom Perkins, 'Deutsche Schule', V-incised and painted Portland stone, 1982. 285cm across.

Teucer Wilson, 'Sene Barn', riven Welsh slate house sign, with deeply carved lettering that is painted. Approximately 75 × 50 × 3cm. Private commission.

Tom Perkins, V-incised green slate roundel for Gainsborough's House, Sudbury, Suffolk, 1990. 65cm diameter.

Tom Perkins, letter 'C', V-incised and painted on hand-shaped Welsh slate 'pebble'.

Riven Slate

At a later stage you may wish to try carving a house name in riven slate, which is slightly more challenging for the beginner, its irregular surface rendering it more difficult to trace down the design accurately. It especially helps to have a good understanding of letterforms when using such surfaces, as some adjustments to the letters may need to be made as you are carving. This is equally true if you draw the lettering directly on to the slate without tracing. For the beginner, a riven surface also makes it more difficult to assess clean V-incised letter outlines.

Other Applications

Carved names may be required for other types of buildings besides houses. The illustrations opposite and above show such other uses, including a school sign in Portland stone (set into a recess in the brick wall), a circular slate sign and a slate name for a school theatre (the latter two both dowelled into the wall).

Using Boulders and Pebbles

For situations where a larger-scale name may be required, and where something other than a smooth or riven stone or slate fixed to a wall is desired, a natural boulder may be an attractive option. This would most likely require larger, bolder letter carving. In addition to signage purposes, smaller boulders and pebbles can make very attractive artefacts with people's names carved on them, to commemorate birthdays, weddings, births, christenings and other special occasions.

Alphabet Project in Formal Roman Capitals

Formal Roman capitals are a suitable starting point for the beginner letter carver, and designing and carving a complete alphabet provides a very good basis for further letter carving work. Apprentices and assistants to Eric Gill were required to carve a Roman capital alphabet for their first letter carving exercise, and this sometimes included Roman lower case and numerals. This was a practice that David Kindersley, who trained with Eric Gill, continued at his workshop in Cambridge. Kindersley said:

> Roman capitals are an ideal starting point, educationally speaking. They include the subtleties, optical illusions and problems of form that are common to all alphabets. I would start an apprentice there, but would later introduce them to a wide variety of lettering styles and sources. (Quoted in O'Donnell, Lettering in the 20th Century: a report on the practice, development and teaching of lettering in Britain this century, Crafts Study Centre, 1981)

Drawing the Alphabet

Here I have deliberately adopted a fairly standard layout, as the point is to concentrate on the letterforms and the spaces between them rather than on more complex layout possibilities.

The first consideration is the size of the letters, as this will influence the overall size of the design – a minimum of 5cm (2in) is recommended. Next, if you are relatively

Kevin Cribb, Roman capital alphabet, V-incised Welsh slate, Cambridge, 1988. 61 × 15cm Private collection.

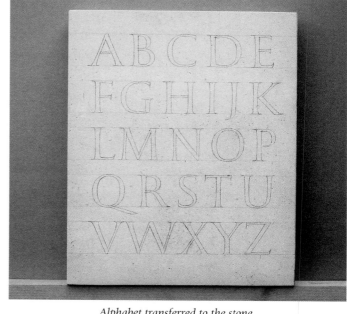

Alphabet transferred to the stone.

new to lettering, I would suggest you rule up pencil lines on layout paper 5cm (2in) apart and draw the alphabet, disregarding layout at this stage but giving consideration to even and suitable letter spacing, as this will cut down adjustments at a later design stage. To determine suitable letter spacing, draw an accurate Roman capital 'H' at the 5cm (2in) height and place an 'I' next to it at a distance equal to approximately half the height of the letters. This will give the distance between all adjacent straight-sided letters, and the area between all the other letters drawn at this height. Obviously, some letter combinations are more difficult to space than others (see Chapter 7 for further details). The letter stem width to height ratio selected is approximately 1:8. For details of drawing Roman capital letterforms (see Chapter 5).

Layout of the Alphabet

After completing the drawing of the letters, rule up at 5cm (2in) for the letters and 2.5cm (1in) for interlinear space on a new sheet of A2-size layout or tracing paper. Trace your letters, either aligning the rows flush left, as I have done in this project, or centring each line and arranging several letters to a line. Here I have made it five letters, apart from the second line which has six. Make any adjustments to letter spacing and fine-tune letterforms as necessary during this stage.

The surrounding margins must then be assessed. On this alphabet I have allowed 4cm (1¼in) for the top margin,

5cm (2in) for the bottom margin, and approximately 4.5cm (1¼in) for the side margins. This must be worked out before ordering the slate or stone. For this project Portland stone has been used at a size of 44 × 36cm (17¼×14in).

Next, cut out small triangles with a craft knife, at approximately 7.5cm (3in) intervals along the base and top lines of each line of letters, which will help with lining up the design and ruled lines on the stone during the tracing down.

Ruling Up the Slate or Stone

Next, ensure the slate or stone is dust free and remove any scratches by sanding with wet-and-dry paper round a cork block, as on the previous project.

Measure, mark and draw lines with a hard pencil on stone or a sharp white crayon on slate. Check that lines are at right-angles to the vertical edges of the stone by means of a set square before tracing down the alphabet, taping it onto the stone with pieces of masking tape and using handwriting carbon paper and a hard pencil for tracing down. Ensure the lines drawn on the stone and lines on the design align through the cut-out triangles, and check that the tracing is coming through shortly after beginning.

For beginners it is better to trace the whole design from one sheet of paper, in order to ensure everything is in the right place before carving. though when more experienced you may prefer to draw out each line of lettering on a separate strip of paper and trace them down singly, carving one line before tracing the next, which is the procedure I use.

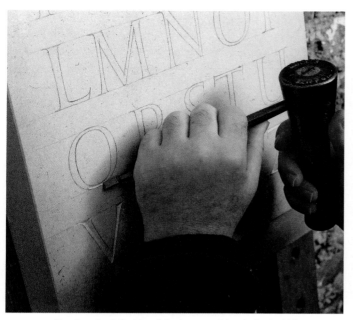

Carving the left side of the bottom thin stroke in 'Q'.

Close-up of 'N', part carved.

Carving

Either carve the bottom line of lettering first, working up the stone line by line, or if starting carving with the top line, cover the rest of the design with a sheet of paper (taped on) to prevent the design being rubbed off whilst carving.

Practice carving stems, horizontals, curves, diagonals and stop cuts before attempting to carve an alphabet. Junctions of thick and thin strokes, especially on letters with diagonals, need particular attention and practice. It is advisable to follow the carving procedure in Chapter 4, where further carving details of this alphabet are shown.

Painting

The alphabet can be left as carved, or painted. After carving has been completed, ruled pencil lines should be removed, possibly with an eraser on stone, or with use of very fine wet-and-dry paper (used dry). For non-porous material such as slate, which can be flood-painted, lines do not have to be cleaned off before painting, but porous stones such as Portland, which cannot be flood-painted, would need the pencil lines cleaned off before (as cleaning them off after painting may damage the paint).

It is best to master the painting of letters before attempting gilding. Further details about painting and fixing carved lettering can be found in Chapter 10. The illustrations following demonstrate some of the many design possibilities for carved alphabets using different letterforms and layouts.

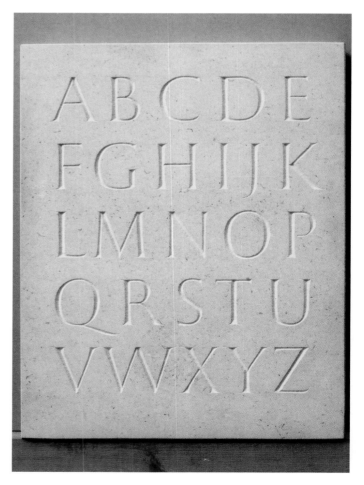

Completed carved alphabet.

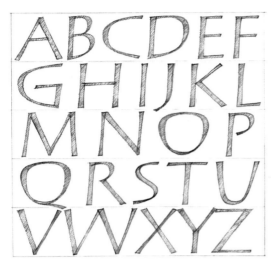

Alphabet design using dynamic capitals.

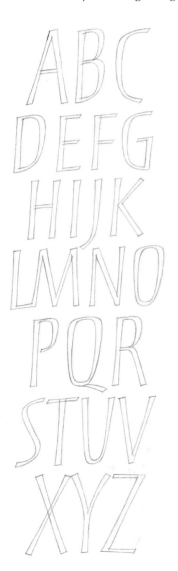

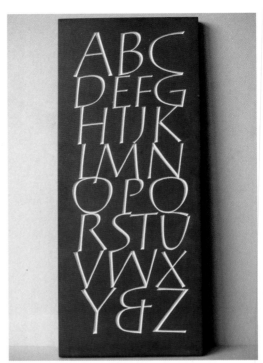

Tom Perkins, V-incised alphabet design in Welsh slate, using dynamic capitals.

Preliminary sketch of lateral alphabet design for carving.

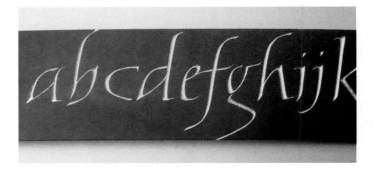

Tom Perkins, V-incised and gilded italic alphabet in Welsh slate, 2002. Detail. 10 × 88cm.

Far left, narrow, vertical alphabet design for carving.

Preliminary sketch of vertical alphabet design for carving.

Poetry Project

Making inscriptions in stone or slate with poetry can be a very rewarding way of using letter carving, and can range from large-scale public arts commissions to smaller-scale artefacts for the domestic environment – both for interior and garden locations. Whether a regular-shaped stone (rectangular, circular or oval) with a fine-rubbed surface, or a single rough menhir or boulder with riven surface, or a group of stones, the creative possibilities are extensive.

Materials

The house name and alphabet projects used fine-rubbed slate or stone, as this is the most suitable surface when beginning letter carving.

This poetry project tackles carving on a rough Welsh slate menhir that has a riven surface. The slate used in this particular project was obtained from a local garden centre. Be sure to ascertain the source of the slate, as it is not easy to tell prior to carving and some imported slates can be much harder to carve than Welsh slate, which is recommended for beginners and used extensively by letter carvers.

'World', rough design for the carving illustrated opposite.

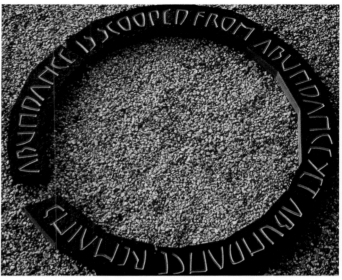

Charles Gurrey, 'Well Head', Caithness stone, V-incised and painted lettering, 2004. Circle diameter 169cm. Quote 'Abundance is scooped from abundance yet abundance remains', from Ann Sexton's poem 'What the bird with the human head knew' (from 'The Awful Rowing toward God'). Privately owned.

Tom Perkins, 'World', V-incised and painted Portland stone, surface left with a chiselled finish. 48 × 17cm. Text by Kathleen Raine (by kind permission of Brian Keeble, the Golgonooza Press).

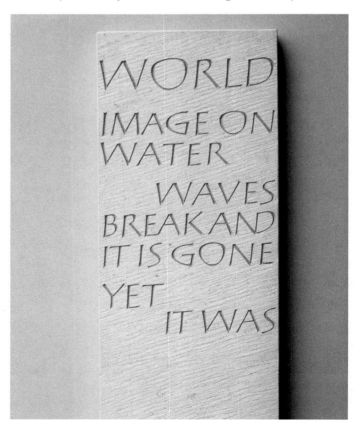

Initial Designs

Having chosen the text, the procedure is the same as for other projects – beginning the design process by making thumbnail sketches. I wanted the slate to stand vertically, and several design possibilities are shown below in the thumbnail sketches for a vertical orientation. I decided to have the lines of text running up the slate to create an interesting texture; this also avoids splitting words on a narrow slate or stone. For letterform I chose dynamic capitals.

Thumbnail sketch for carved poetry using dynamic capitals.

Thumbnail sketch for carved poetry using an italic variation.

Scale and Drawing

The next step is to draw round the stone on layout paper (fixing sheets together if necessary). Then lightly and quickly sketch in the text, in monoline following the selected thumbnail idea, quite roughly at this stage, to see at what scale the lettering will fit the stone (allowing for adequate surrounding space). Note that for this freer inscription on an uneven slate surface, no lines are ruled for the lettering.

Having established the scale of the lettering, the next step is to draw round the stone again on layout paper and draw out the lettering more carefully, this time using weighted letterforms. If necessary after this stage, overlay a further sheet of layout paper on the drawing to make further improvements in layout, letter spacing and letterforms.

Transferring the Design to the Slate

To transfer the design to the slate, cut round the drawing so it is no larger than the outline of the slate; this makes it easier to align the drawing to the slate. Attach the drawing to the slate at intervals with pieces of masking tape, and insert a sheet of handwriting carbon paper between drawing and slate, and trace down the letters. Here the surface, although riven, is reasonably even. If your slate is very uneven, you will have to improve traced forms as necessary after tracing.

Another method, for use with a very rough surface, is to make a grid over the design, and similarly, rule a grid on the slate with a white crayon, and copy the inscription on

Thumbnail sketch for carved poetry using compressed capitals.

to the slate freehand, with the white crayon. Some people prefer to draw the design freehand directly onto the slate without any grid, but unless the surface is very problematic it is recommended that the inscription is designed first and traced down.

Carving

It is safest to trace the whole design down before starting carving, protecting the traced lines not being worked on with a taped-on sheet of layout paper. See Chapter 4 for carving information and techniques.

Finishing and Fixing

The inscription can be left as cut, or painted (see Chapter 10 for details). Gilding a riven surface can be tricky. Smallish menhirs can either be set in the ground, in a hole dug to a depth of around 20cm (8in) for a menhir standing 1m (3ft 3in) above ground, and set in several inches of concrete with earth infill above the concrete, or can stand on a firm base of bricks, at a depth of around 30cm (12in), with packed earth infill.

Alternatively, the menhir can be fixed into a stone base, which needs to be of sufficient size and weight to be stable. The base shown in the finished piece (right) is approximately 7.5cm (3in) deep. The menhir can be doweled into the base with two pieces of metal dowel. To do this, two holes need to be drilled into the bottom of the menhir, to a depth of around 7.5cm (3in). The hole diameter should be slightly wider than the diameter of the dowel, which for a 1m (3ft) menhir that is 5cm (2in) thick should be approximately 1cm (½in). The stainless steel dowels need to be 12.5cm (5in) long. The dowels are glued into the bottom of

the menhir with epoxy resin (see page 157). Similarly, two holes need to be drilled into the base, to a depth of 5cm (2in), to align with the dowels in the menhir. Once the dowels have been glued into the bottom of the menhir, it should be lowered into the base to check that the dowels will fit into the holes comfortably, and the holes drilled out further if necessary before epoxy resin is placed in the holes and the menhir fixed into place. Note that you could dowel the menhir into a concrete slab in the same way and bury the slab under a few inches of earth.

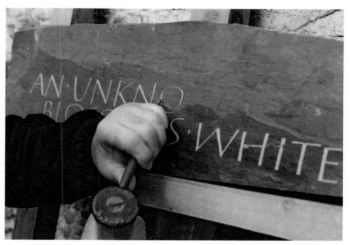
Carving in progress.

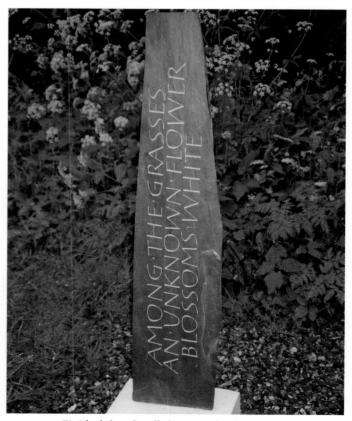
Finished slate dowelled into Portland stone base.

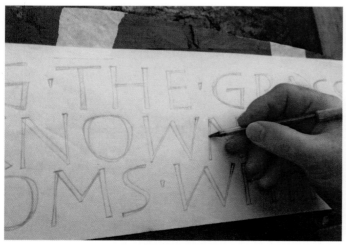
Selected design taped to slate for tracing down.

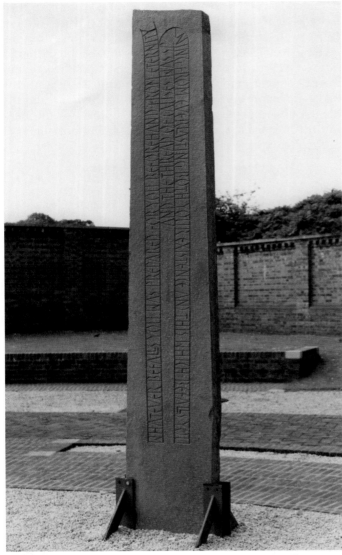

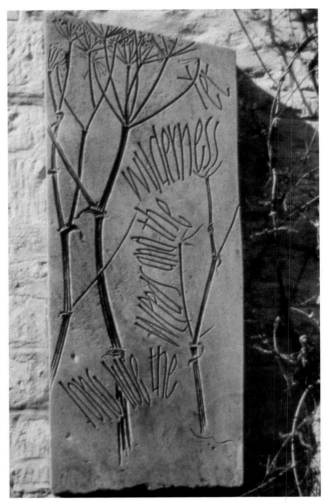

Charles Smith, 'Long live the weeds', incised carving and inscription, old Yorkshire scant, 1995. 130 × 56cm. Quotation 'Inversnaid', poem by Gerard Manley Hopkins in Gardner, W.H. and Mackenzie, N.H. (eds) Poems of Gerard Manley Hopkins, 4th edition. (1970, Oxford University Press). By permission of Oxford University Press on behalf of the British Province of the Society of Jesus. (Work in the collection of Rory Young, shown by kind permission)

Richard Kindersley, 'Whatever befalls…', riven Caithness flagstone menhir, lettering set out in runic form. Text by Marcus Aurelius, from his 'Meditations'.

Example Carvings with Poetry

A carved work with poetry by Charles Smith is shown above right. His following commentary gives an insight into his preferred approach to sculpting letters in stone, which

…is free from the classical Roman letter. Such letters as in the famous Trajan alphabet for example, are very beautiful, but carving them means following a procedure, a procedure of long ago perfected shapes, contours and spacings. And using this code inevitably leads to each piece of finished work looking very much alike, however beautiful and fine. I was trained in such a tradition, both in carving and calligraphic terms. In

reality of course this proved most fortunate. It was the perfect basis from which I could experiment and evolve a more personal contribution, when eventually I felt the need to do so.

I began freely moving the letters around on the surface of the material. I soon realised that the exquisite serifs of the Roman letters, were now out of place, seeing that my work was not designed to be on, or in between, writing lines. So they were naturally discarded. I love movement and complexity and I began to find the letter shapes evolving to assist in creating these ideas. Also letters now became abstract marks to be considered singularly or as words, and no two 'A's or 'B's etc. needed to be absolutely identical. The influence of calligra-

Helen Mary Skelton, slate bowl, oiled Welsh black slate. 45 × 25 × 14cm. Poem by the artist.

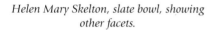

Helen Mary Skelton, slate bowl, showing other facets.

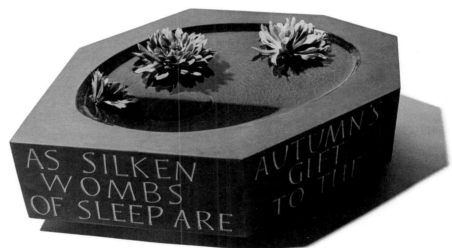

phy, being the thickness and thins or gradations of weight being distributed by the nature of the pen, seemed of less importance and freed the chisel from being subservient to such characteristics. I do not worry too much about legibility except that the lettering must communicate its meaning. And the meaning itself can inspire the design.

I particularly like carving words with which I have complete empathy and which offer scope for illustration. The poem 'Inversnaid' by Gerard Manley Hopkins is an excellent example. In so doing I try to aim for an equality between that illustrated and carved words. I love lettering too much to use it merely as a descriptive caption. (reproduced by permission of Church Building Publication)

The following brief description by Christopher Elsey shows a free approach to designing for carving on a rough boulder:

The opportunity to work in a free and direct way presented itself when considering a present for my parents' golden wedding. First, I came across a large Delabole slate boulder at my local stone yard. This gave me the idea for a poem relating to the view from my parents' garden. I proceeded to compose the poem, first on paper and then directly on the slate, changing the composition of the text both for literary reasons and for layout. This was achieved using different colour crayons, so that corrections could be easily interpreted during the carving process. The result gave the finished work an unrefined feel to go with the unprocessed slate boulder. (Christopher Elsey, statement provided to the author)

The following projects show some further examples of the range of interesting uses of carved poetry, both small-scale artefacts, and large-scale public art commissions. The slate bowl above, designed and carved by Helen Mary Skelton, has a carved depression 7cm (2¾in) deep, with an acorn in the centre and free capitals carved

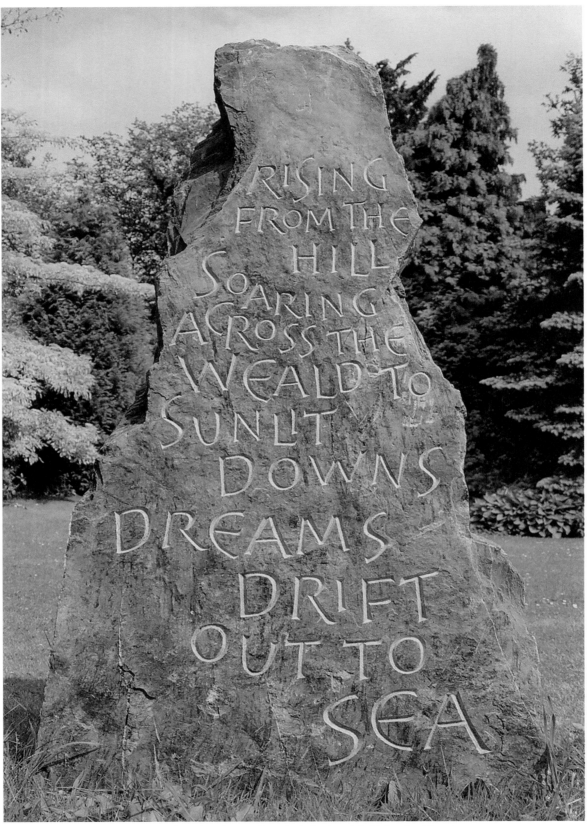

Christopher Elsey, 'Rising from the hill…', Delabole slate boulder, V-
incised. 122cm high. Words by the artist.

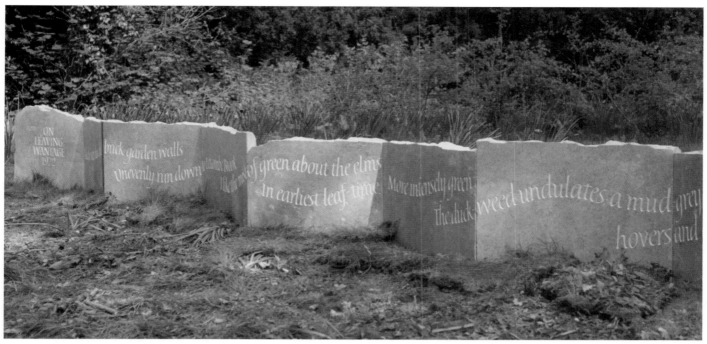

Alec Peever, 'Poetry Wall', Purbeck stone, the Betjeman Millennium Park, Wantage, Oxfordshire, 2002. 20m long. Poem is called 'On Leaving Wantage' by Sir John Betjeman, who lived in Wantage for 20 years until 1972 when he left for Cornwall.

Pip Hall, inscription from the 'Poetry Path', part of a series of twelve short poems, written by Meg Peacocke, installed at intervals along a circular route of public paths either side of the river Eden on the outskirts of Kirkby Stephen, Cumbria.

on each of the facets. The poem is by the artist.

The 'Poetry Wall' by Alec Peever, in the Betjeman Millennium Park, Wantage, is a large-scale work, 20m long. Alec Peever says of this work,

> it shows one of a series of quotations selected from the work of the former Poet Laureate, because the poem 'On Leaving Wantage' describes the town and its charms, mainly appreciated by strolling alongside Letcombe Brook. The wall is arranged in a zigzag pattern so that it cannot be seen all at once

and has to be read at a walking pace. In my public art work, the way in which the words are delivered to the reader is crucial to its purpose. (Alex Peever, statement provided to the author)

Another large-scale public art commission, by Pip Hall, is 'The Poetry Path'. The works consist of twelve short poems written by Meg Peacocke, carved and installed at intervals along a circular route of public paths either side of the river Eden on the outskirts of Kirkby Stephen, Cumbria. Carved design motifs with each poem depict some of the activities associated with every month of the hill farmer's year.

Gallery

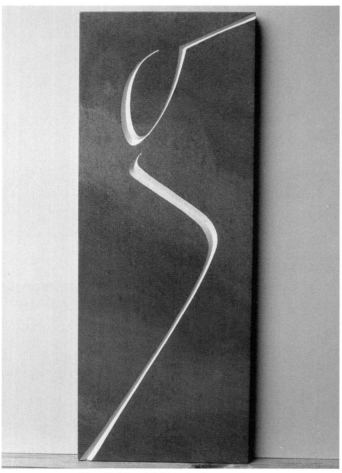

Tom Perkins, 'g', V-incised green slate.

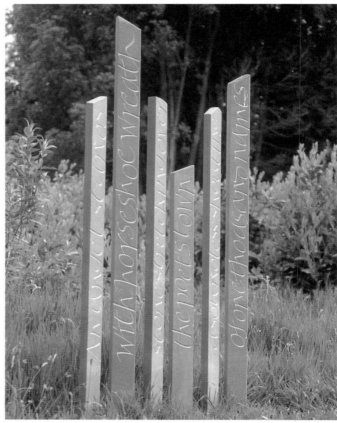

John Neilson, 'Angel', Cumbrian green slate, located at the National Park Centre, Brockhole, Cumbria. Approximately 1.5m high. Commissioned through Cumbrian Public Art for 'Skylines' project, 1999. Text by children from Cockermouth High School.

Incisive Letterwork (Annet Stirling and Brenda Berman), 'Landscape', Purbeck Pond Freestone. 20 × 90 × 2cm. Inspired by the Dutch fields seen when flying low near Schiphol airport. (In the collection of Magda Rogers)

The Cardozo Kindersley Workshop, Stations of the Cross, cut in Welsh slate, at the London Oratory School.

Sheena Devitt, Hopton Wood Limestone, 2005. 40 × 60cm.

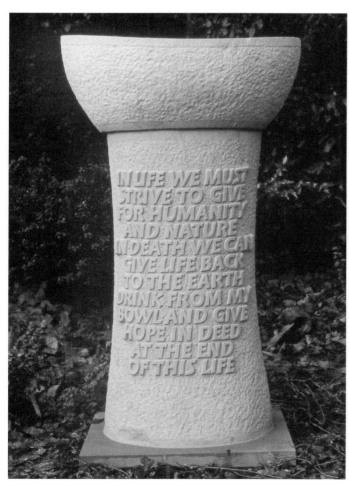

Will O'Leary, 'From the earth to the heavens', memorial font, raised lettering in Beer stone, 1998. 84 × 53.5cm.

Wolfgang Jakob, sandstone headstone, lettering sunk-raised, designed as part of the roots for the tree of life. 125 × 50 × 20cm.

John Nash, memorial tribute to Ben Shahn, incised and relief carving on the front, Welsh slate, 1998. 86 × 38 × 4cm. Made for Memorials by Artists exhibition, Blickling Hall, Norfolk.

John Nash, memorial tribute to Ben Shahn, inscription on back of slate.

Richard Kindersley, 'The Emigration Stone', Cromarty. Caithness flagstone. 420cm high. The inscription is from Hugh Miller's report in the Inverness Courier of the sailing of the Cleopatra in June 1893, with the names of 39 ships that embarked from Cromarty for the New World in the 1830s and 1840s.

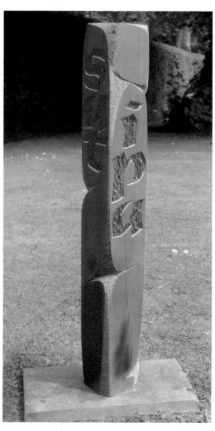

Malcolm Sier, 'Satipatthana', incised carving, Welsh slate, 2005. 75 × 10 × 10cm.

John Neilson, 'Ça Casse, Ça Passe', Woodkirk Sandstone, 2005. 450 × 600 × 5cm. Text from song lyric by Arno Hintjens.

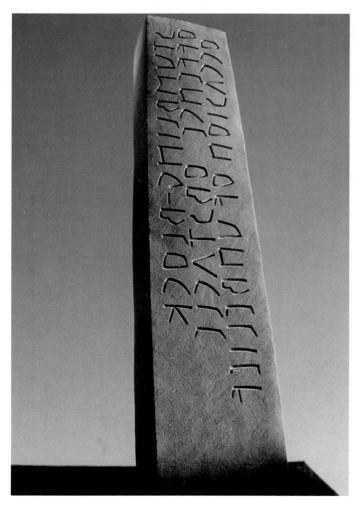

Ben Jones, Memorial to 'Noah', V-incised Portland limestone flagstone. 60cm square. Inscription to a young chorister carved into one of the stones that pave the cremation area in the cloisters of Exeter Cathedral. (Illustrated by kind permission of Sarah Geran)

Charles Gurrey, 'Stumbling Block', Branshaw sandstone, 2004. 160 × 27 × 18cm. Text by the artist (though people take it as a form of paraphrase of 1 Corinthians 1:23), chosen for 'concrete' reasons, and the feel of the words 'stumbling block, offence, obstacle and occasion of unbelief'.

Jon Gibbs, 'Be Still…', V-incised and painted memorial in Griffeton Wood stone. Front of memorial. 75 × 25cm.

Jon Gibbs, 'Be Still…', back of memorial.

Tanja Bolenz, V-incised and painted Welsh slate, 1998. 13 × 74 × 1.4cm. Poem by Kathleen Raine. (Reproduced by kind permission of Brian Keeble, Golgonooza Press)

Michael Harvey, low relief lettering on a Portland stone bird bath for the artist's garden. 'Charlie Parker', the jazz musician, was known as 'Bird'.

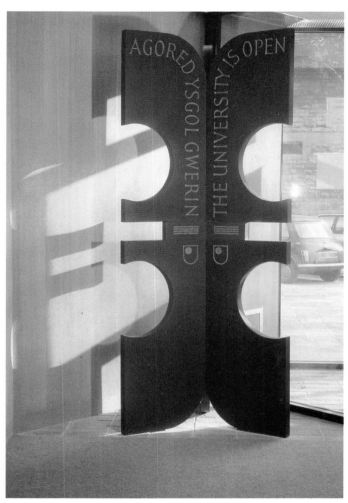

Ieuan Rees, Slate Sculpture for the Open University of Wales, Cardiff. 223cm high.

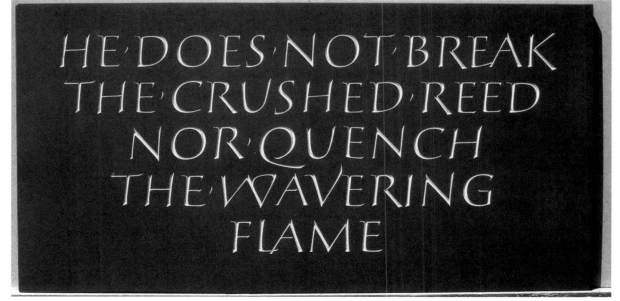

Gareth Colgan, 'He does not break…', V-incised and painted Welsh slate, 1999. 25 × 46cm. Text from Isaiah 42:3.

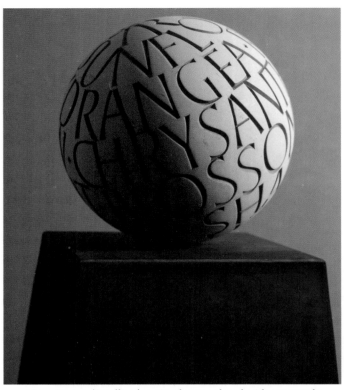

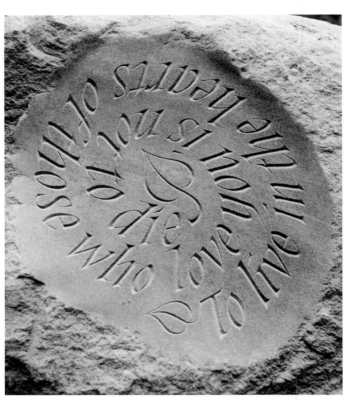

Gary Breeze, 'Satellites', a visual game played with apparently unconnected elements. A focus point for a garden, this 'celestial' globe contains the names of nine flowers spiralling over its whole surface. The list is taken from the names of Japanese and Korean communications satellites. The sphere is 30cm in diameter, made of Purbeck limestone and stands on a slate plinth.

David Holgate, 'Heart' quotation, V-incised on rough York stone boulder, 2000. 100 × 80 × 110cm.

John Neilson, inscription in Woodkirk sandstone round a circular wall at Cefn Mawr, Wrexham, 2001. 15cm × 17cm. Text by Iwan Llwyd.

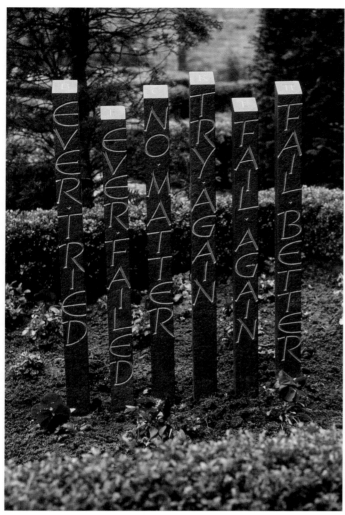

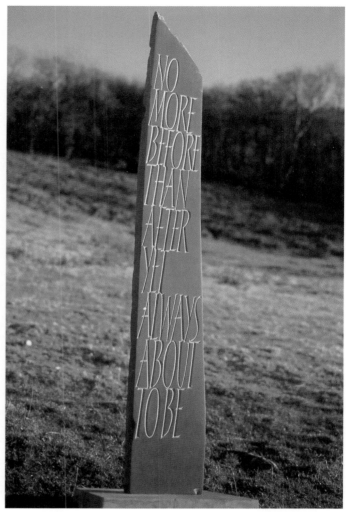

Michael Harvey, V-incised letters on six riven Cumbrian slate menhirs, Museum of the Book, the Hague, 2000. Approximately 75cm high.

John Neilson, 'No more before…', V-incised Welsh slate, 2000. 127 × 15 × 5cm. Text from R.S. Thomas' poem 'Abercuawg'.

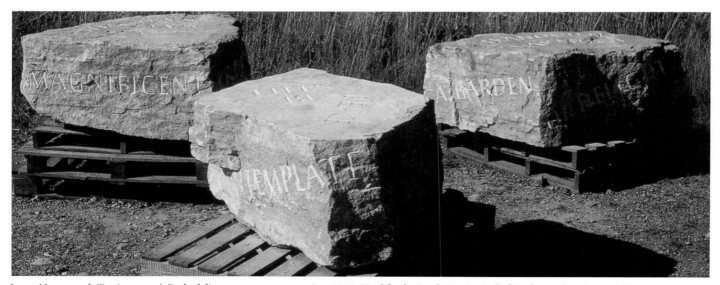

James Honeywood, 'Resting stones', Purbeck limestone, meant as seating, 1998. Used for the South East Festival of Craftsmanship, Petworth House, West Sussex.

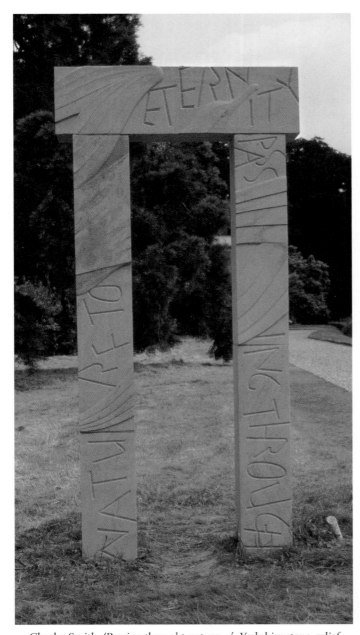

Philip Surey, letter 'R', relief carving in York stone, 2001. 24 × 39 × 4cm

Charles Smith, 'Passing throught nature…', Yorkshire stone, relief carving with incised inscription. For the 'Art of Remembering' exhibition, Blickling, Norfolk, 1998. 230 × 100cm. Charles Smith recalls, 'I had long wanted to carve the words "Passing through nature to eternity", and while visiting the Hancock Museum, Newcastle upon Tyne for the purpose of studying the feet of the Heron for a carving I was busy with (I often see the heron, but not its feet as they are either in water, or covered by pasture or the leaves of the tree in which the bird is perched), I came across a wonderful exhibit, that of the Magnificent Frigate Bird. Although there and then it occurred to me to use its image with the quotation from Hamlet, it was eighteen months later that the opportunity came to do so, when asked to present an example of my work at The Art of Remembering Exhibition, sited at Blickling Hall. The design worked itself out very quickly on paper. Sometimes I wonder if I should have carved the lettering in relief rather than icising it." (Charles Smith, statement provided to the author)

Charles Gurrey, 'Two Thousand'. Date stone, Cadeby (magnesian) limestone. 90cm square. Privately owned.

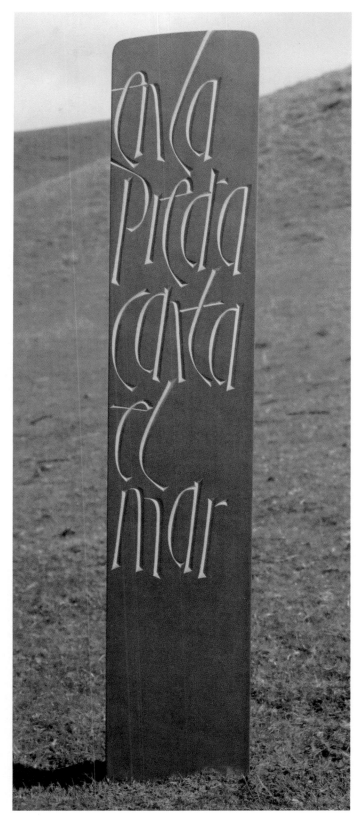

Andrew Baxter, 'Om Ah Hum', Mani stone, Cornish slate.
64 × 14 × 4cm.

John Neilson, 'En la piedra canta el mar' ('In the stone sings the sea').
V-incised Welsh slate. Words by the artist.

Tom Perkins, memorial to Kenneth John Lovatt, V-incised Welsh slate.

Gaynor Goffe, 'Earth', V-incised and painted Delabole slate with calligraphic collage. 78 × 47cm.

Keith Bailey, V-incised inscription in York stone boulder, with central carved acorn. Boulder 75cm maximum dimension, placed in a garden in Shelford, Cambridge.

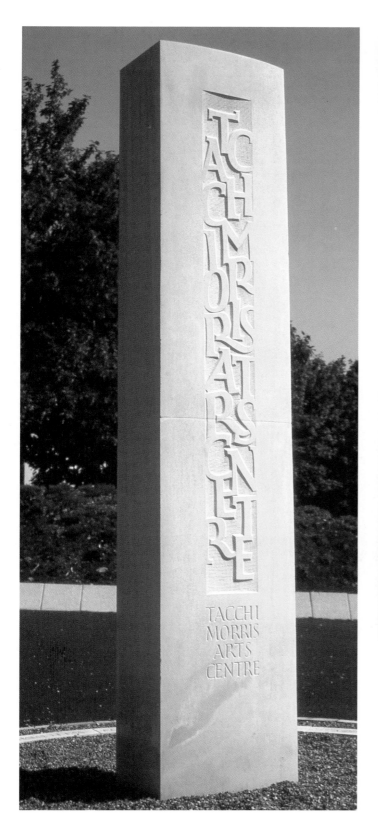

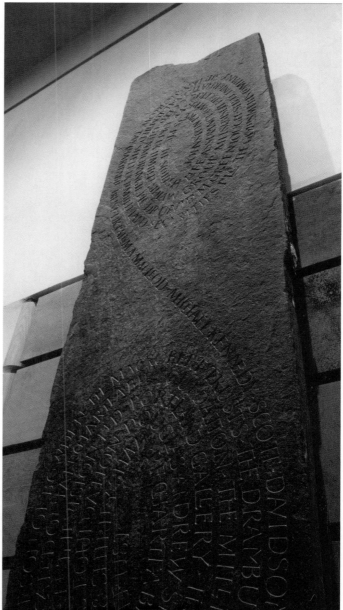

Richard Kindersley, 'Guardians' inscription, 1999. Names of 175 Guardians of the Museum of Scotland, Edinburgh. The names are carved into three 3.8m high Caithness standing stones in double spirals.

Philip Surey, marker stone in Portland stone for Tacchi Morris Arts Centre, Taunton. V-incised letters and relief carving, 1999. 300 × 60 × 40cm. The stone has both its faces and top convex, and is based on human proportions, reflecting that people are central to the building's purpose and also reflecting the strength of Kathleen Tacchi Morris. The movement and relationships in the relief carved lettering reflect dance, music and theatre.

Bibliography

Ashurst, J. and Dimes, F.G., Stone Building (1977, The Architectural Press Ltd)

Benson, John Howard and Carey, Arthur Graham, The Elements of Lettering (McGraw-Hill, 1950)

Berman, B. and Stirling, A., Heavens Above (Ian Grant, 2005)

Bignell, E.(ed) The Natural Stone Directory (QMJ Publications Limited, Biennial)

Bower, P., 'The making of The Language Pillar: a collaboration between Sally Bower and Mark Frith', The Edge (Vol 5, No 3, Winter 1999, pp. 4–13)

Catich, Edward M., The Origin of the Serif (The Catfish Press, 1968)

Child, H. (ed.) Formal Penmanship and Other Papers by Edward Johnston (Lund Humphries, 1971)

Edward Johnston Foundation, Font (Edward Johnston Foundation, 2000)

Evetts, L.C., Roman Lettering (Pitman, 1962).

Fleuss, Gerald Tom Perkins Letter Carver (Calligraphic Enterprises, 1998)

Frazer, H. and Oestreicher, C., The Art of Remembering (Memorials by Artists, 1988).

Gayford, Martin, Kindersley, David and Lopes Cardozo Kindersley, Lida, Apprenticeship (Cardozo Kindersley, 2003)

Grasby, Richard, Lettercutting in Stone (Sacketts, 1989)

Grasby, Richard, Latin Inscriptions: Studies in Measurement and Making. (Papers of the British School at Rome, Vol LXX, 2002)

Harvey, Michael, Lettering Design (The Bodley Head, 1975)

Harvey, Michael, Creative Lettering Drawing and Design (The Bodley Head, 1985)

Harvey, Michael, Carving Letters in Stone and Wood (The Bodley Head, 1987)

Jakob, Sepp, Leicher, Donatus, M., Schrift und Symbol (Callwey, 1977)

Johnston, E., Writing and Illuminating, and Lettering (Sir Isaac Pitman and Sons Ltd, 1906)

Kemp, Tom, Formal Brush Writing (Twice Publishing, 1999)

Kindersley, David, Letters Slate Cut (Lund Humphries, 1981)

Kindersley, David and Lopes Cardozo Kindersley, Lida, Optical letter spacing (Cardozo Kindersley, 1996)

Lloyd-Jones, Emma and Lopes Cardozo Kindersley, Lida, Letters for the Millennium (Cardozo Kindersley, 1999)

Martineau, J., A Book of Coincidence (Wooden Books, 1995)

Mosley, James, 'Trajan Revived' (Alphabet, 1964)

Peace, David, Glass Engraving, Lettering and Design (Batsford, 1985)

Perkins, Tom, 'The Trajan Secrets', The Edge (journal of the Calligraphy and Lettering Arts Society, January, 1977)

Poynder, M., Pi in the Sky (Collins Press, reprint 1998)

Thom, A., Megalithic Sites in Britain (Oxford University Press, 1967)

Zapf, Hermann, Hermann Zapf and His Design Philosophy (Society of Typographic Arts, Chicago, 1987)

Useful Addresses

TOOLS: SUPPLIERS IN THE UK

Alec Tiranti Ltd
3 Pipers Court
Berkshire Drive, Thatcham
Berkshire RG19 4ER
Tel: 0845 123 2100
Email: enquiries@tiranti.co.uk
www.tiranti.co.uk

Avery Knight & Bowlers Engineering Ltd
James Street West
Bath BA1 2BT
Tel: 01225 425894
Email: sales@averyknight.co.uk
www.averyknight.co.uk

B.I. Crawshaw & Co Ltd
Silverwing Industrial Park
Horatius Way
Croydon
Surrey CR0 4RU

Tel: 0208 686 7997
Email: info@crawshaws.co.uk
www.crawshaws.co.uk

C.M.S. Masonry Supplies Ltd
Unit 1, Ripley Road Business Park
Bradford
West Yorkshire BD4 7EX
Tel: 01274 730100
Email: info@masonrysupplies.co.uk
www.masonrysupplies.co.uk

Harbro Supplies Ltd
Morland Street
Bishop Auckland
Co Durham DL14 6JG
Tel: 01388 605363

Tim Morgan
7 Volunteer Road
Theale
Reading

Berkshire RG7 5DN
Tel: 0118 930 5604

R.H. & G. Travis & Sons Ltd
1A Bird's Royd Lane
Brighouse
West Yorkshire HD6 1LQ
Tel: 01484 713504
(Suppliers of Al-Orr letter carving chisels and masonry tools.)

STONE AND SLATE SUPPLIERS

There are many quarries and other stone suppliers listed in the Natural Stone Directory, published biannually by:

Herald House Ltd
96 Dominion Road
Worthing
West Sussex BN14 8JP

Tel: 01903 821082
Email: media@heraldhouse.co.uk
www.naturalstonespecialist.com

Stone suppliers can also be found in the Endat Standard Indexes External Works Compendium of products and specialist services for the external environment, published by:

Endat Group Ltd
Ochil House
Springkerse Business Park
Stirling, FK7 7XE
Tel: 01786 407000
Email: info@endat.com
www.endat.com

QUARRIES

Burlington Slate Ltd
Cavendish House
Kirkby-in-Furness,
Cumbria LA17 7UN
Tel: 01229 889661
Email: sales@burstone.demon.co.uk
www.burlingstone.co.uk

Caithness Slate Products Ltd
Calder Quarry
Halkirk
Caithness KW12 6XQ
Tel:01847 831980
E-mail: info@caithnesslate.net
www.caithnesslate.net

Delabole Slate Co, The
Pengelly
Delabole
Cornwall PL33 9AZ
Tel: 01840 212242
Email: info@delaboleslate.co.uk
www.delaboleslate.co.uk

Ffestiniog Slate Quarry Co
Goddfa Ganol Slate Mine
Blaenau Ffestiniog
Gwynnedd, LL41 3NB
Tel: 01248 600656
Email/website: As for 'Welsh Slate'

Hornton Quarries Ltd
Edgehill
Banbury
Oxfordshire OX15 6DX
Tel: 01295 670238
Email: info@horntonquarries.co.uk
www.horntonquarries.co.uk

Kirkstone Green Slate Quarries Ltd
Skelwith Bridge Sawmills
Near Ambleside
Cumbria LA22 9NN
Tel: 01539 433296
Email: info@Kirk-admin.demon.co.uk
www.kirkstone.com

Welsh Slate
Business Design Centre
Unit 205, 52 Upper Street
London N1 0QH
Tel: 020 7354 0306
Email: enquiries@welshslate.com
www.welshslate.com

Wincilate Ltd
Aberllefenni Slate Quarries
Machynlleth
Powys, Wales
Tel: 01654 761602
Email:slate@wincilate.co.uk
www.wincilate.co.uk

Woodkirk Stone
Brittania Quarry
Morley
Leeds
West Yorkshire LS27 0SW
Tel: 01132 530464
E-mail: sales@woodkirk.co.uk
www.woodkirk-stone.co.uk

OTHER STONE SUPPLIERS

Grassby & Sons
Dorchester Road
Grinstone
Dorchester
Dorset DT2 9NA
Email: info@grassby-funeral.co.uk

Medusa Stone Supplies Ltd
Gundrymor Trading Estate
Collingwood Road
West Moors
Wimborne
Dorset BH21 6QJ
Tel: 01202 894110
E-mail: john.richardson@lidster.co.uk
www.lidster.co.uk

P.A. Hibble
3 Quy Waters
Newmarket Road
Teversham
Cambridge CB1 5AT
Tel: 01223 293593

Realstone Ltd
Wingerworth
Chesterfield
Derbyshire S42 6RG
Tel: 01246 270244
Email: johnc@realstone.co.uk
www.blockstone.co.uk

Stonecraft Design
Longlands Road
Bowness-on Windermere
Cumbria LA23 3AS
Tel: 01539 443600
Email: sales@stonecraft-design.com
www.stonecraft-design.com

OTHER USEFUL ADDRESSES

Calligraphy & Lettering Arts Society
54 Boileau Road
London SW13 9BL
Tel: 020 8741 7886
Email: info@clas.co.uk
www.clas.co.uk

West Dean College
West Dean, Chichester
West Sussex
PO18 0QZ
Tel: 01243 811301
Email: westdean@pavilion.co.uk
www.westdean.org.uk

Crafts Council
44a Pentonville Road
Islington
London N1 9BY
Tel: 020 7272 7700
Email: reference@craftscouncil.org.uk
www.craftscouncil.org.uk

Edward Johnston Foundation
Old School House
Ditchling
Sussex BN6 8TB
Tel: 01273 844505
www.ejf.org.uk
Email: info@ejf.org.uk

Letter Exchange
Tel: 01903 831510
E-mail: letterexchange@rust.clara.co.uk
www.lettrexchange.org

Memorial Arts Charity, The
Snape Priory
Snape,
Saxmundham
Suffolk IP17 1SA
Tel: 01728 688934
Email:
enquiries@memorialsbyartists.co.uk
www.memorialsbyartists.co.uk

Orton Trust
PO Box 34
Rothwell
Kettering
Northamptonshire NN14 6XP
Tel: 01536 761303
Email: info@ortontrust.org.uk
www.ortontrust.org.uk

Weymouth College
Architectural Stone Masonry and Carving Section
Newstead Road
Weymouth
Dorset DT4 0DX
Tel: 01305 208946
Email: devunit@weycoll.ac.uk
www.weymouth.co.uk

TOOLS AND MATERIALS IN THE USA

Buckingham Virginia Slate Corporation
1 Main Street
P O Box 8
Arvona, Virginia 23004-008
Tel: +1 0800 235 8921
www.bvslate.com

John Neal, Bookseller
1833 Spring Garden Street,
Greensborough,
NC 27403,
USA
Tel: +1 336 272 6139
Email: info@johnnealbooks.com
www.johnnealbooks.com
(Letter carving tools in addition to books
and other lettering supplies.)

Trow & Holden Inc

45 South Main Street
Barre, VT 05641
www.trowholden.com
(Stonecarving tools though not chisels for
hand carving as yet.)

Vermont Structural Slate Company Inc
Box 98
3 Prospect Street
Fair Haven, VT 05743
Tel: +1 802 265 4933
www.vermontstructuralslate.com

Index